Affordable
Home Design

Affordable Home Design

Innovations and Renovations

Martha Torres

HARPER
DESIGN

An Imprint of HarperCollins*Publishers*

AFFORDABLE HOME DESIGN: INNOVATIONS AND RENOVATIONS
Copyright © 2004 by HARPER DESIGN and LOFT Publications

First published in 2004 by:
Harper Design,
An imprint of HarperCollins*Publishers*
10 East 53rd Street
New York, NY 10022
Tel.: (212) 207-7000
Fax: (212) 207-7654
HarperDesign@harpercollins.com
www.harpercollins.com

Distributed throughout the world by:
HarperCollins International
10 East 53rd Street
New York, NY 10022
Fax: (212) 207-7654

HarperCollins books may be purchased for educational, business, or sales promotional use. For information, please write:
Special Markets Department HarperCollins Publishers Inc. 10 East 53rd Street, New York, NY 10022

Author
Martha Torres

Editorial Director
Nacho Asensio

Texts
Martha Torres

Translation
William Bain

Design and layout
Nuria Sordé
Andrea Gusi

Editorial project:
Bookslaab, S.L.
editorial@bookslab.net

Library of Congress Cataloging-in-Publication Data

Torres, Martha.
 Affordable Home Design: Innovations and Renovations, by Martha Torres.
 p. cm.
 Includes index.
 ISBN 0-06-058908-6 (hardcover)
 1. Architecture, Domestic. 2. Architecture, Domestic--Conservation and restoration. 3. Architecture, Modern--20th century. 4. Architecture, Modern--21st century. 5. Architects--Directories. I. Title.
 NA7110.T497 2005
 728.1--dc22

 2004014995

Printed by:
Grabasa. Spain

D.L: D-47511-04

First Printing, 2004

Contents

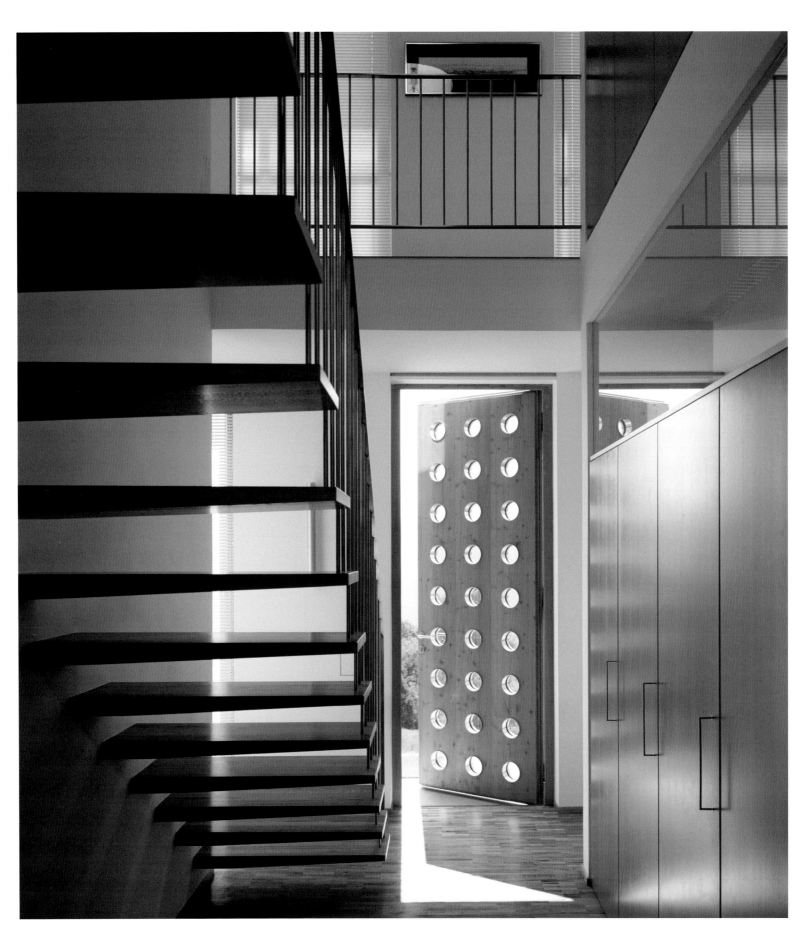

Introduction

One of the most basic human needs is the dwelling. Architecture has to meet this need with designs that guarantee with the highest of principles the client's well-being and comfort. Designing a house is one of the most important challenges architecture has had to face, not only because it is one of the most recurrent projects, but because it often means dealing with smaller investments and finding ways to accomodate the economic restraints of each individual project.

Given such economic considerations, the spatial quality of the house is often determined by the costs invested in it. But a habitable space can be designed in many forms, without large budgets. Ingenious solutions that address cost-effectiveness in terms of design or financial considerations can generate highly attractive results.

There are many starting points from which to achieve an affordable solution: from the structural proposal of the dwelling, to that of the materials, to sustainable projects that increase the initial investment but compensate by making the house more economical in terms of energy consumption. All of these proposals are valid from the architectural point of view.

This book surveys different affordable typologies: extensions for houses or apartments that are already standing, ecological housing designs, sustainable and structurally cost-effective houses, and new buildings in strictly coded conservation zones. The aim is for the wide array presented here to examine different responses to the same significant architectural challenge.

NEWLY CONSTRUCTED HOUSES

ECOLOGICAL / SUSTAINABLE

STRUCTURALLY ECONOMICAL

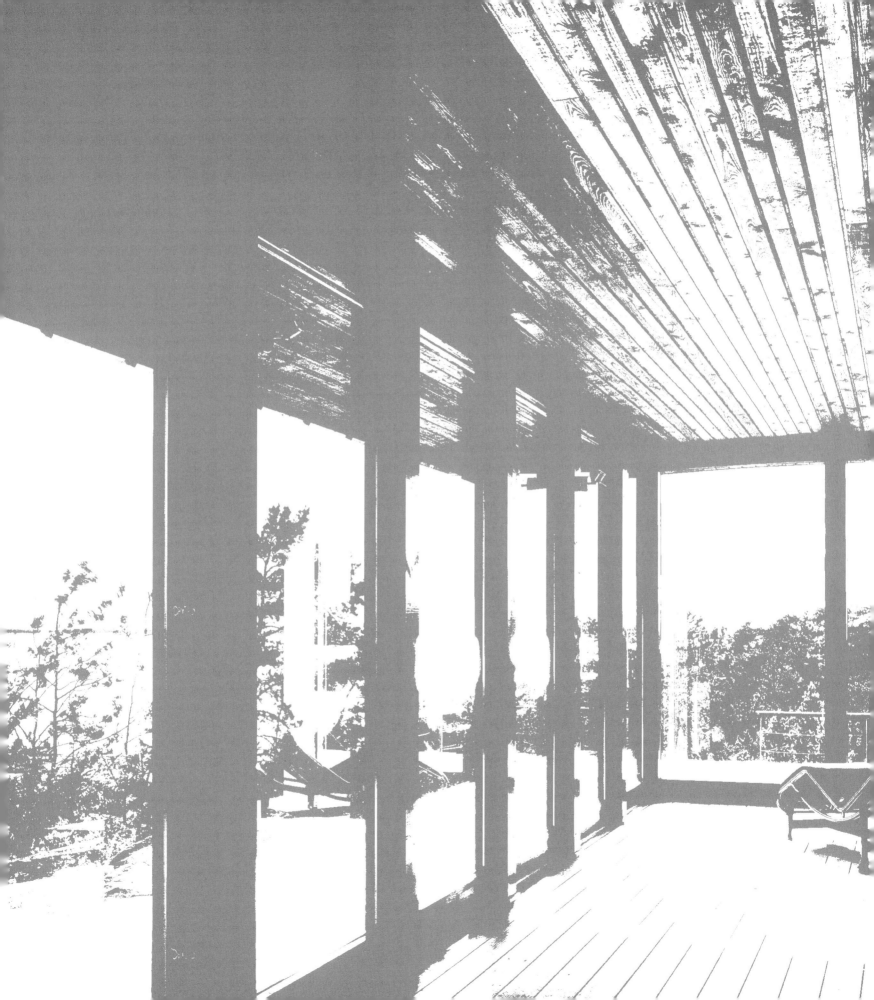

This project is located on a cliff in the midst of a eucalyptus forest recently designated as a National Park. The isolated enclave of the residence and the absence of public utilities (water, electricity, sewer, or phone) suggest that designer and client were inclined to experiment with extreme conditions and the idea of a self-sufficient home. Consequently, the site is manipulated so that its self-regulating processes will not damage human interests. From this standpoint, the house wasn't built to "protect" nature but to organize the sustainability of human presence. This brings new challenges to the house since it must obtain, control, and manage its own energy sources.

The architects' holistic approach was to reconcile activities with a low environmental impact, to use readily available materials and technology, and to recycle the waste produced. Water is supplied by rain collection. Solar energy is used for water heating and generating electricity. Wood burning is used for heating and cooking. The residual waste is treated and sent back to the environment with the knowledge that it will not affect the surroundings. These orientation and construction solutions allow for natural climate control.

On the exterior, we find a series of solar panels, generators, and the garage and stables that open onto an enclosed garden. The covering of the house is resolved with a freestanding, double-sloping roof. As is typical with many Australian barns and agricultural warehouses, a steel structure with galvanized metal is used. In Four Horizons, the positioning, orientation, selection of materials, construction methods, and the careful management of resources and waste were all brought together by an integral concept of harmonious living.

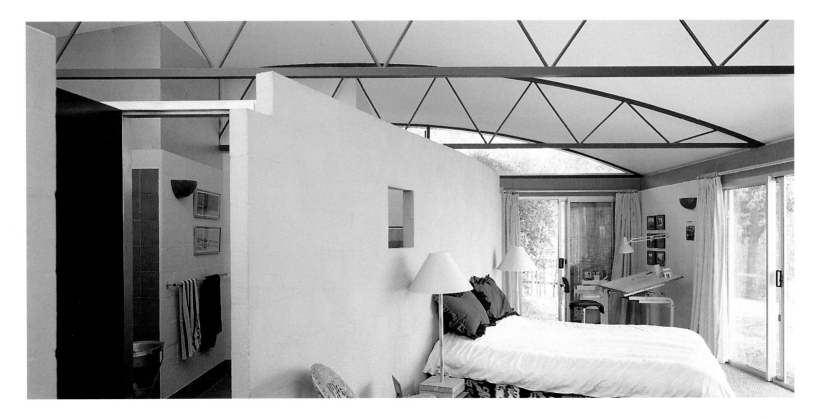

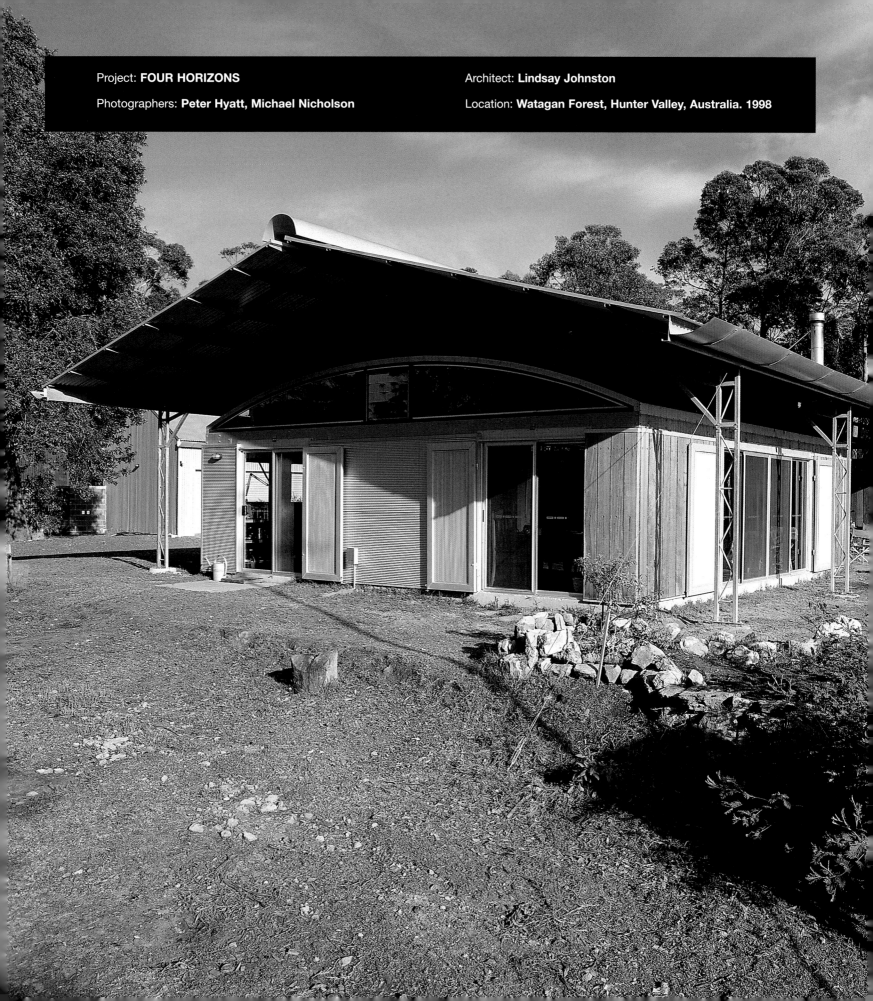

Project: **FOUR HORIZONS**

Photographers: **Peter Hyatt, Michael Nicholson**

Architect: **Lindsay Johnston**

Location: **Watagan Forest, Hunter Valley, Australia. 1998**

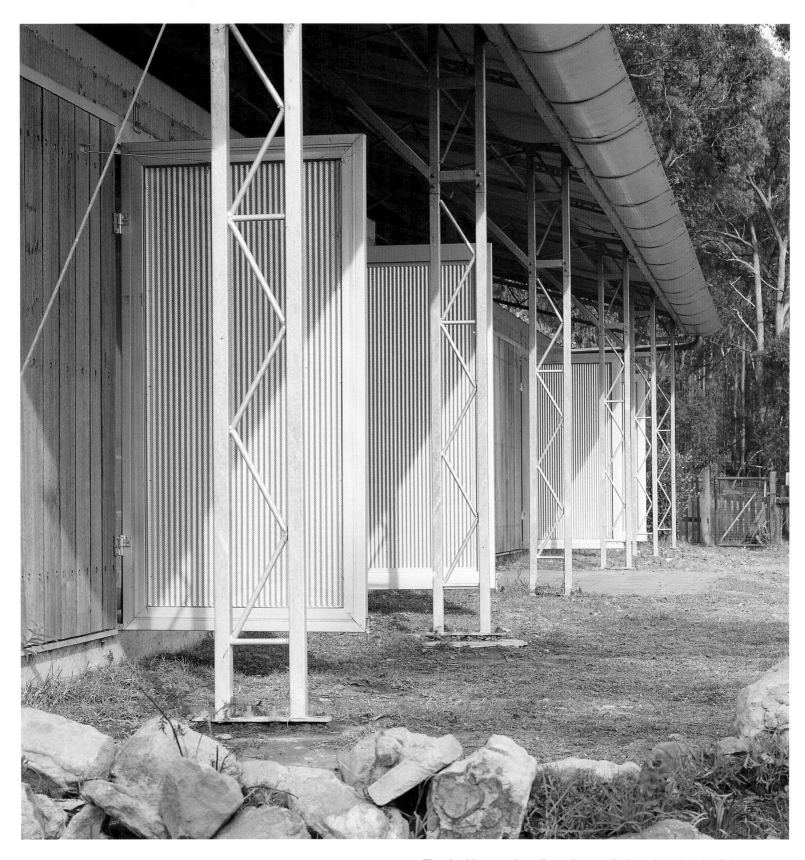

The double covering allows for ventilation of the interior living spaces and regulates temperature and lighting. Water is collected in large tanks that can provide water reserves for many months.

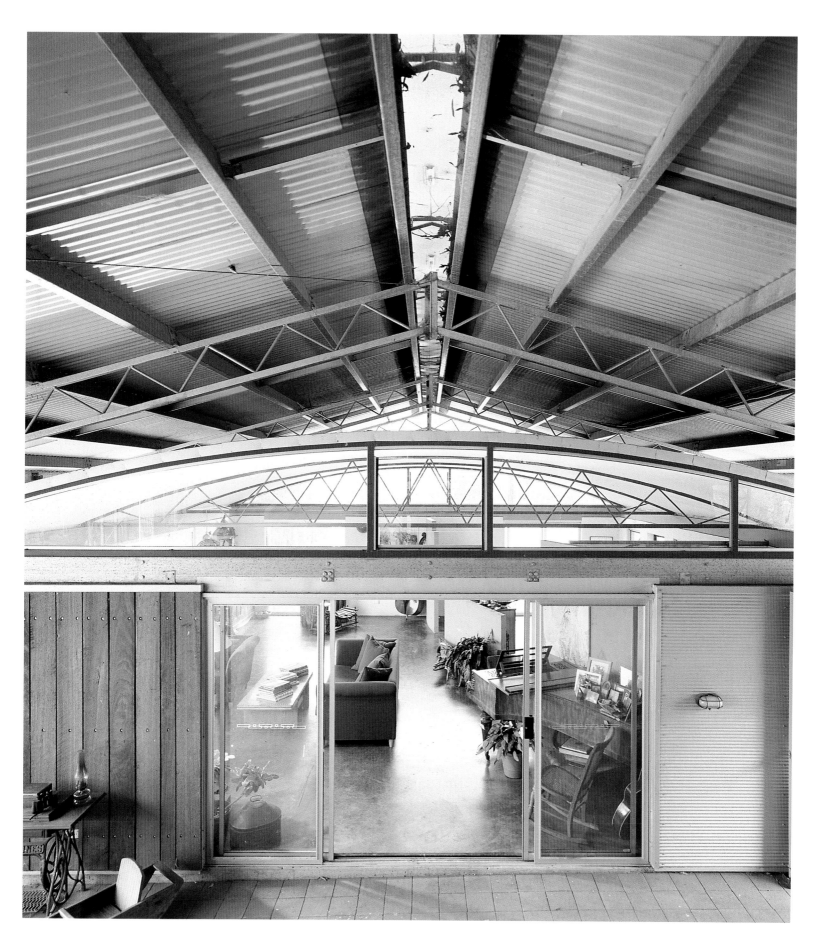

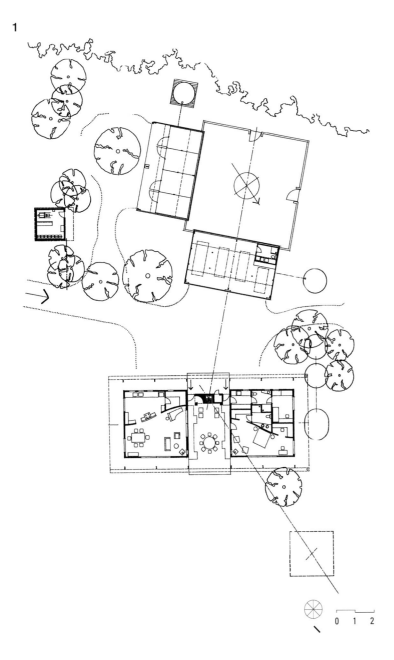

1

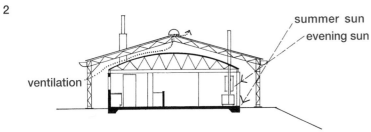

2

1. Ground Floor

2. Section

summer sun
evening sun

ventilation

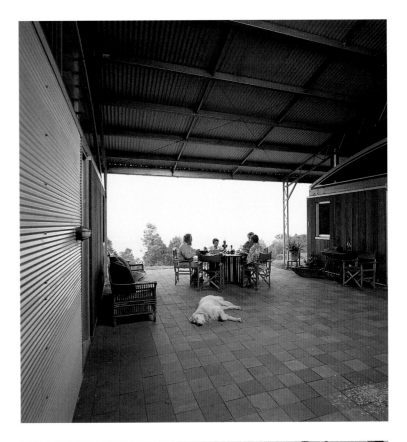

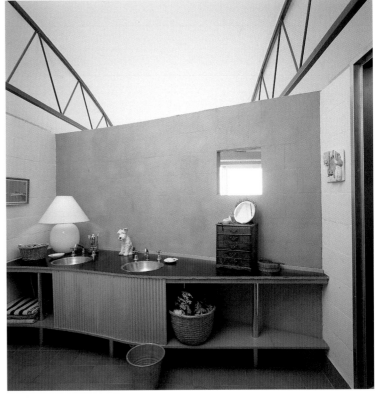

The interiors are also specifically designed to profit from the thermal conditions particular to each season.

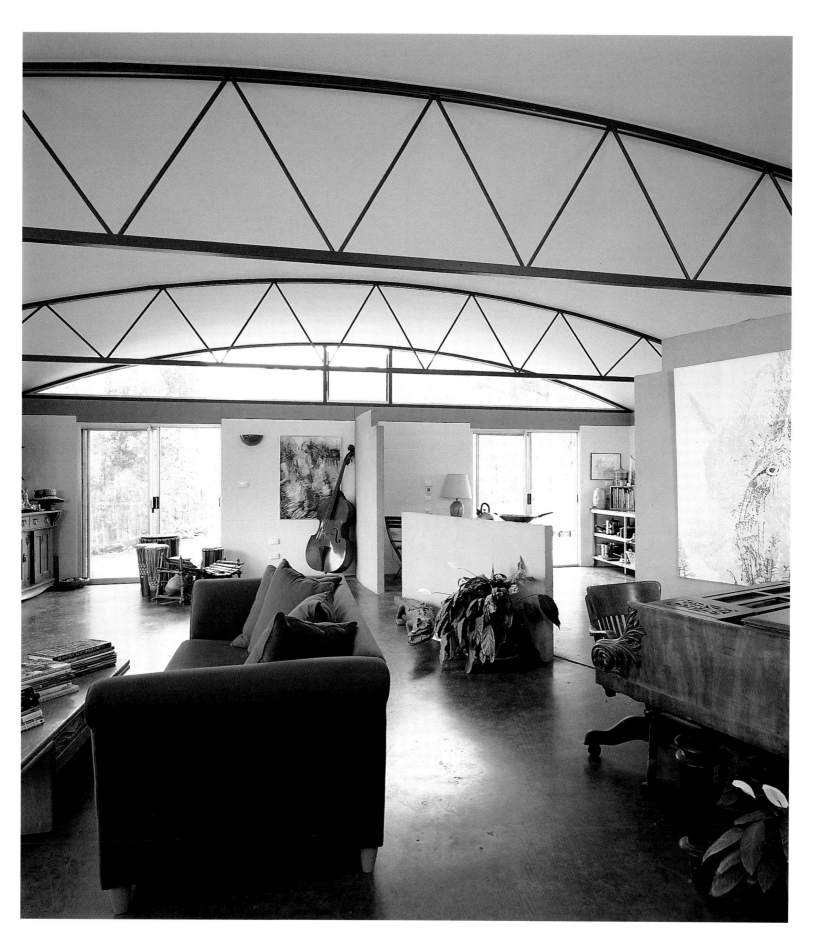

Architect Rolf Disch's firm belief in ecology has led him to become one of the main German proponents of solar power as a means for saving energy. This conviction, as well as tight control over the budget, means that his projects have become an alternative to traditional construction systems. The Solarsiedlung am Schlierberg project was developed on this belief. The design is based on an ecological vision that attempts to be cognizant of the environment and provides the homeowners with savings via residences that are completely powered with solar energy. Meticulous research was carried out and painstaking care taken so that each unit of the project would be guaranteed ample sunlight even in the winter, which would ensure optimum use of the solar panels (placed on the terraces facing south). Apart from the individual installation with which each unit is outfitted, there is community-generated solar energy that provides electricity, distributed through a network to the entire community. But the ecological measures adopted do not stop with solar power. Rainwater is collected, stored, and distributed through pipelines for watering the gardens or for bathroom use in the homes.

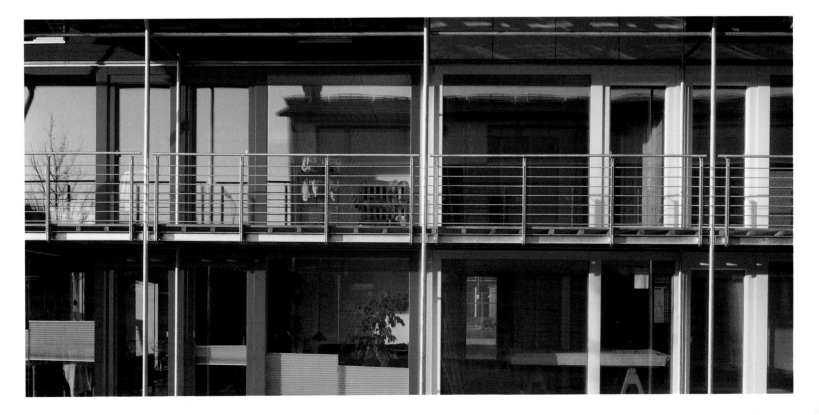

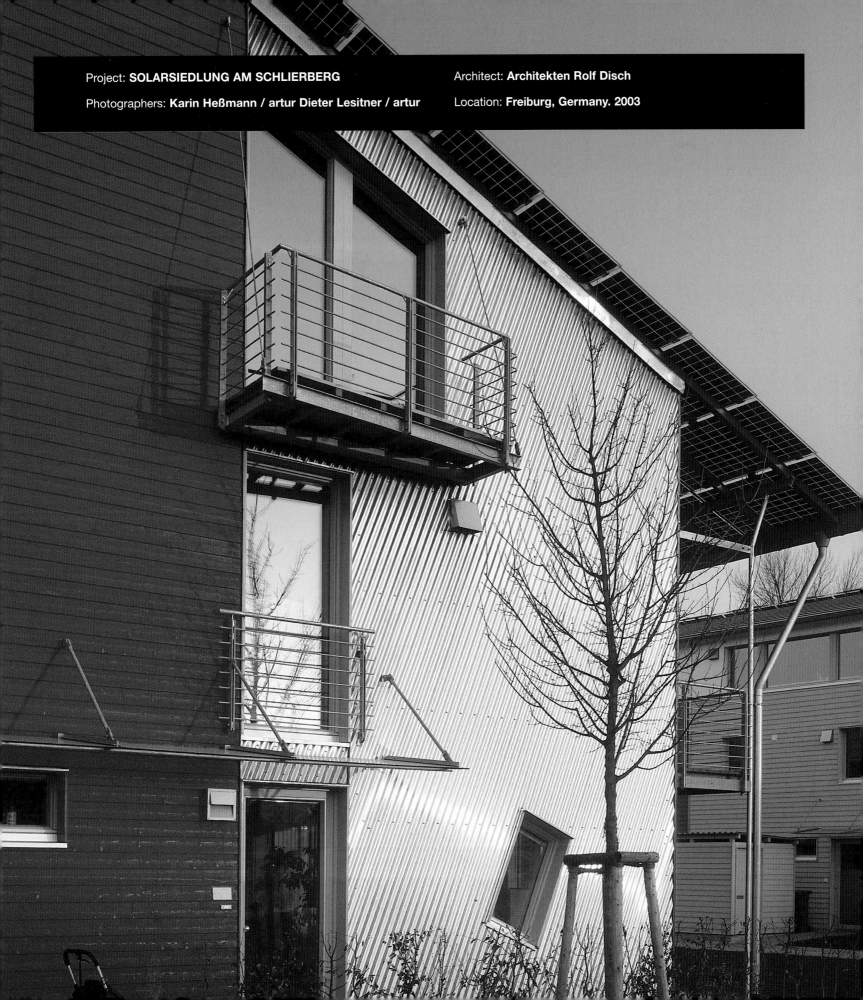

Project: **SOLARSIEDLUNG AM SCHLIERBERG**

Photographers: **Karin Heßmann / artur Dieter Lesitner / artur**

Architect: **Architekten Rolf Disch**

Location: **Freiburg, Germany. 2003**

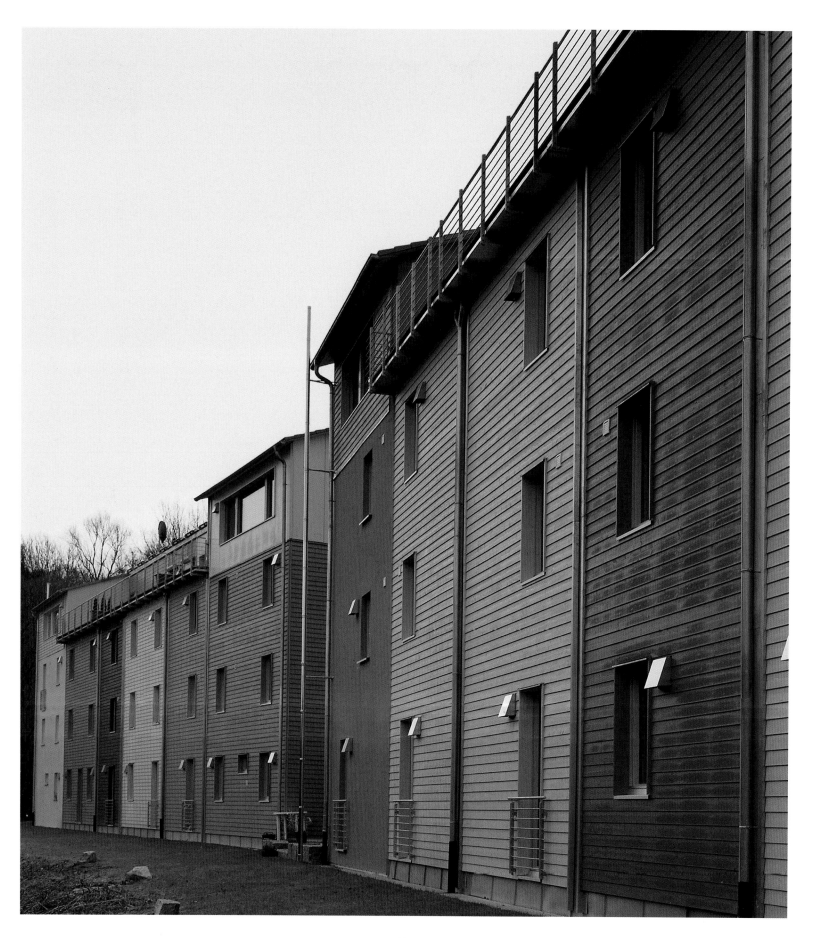

Each of the units in this building was designed to have excellent insulation and thus empower the use of solar panels. This design decision was responsible for the roof slope as well.

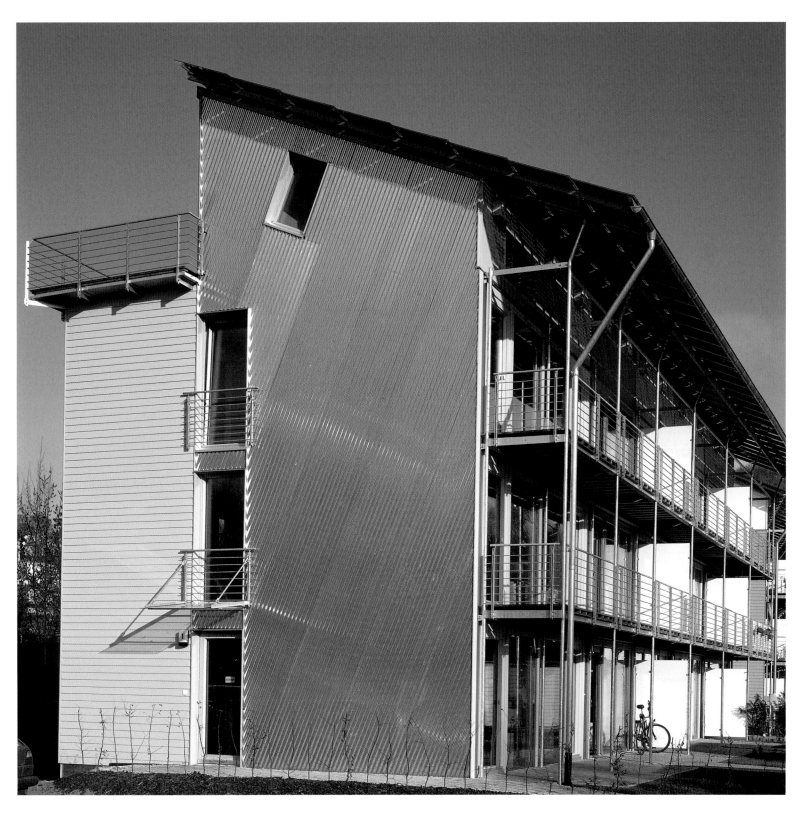

The interiors of these dwellings underscore the accessible nature of the project. The use of plywood and standard furnishings keeps the investment cost-effective in every aspect.

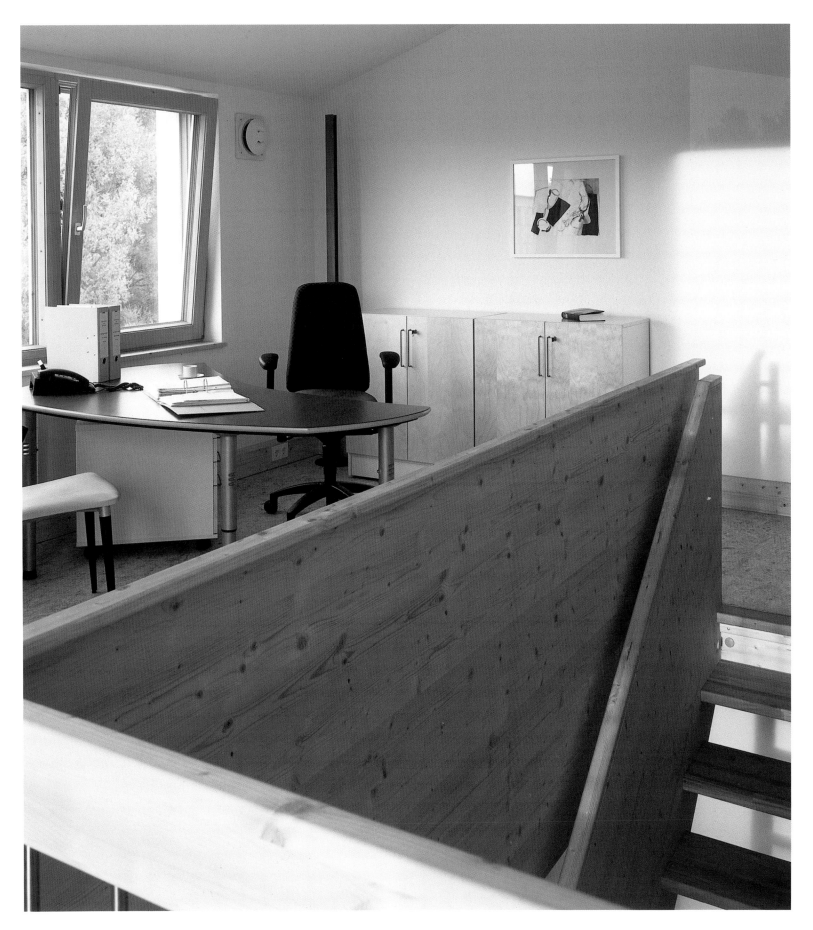

The 25 houses in this project were conceived to be economical in both construction and sustainability. Every aspect of the project was considered with these factors in mind. For example, occupation on the site was optimized to enable the creation of units with two or three levels and a single slope of roofs, which was achieved thanks to the partial fit of the houses on the site. The framing is based on simple wooden structures that were later used as load-bearing elements in the walls. By repeating the model in all of the units, both method and building elements were standardized. But this structural simplicity is offset by the colored shutters, which create visually dynamic façades. The energetic proposal and equally energetic installations are designed according to the canons of low consumption and, in the case the installations, use resources to their fullest by making "walls" of installations. Although the 25 houses were developed on the basis of a single economic concept, different possibilities with different final prices were planned: two- or three-floor dwellings of different widths, different distributions, and with or without basements.

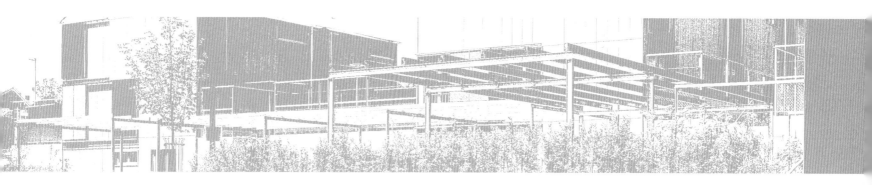

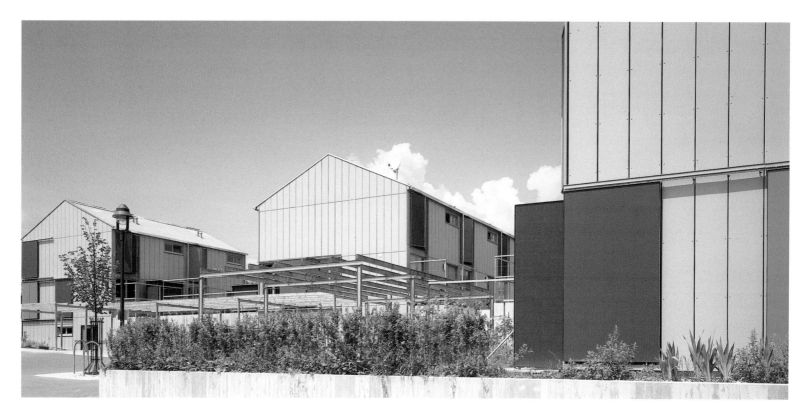

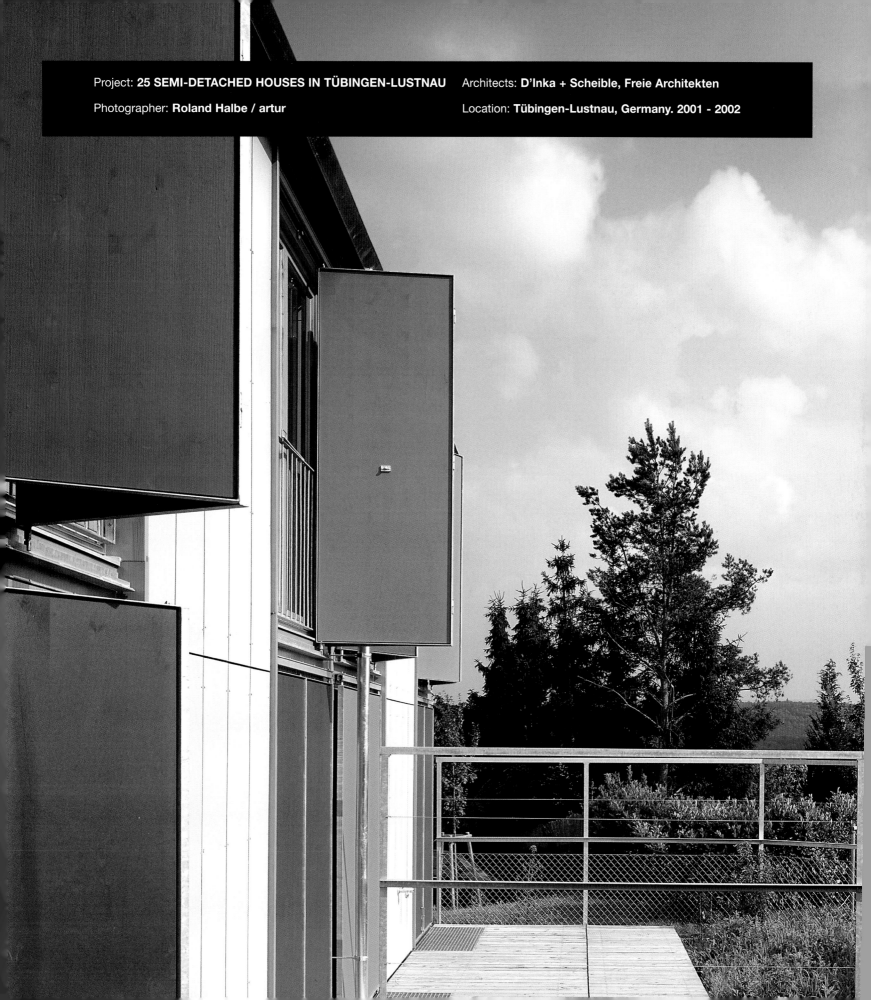

Project: **25 SEMI-DETACHED HOUSES IN TÜBINGEN-LUSTNAU** Architects: **D'Inka + Scheible, Freie Architekten**

Photographer: **Roland Halbe / artur** Location: **Tübingen-Lustnau, Germany. 2001 - 2002**

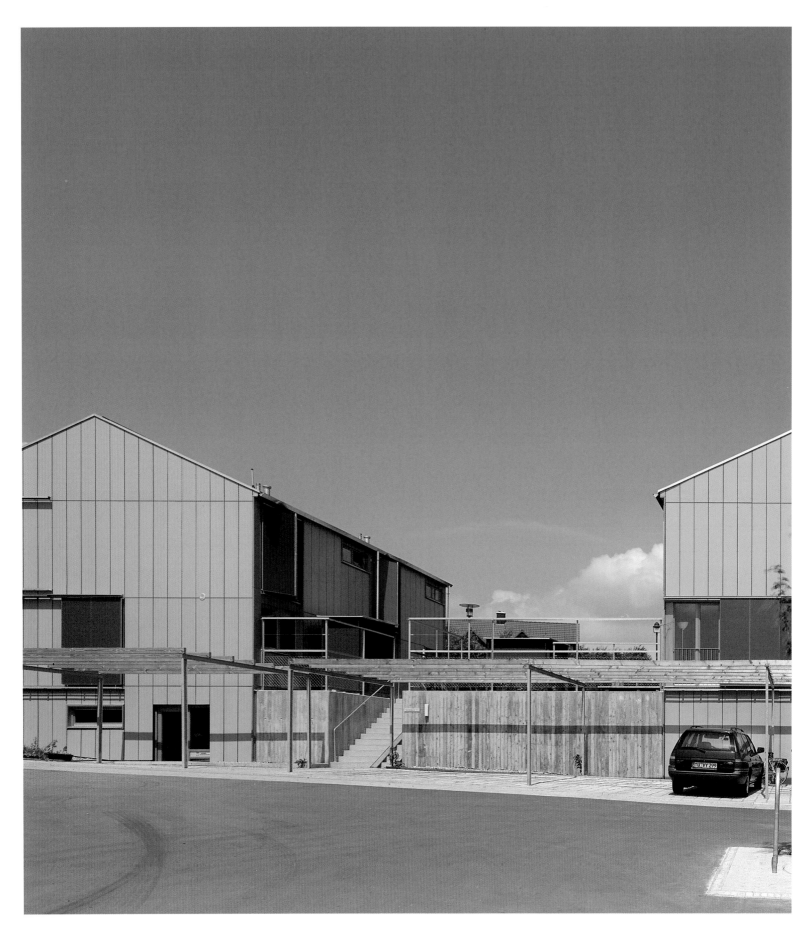

The two-dimensional, monochromatic composition on the front of this building is broken up by the different color blinds, used on the lower floors as a type of party wall or divider.

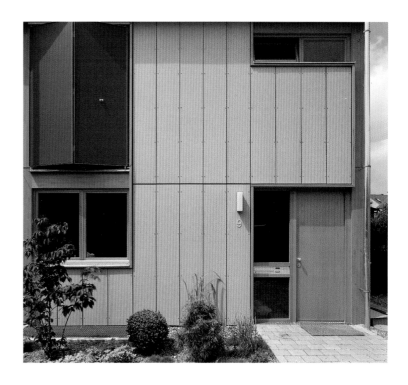

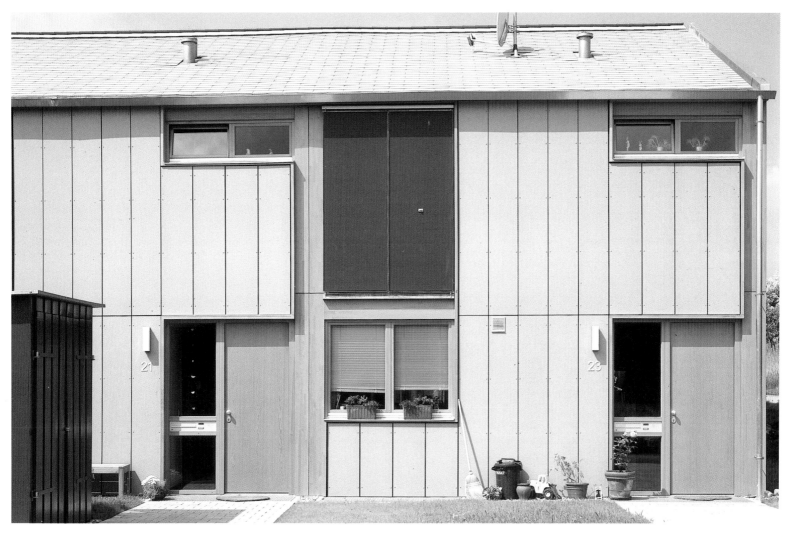

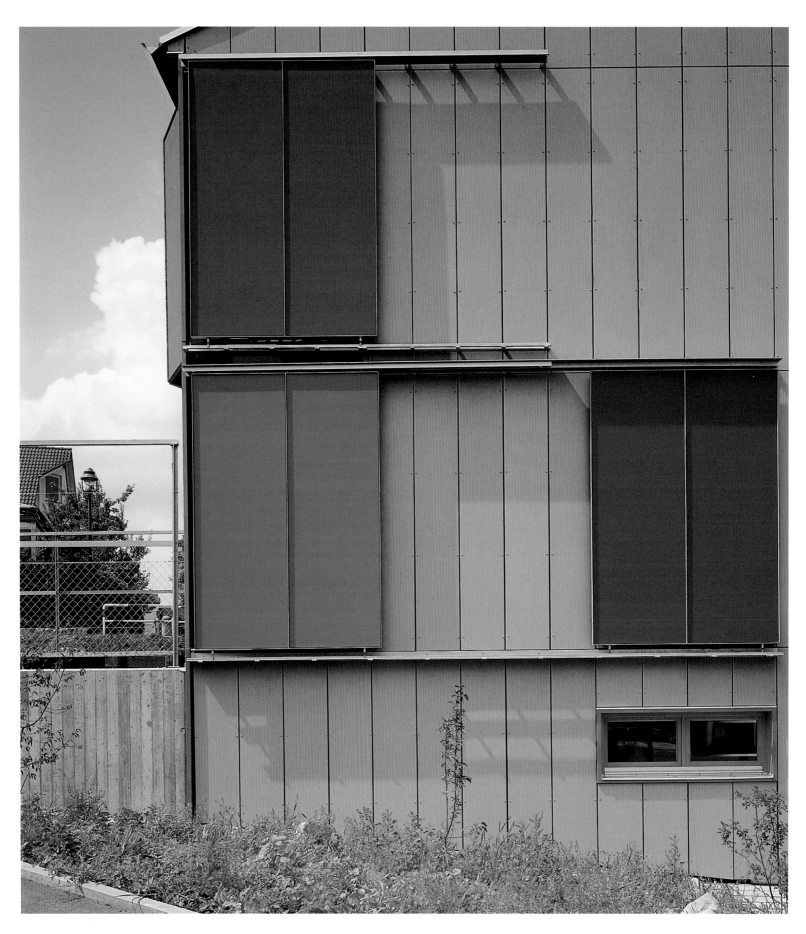

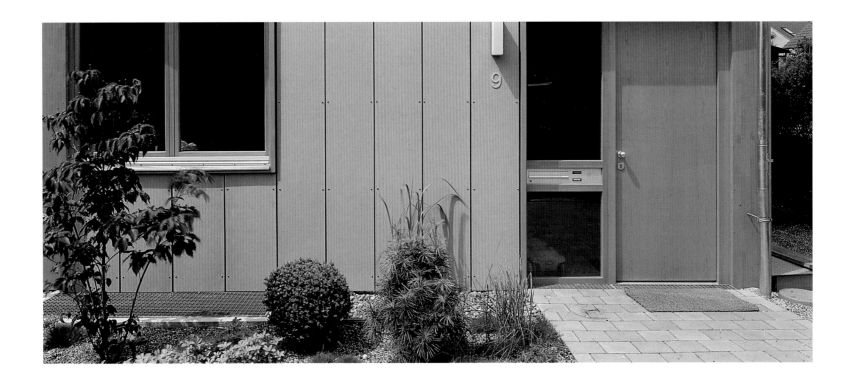

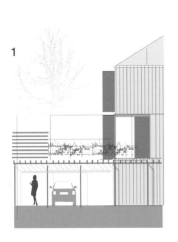

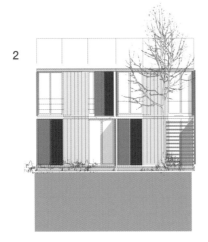

1. Section

2. Elevation

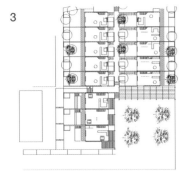

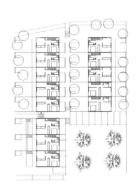

3. Plans

The flexibility with which the plan is organized makes certain alterations possible, such as the different widths and heights of the units.

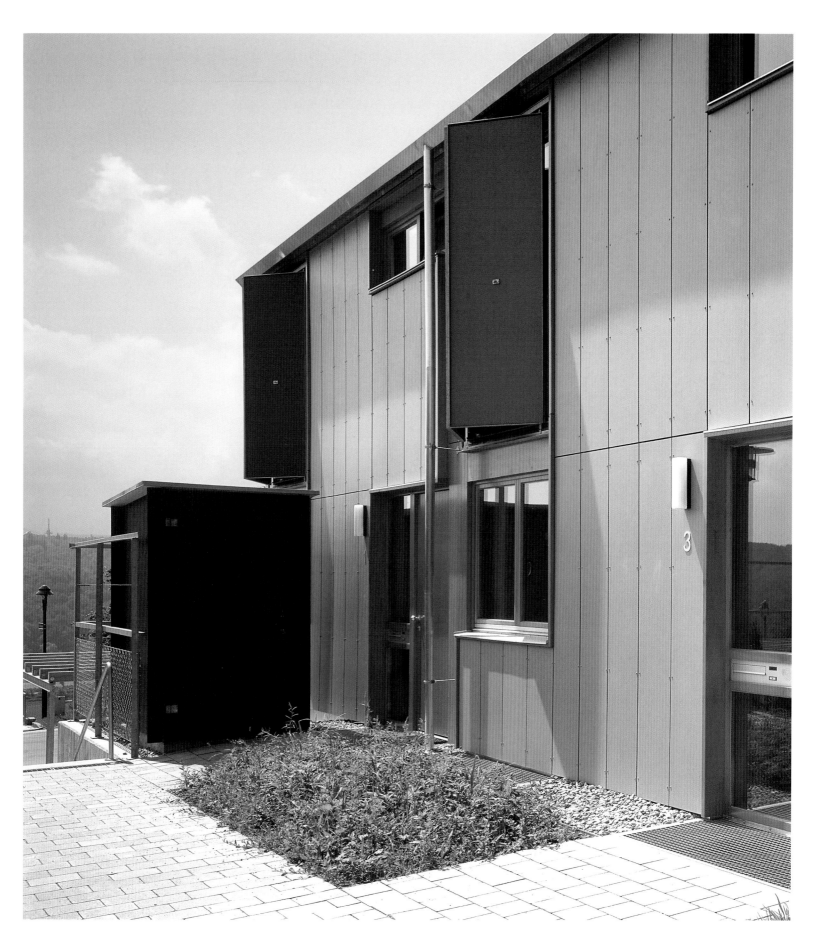

The peculiarities of the site stipulated the design of this house. It is placed on a small island in the Finnish archipelago 50 miles from the capital, practically uninhabited and void of infrastructures. Consequently, the design approach necessitated careful attention to the costs of construction (including labor) and the subsequent costs of maintaining and running the dwelling. The architects opted to use prefabricated materials that were assembled on site, which allowed them to maintain strict control of quality and construction time, lowering the final price tag for the home.

The architects also opted to equip the dwelling with solar and wind power, in order to make it self-sufficient energy-wise. Though the initial outlay in equipment for energy storage (for example, photovoltaic solar panels) is costly, once up-and-running, the system is autonomous. The design results in a delicate volume made of glass and wood that subtly coalesces with the surrounding vegetation.

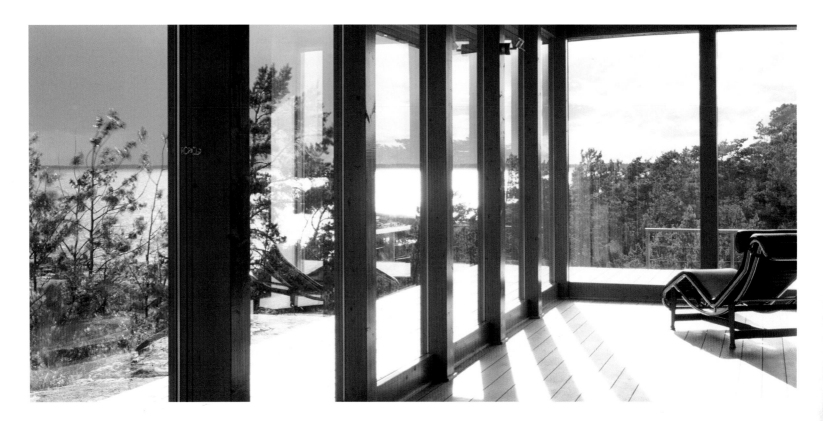

Project: **VILLA MARIA**

Photographer: **Richard Davies**

Architects: **Seth Stein Architects**

Location: **West of Helsinki, Finland. 2000**

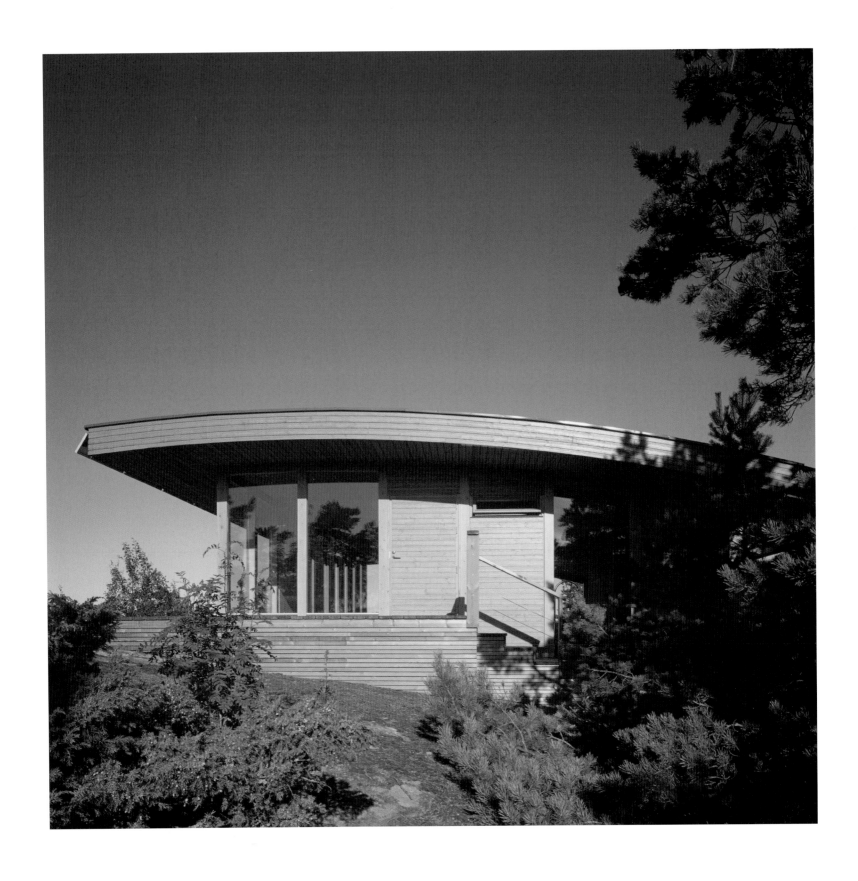

The client wanted the house to be on the highest part of the island to provide a panoramic view of 360 degrees.

The house is framed on the standard measures of the photovoltaic panels. The delicate, curved roof contains the necessary 12 panels the dwelling requires.

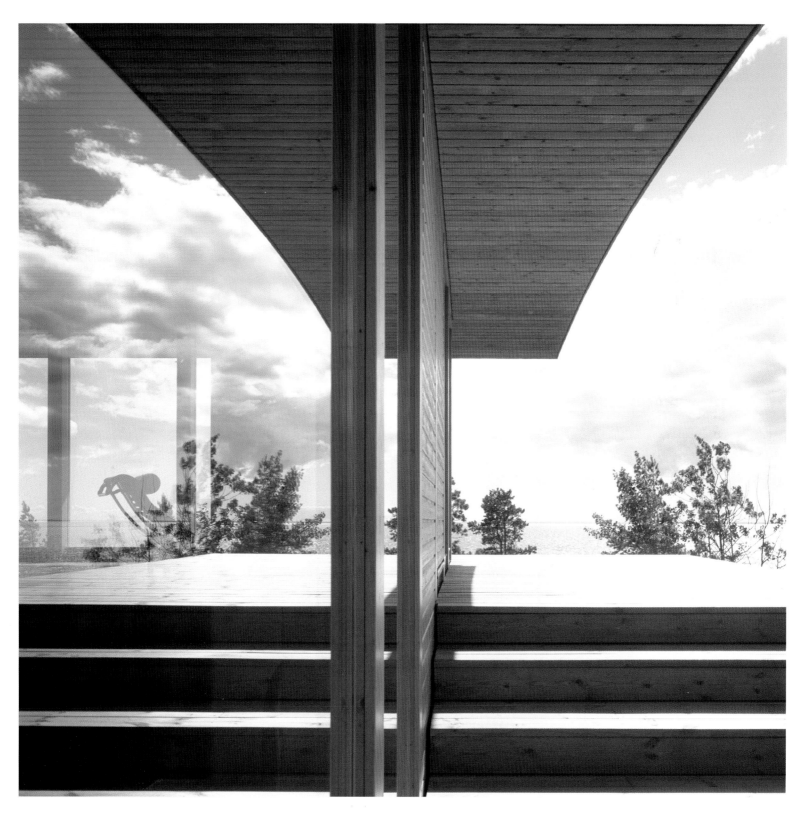

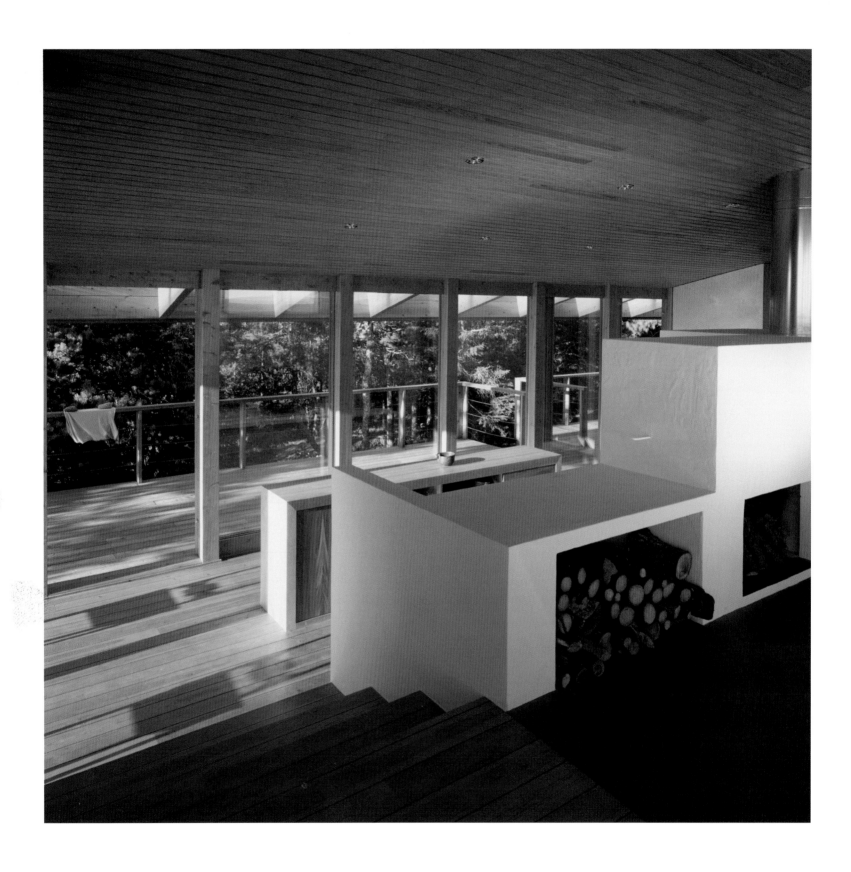

Orthogonal lines are organized simply and clearly to maintain ease of construction. The curved roof on the elevation smoothes out the straight lines of the geometry.

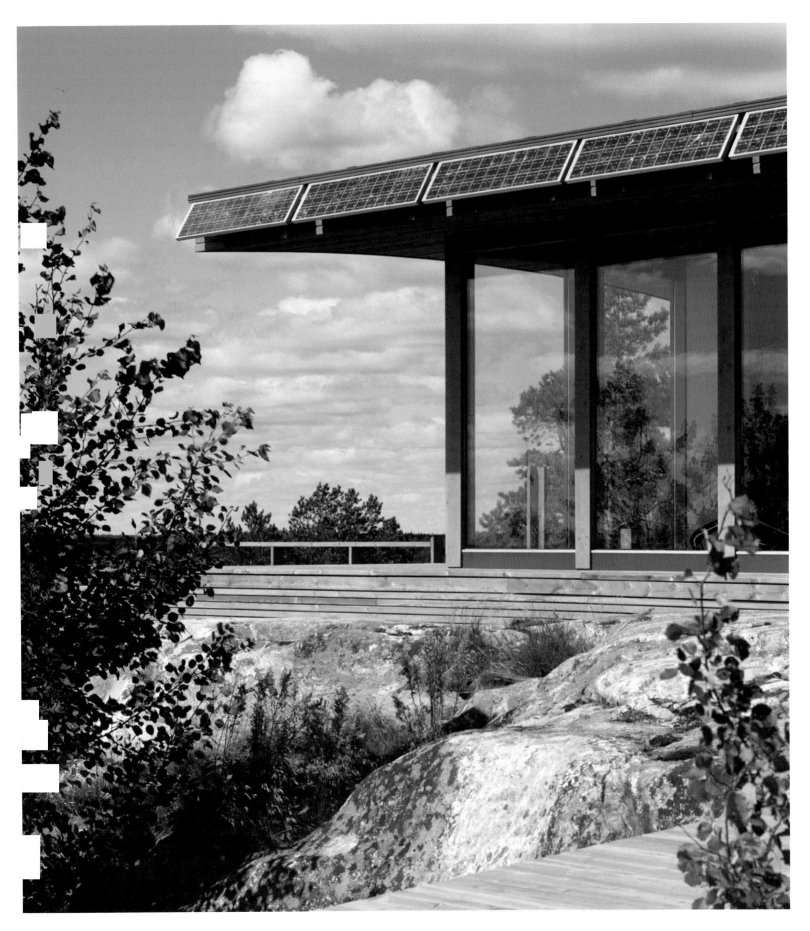

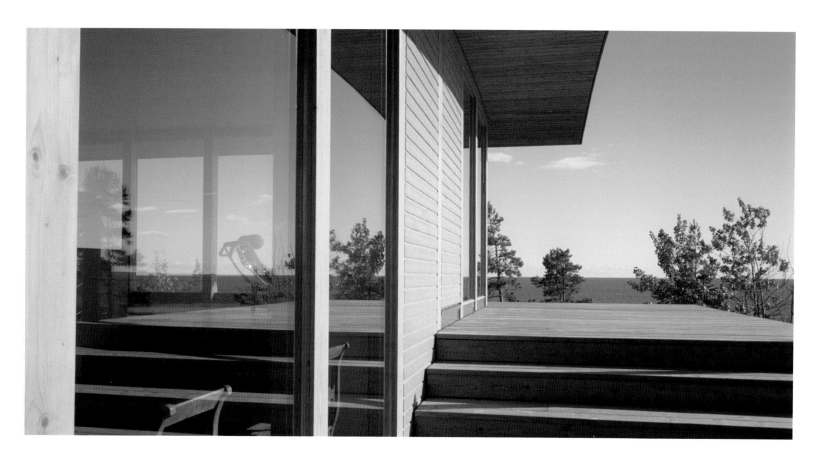

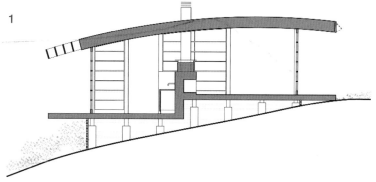

1. Section

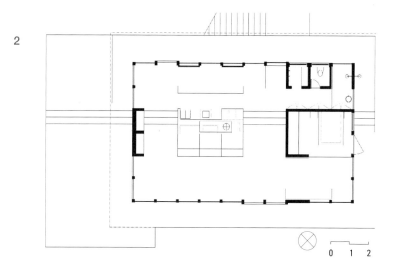

2. Ground floor

0 1 2

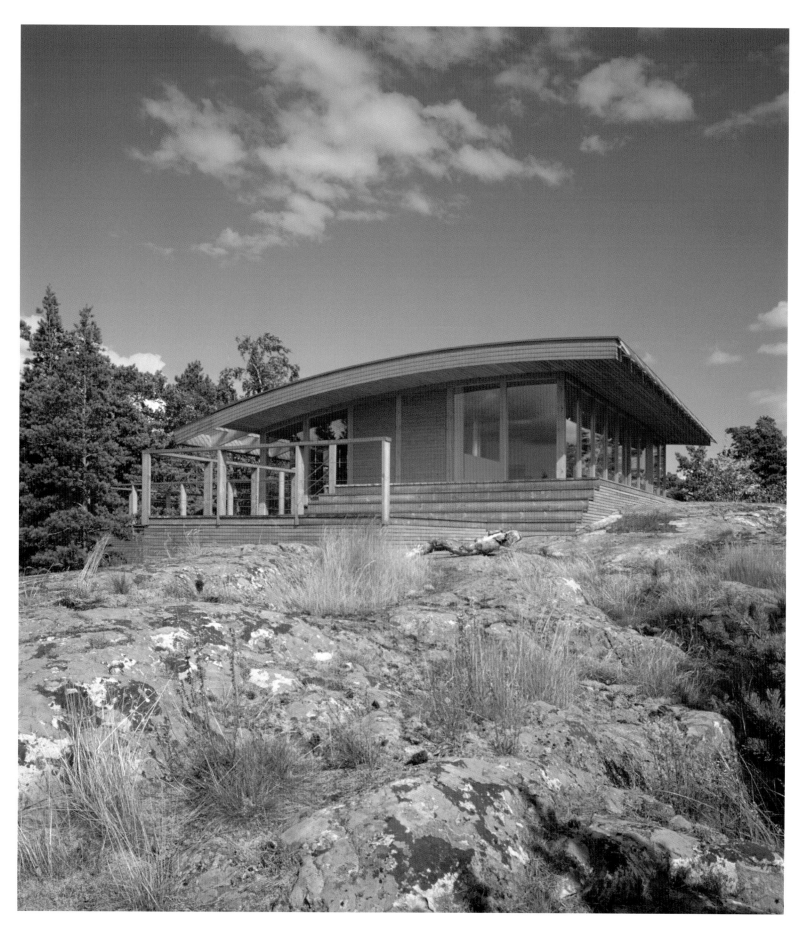

The high quality of their work—technically top-notch, of superb construction, and of excellent design—has helped this Austrian architectural team attain international prestige. When it comes to designing a project, their high concern for and care taken with their budgets have enabled them to carry out numerous projects within the category of low-budget chalets. This does not, however, mean that they turn their back on top-quality spatial design when undertaking a residence project. In the case of Burger–Jussel Chalet, "austerity" is defined not only by keeping within the restraints of a low budget, but also by respecting the beautiful features of the setting and the site, which affords vistas of the Province of Vorarlberg. The project takes a back seat and lets the countryside come to the forefront in a starring role. The proprietor insisted on a large, overhanging terrace, which is one of the project's most attractive elements, though it would fall far short of being considered technological fanfare or showiness. The dwelling has a total floor plan of 2,194 square feet, significantly smaller than similar types of residences in this region.

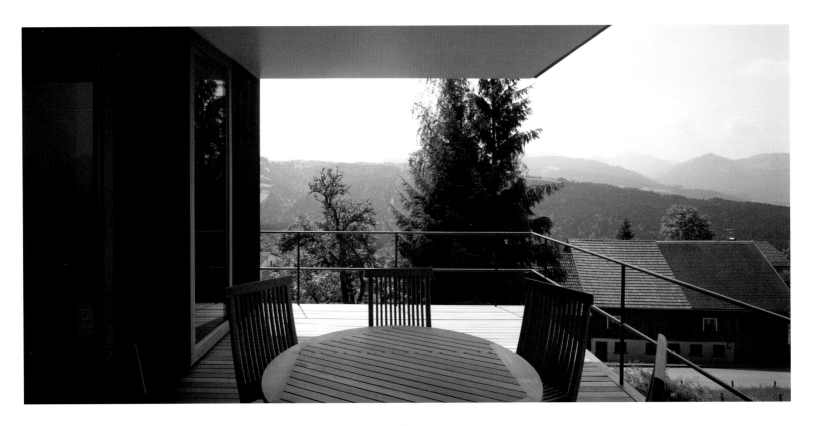

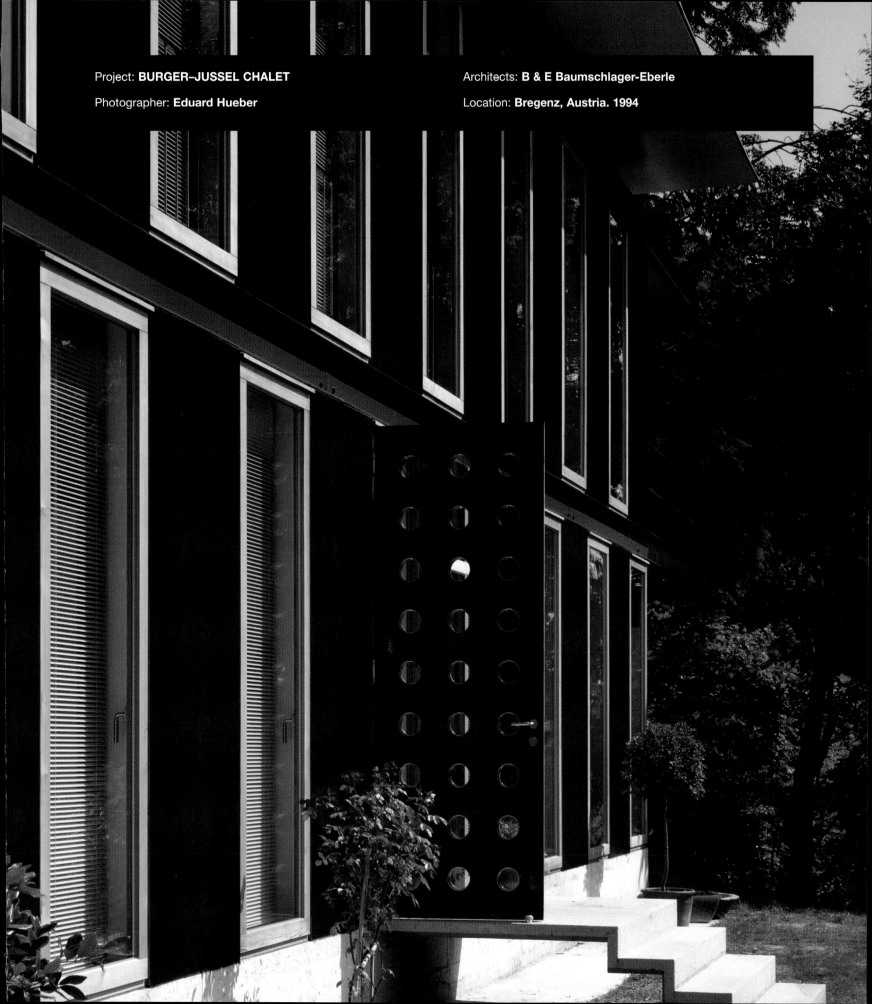

Project: **BURGER–JUSSEL CHALET**

Photographer: **Eduard Hueber**

Architects: **B & E Baumschlager-Eberle**

Location: **Bregenz, Austria. 1994**

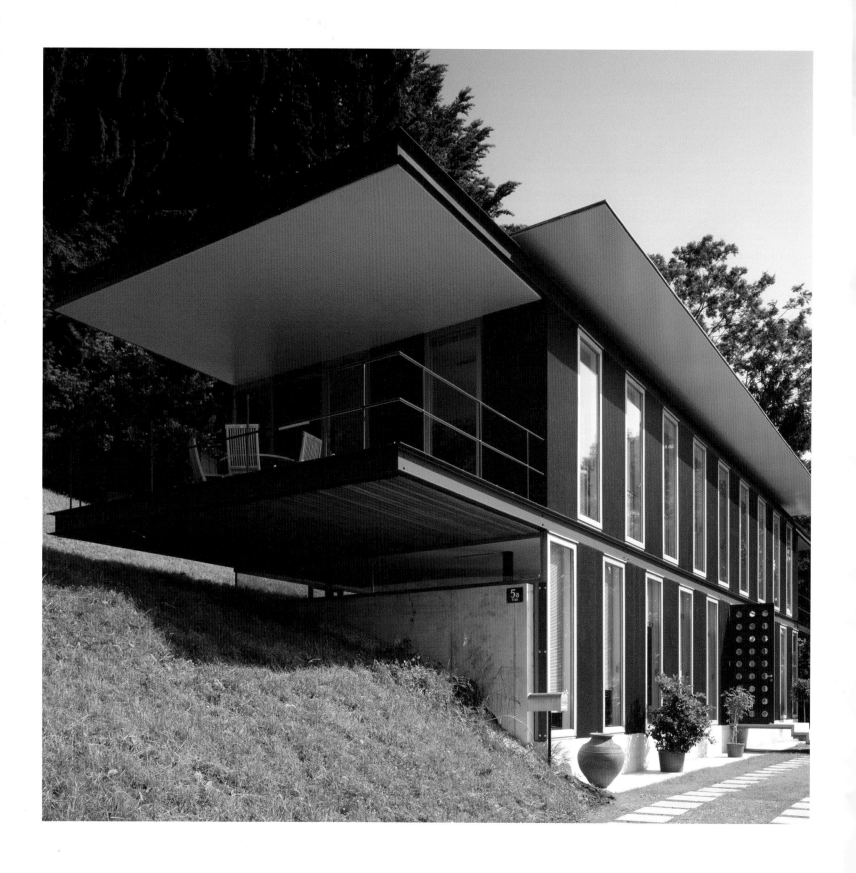

The use of materials like wood and standard measure furnishings avoids the design and construction of special elements, thus cutting costs.

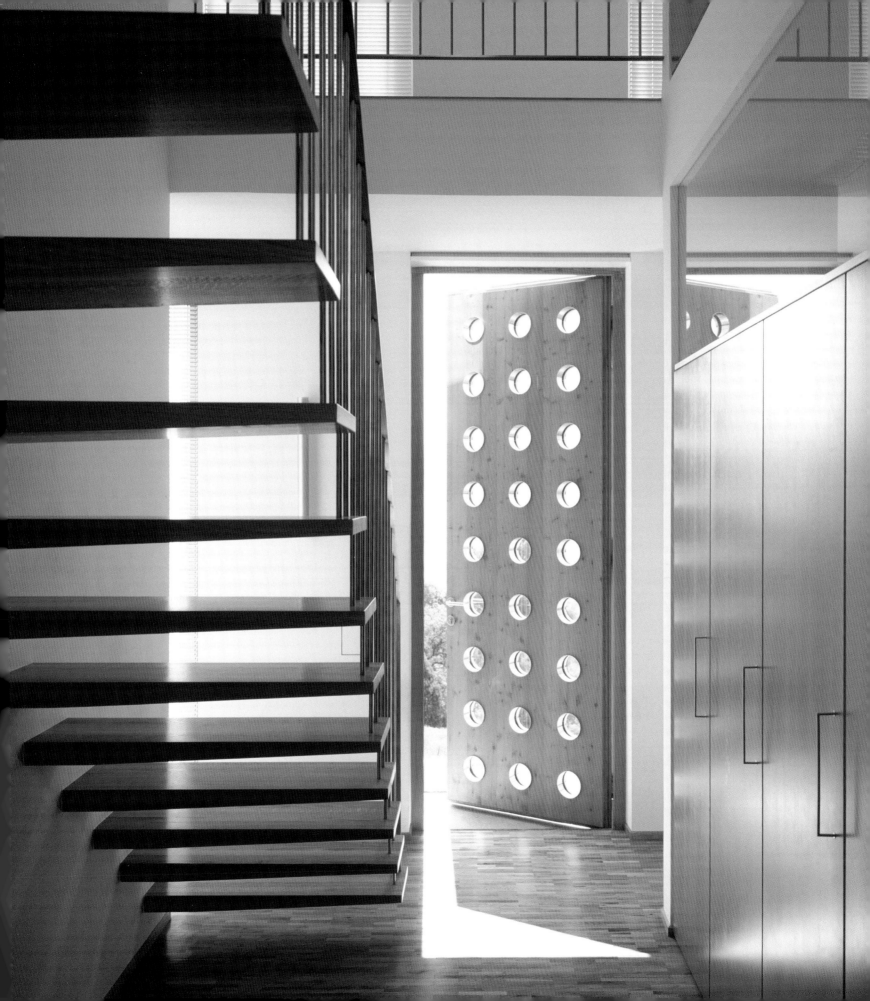

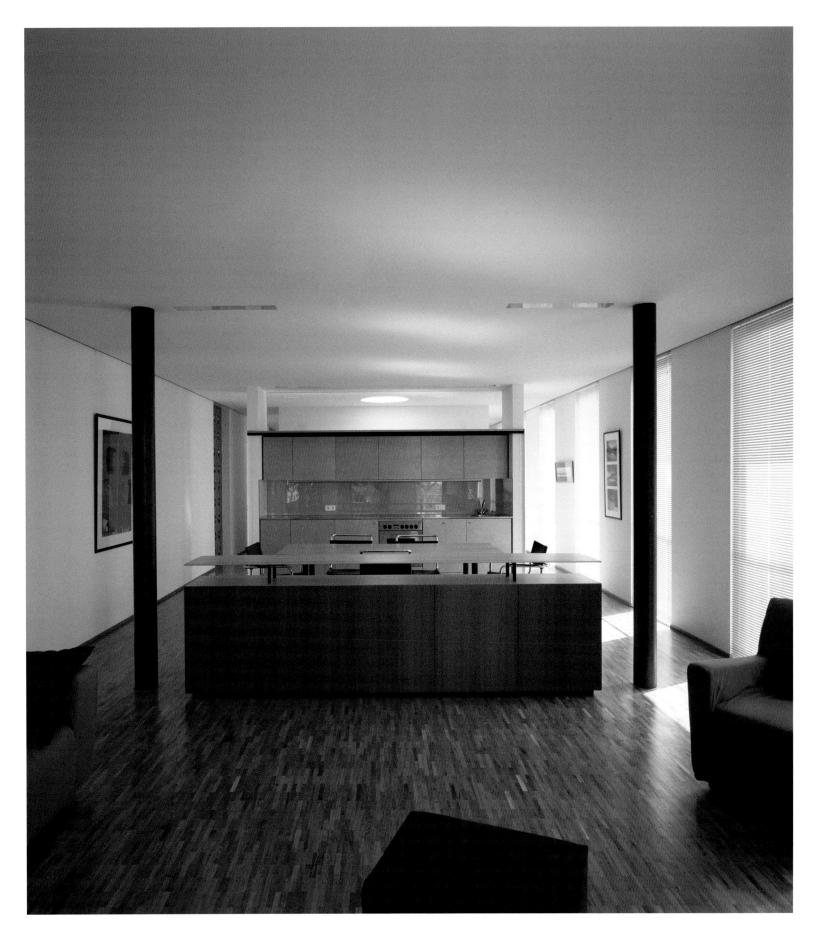

The duplex mass is fitted without undue visual impact on the setting. It boasts a large, buttresslike terrace, which harmonizes with the rest of the structure.

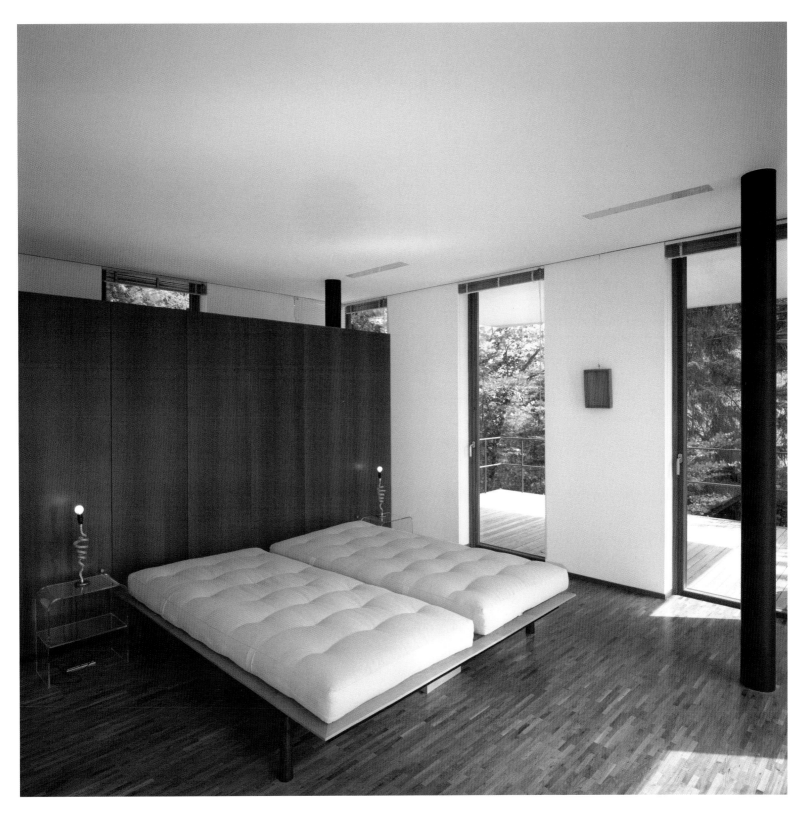

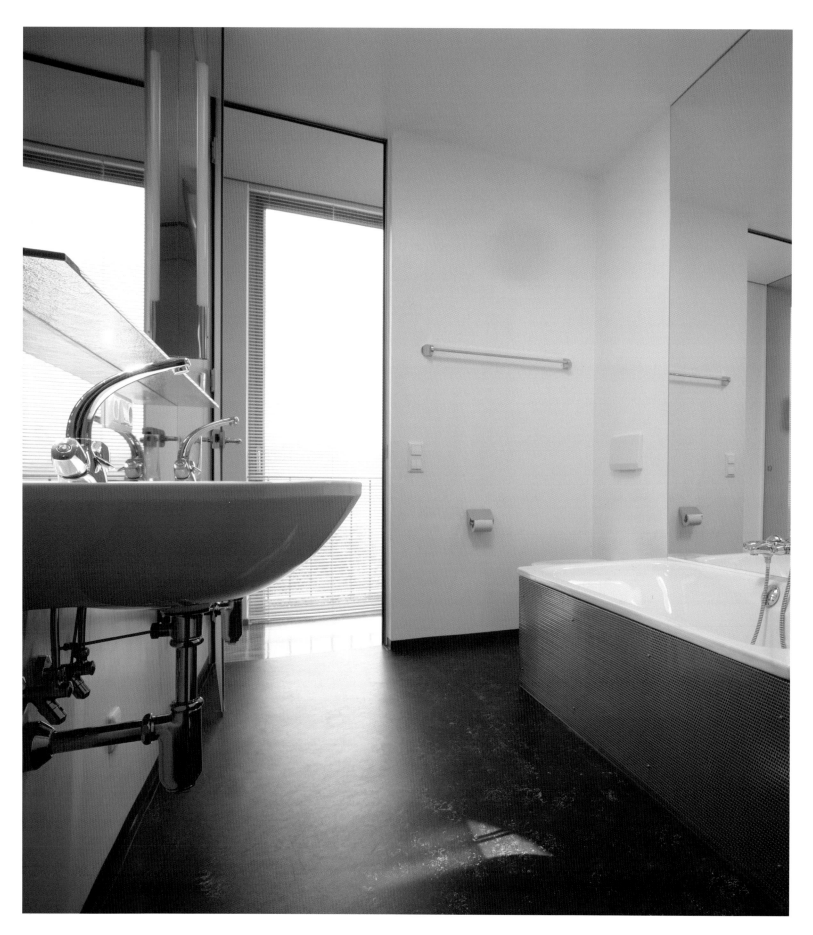

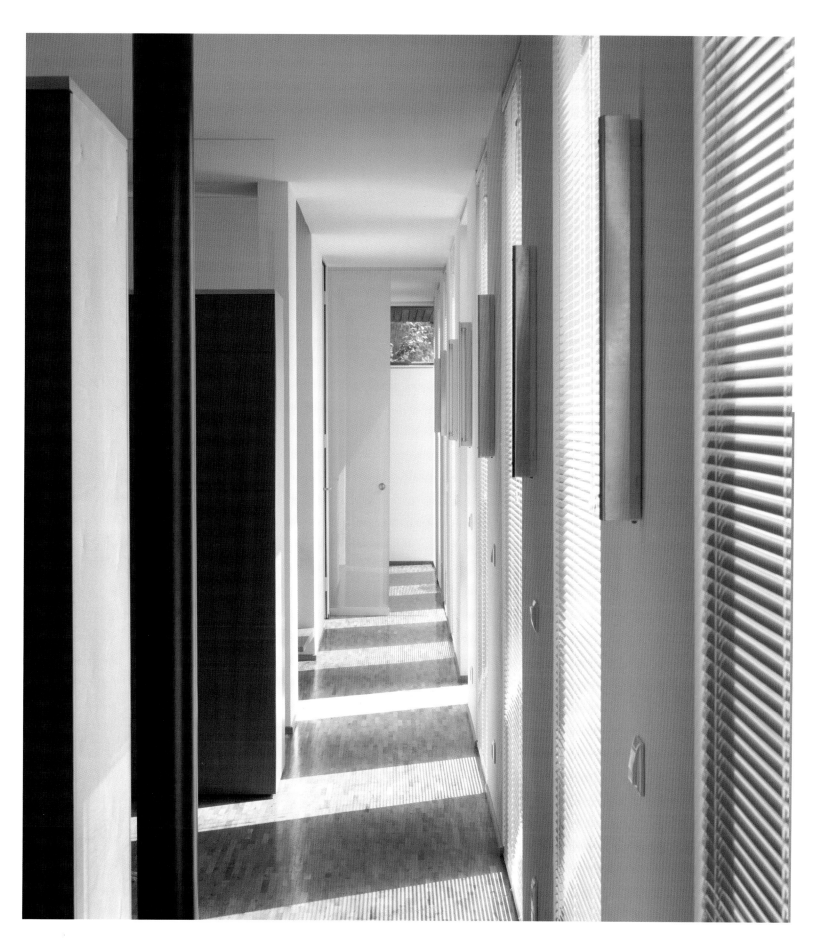

Situated in a sought-after residential area close to the center of Zurich, the Sempacher Loft Apartments are an excellent example of modern and sustainable town renewal. An uninspiring apartment block from the 1930s originally occupied the site, which was in urgent need of repair and upgrading. A detailed survey of the building showed that everything from the wiring to the plumbing needed replacing. Furthermore, the structure did not allow easy alterations to the cramped room layout. Estimating the costs of the required work showed a discrepancy between the overall standard achievable and the required rental levels after the upgrade. A feasibility study indicated clear overall advantages in the replacement of the existing building with a new one. Therefore, the goal for the new building was to create a living structure which would allow flexibility and change for future generations; a modern building that harmoniously connects to the built environment surrounding it; and an eco-friendly building, taking into account the lifetime cycles of materials.

The building footprint was established by site constraints and sculpted to suit as many different internal space layouts as possible. This was further enhanced by placing the bath and kitchen core in the center of the apartments as natural room dividers. The bathroom walls are made of translucent colored glass, allowing the light to connect the divided spaces. The façades reflect the internal layout, and vice versa. The building is clad with translucent overlapping glass "shingles" over colored insulation, which cover the whole north façade and gradually open up towards the south façade.

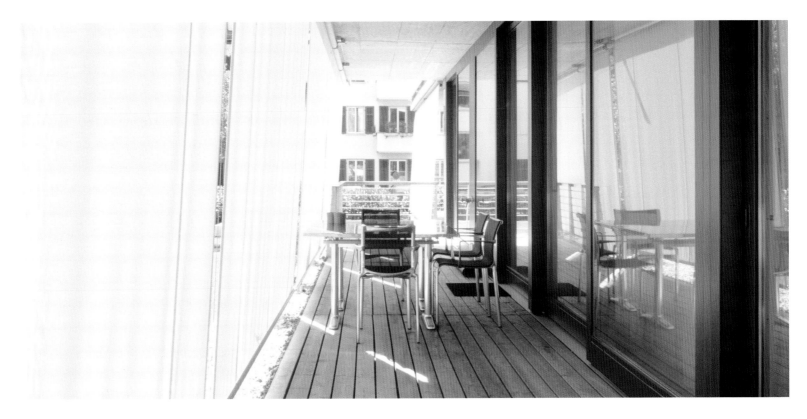

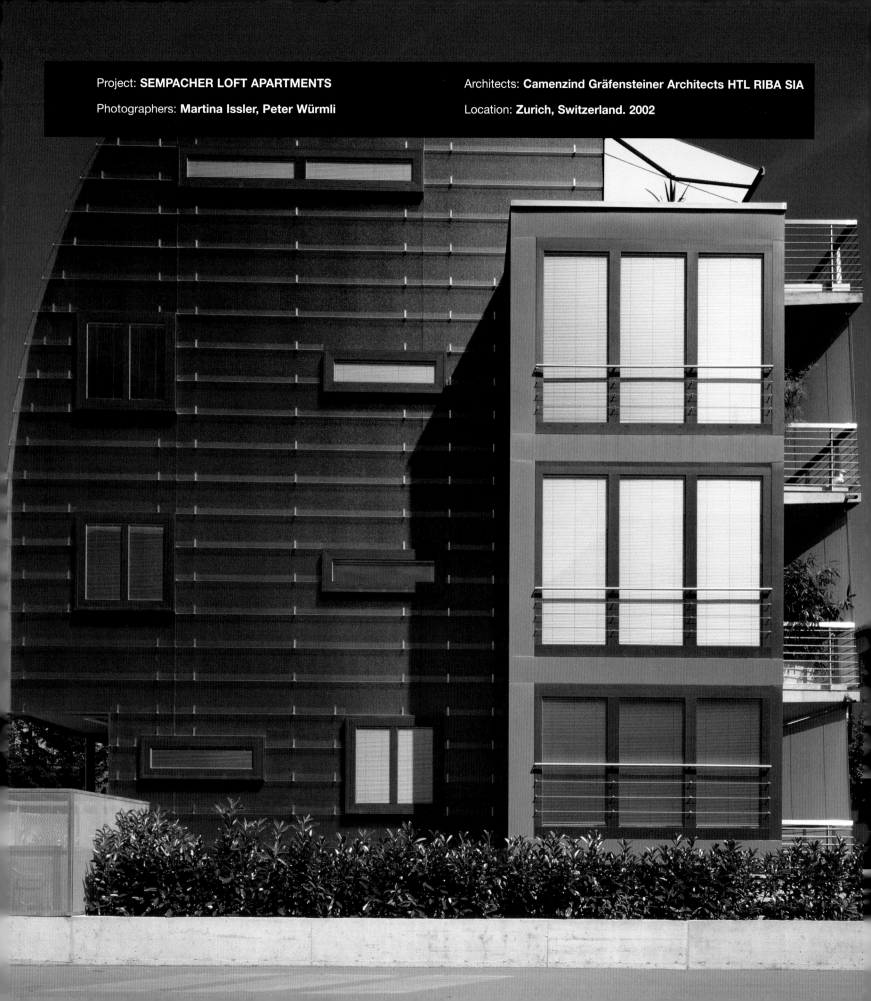

Project: **SEMPACHER LOFT APARTMENTS**

Photographers: **Martina Issler, Peter Würmli**

Architects: **Camenzind Gräfensteiner Architects HTL RIBA SIA**

Location: **Zurich, Switzerland. 2002**

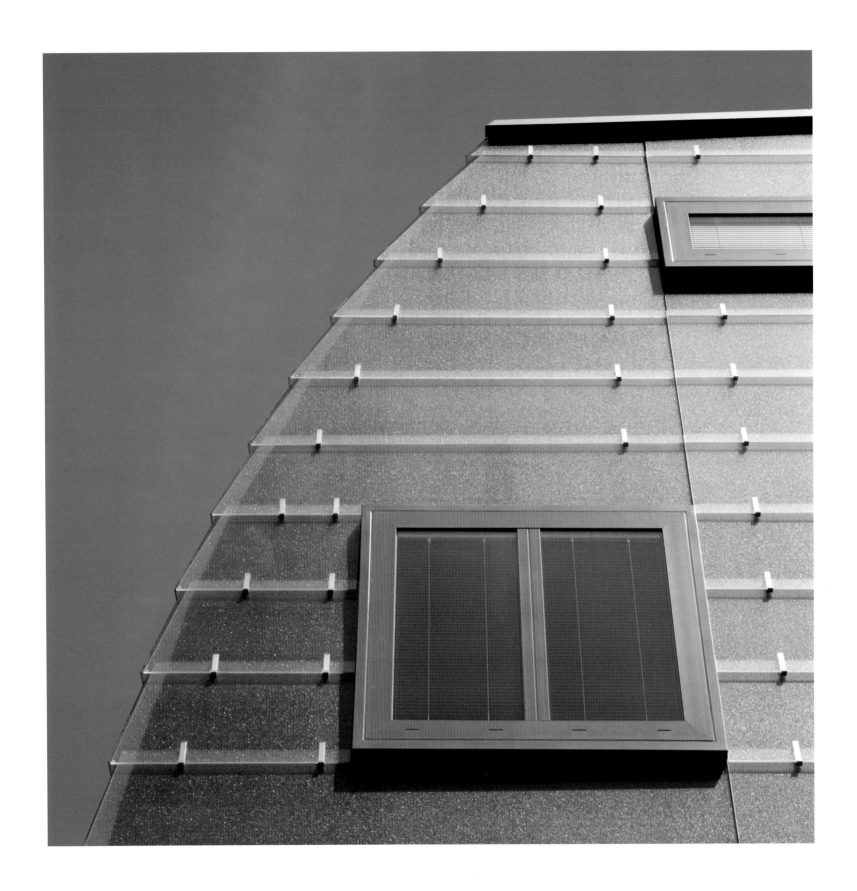

The façade build-up, with colored insulation and translucent cladding, was designed to create a harmonious integration with the surrounding apartment blocks, which are rendered in warm colors and textures.

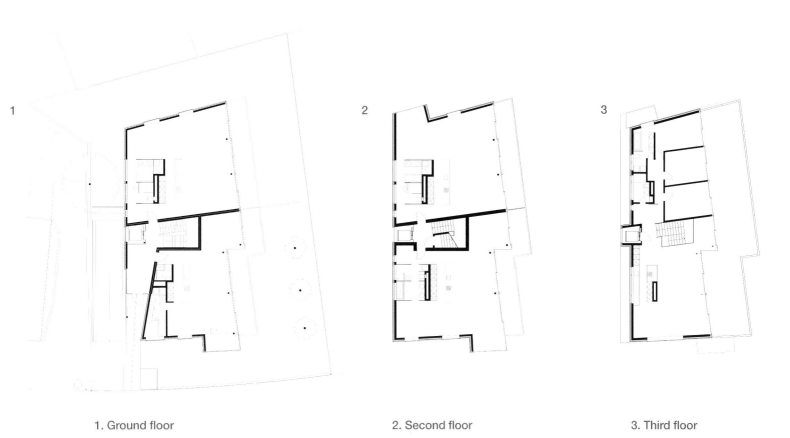

1. Ground floor 2. Second floor 3. Third floor

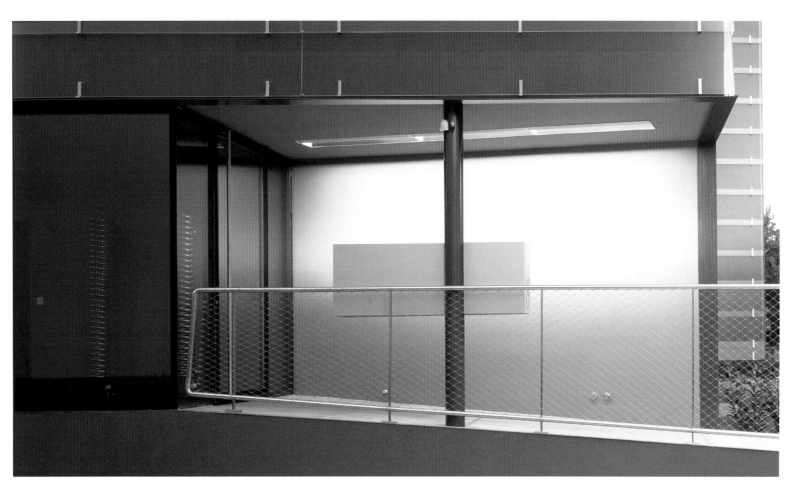

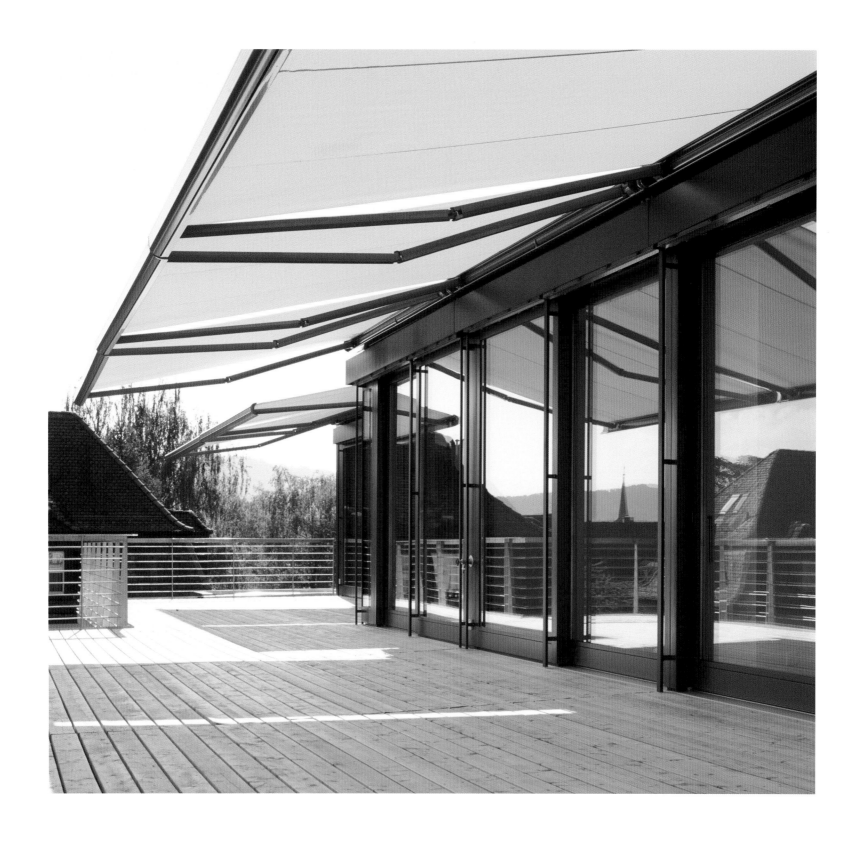

Seasonal and diurnal light changes are resonated in subtle transformations in the appearance of the façade, allowing a smooth transition between the building and its surroundings.

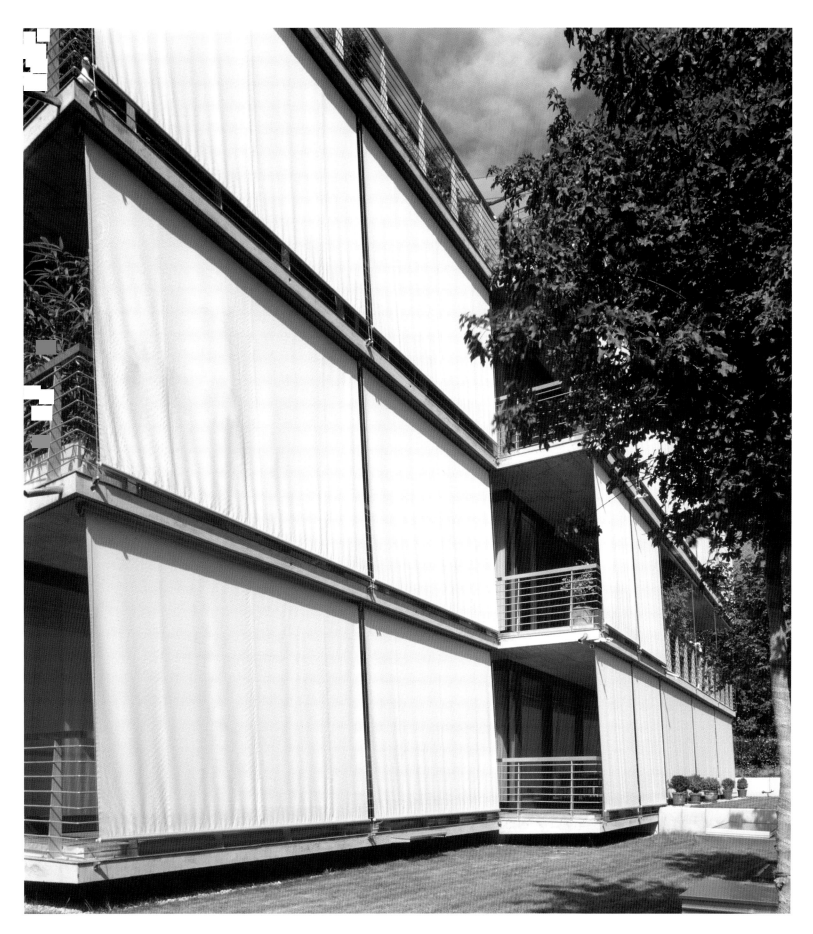

1

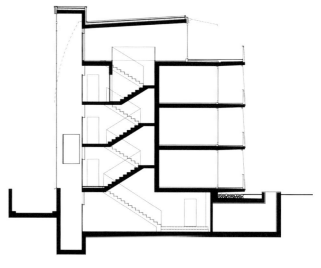

1. Sections

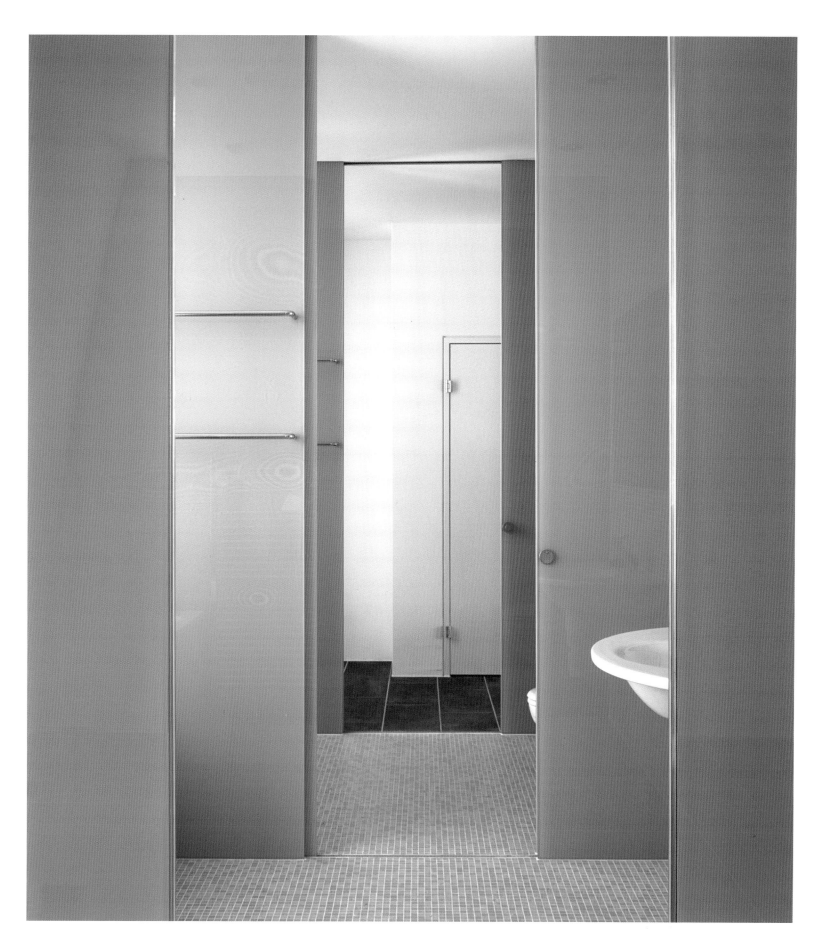

The profession of the proprietors often influences their approach to the design of a project, as specific types of work spaces are needed for each profession. Here, the professional activity of the proprietors—the creation and production of music—determines the formal design of the volumes. Apart from tailoring the design to the homeowners' professional needs, keeping to a low-cost budget was also imperative in the fashioning of this home studio. Located on the outskirts of Berlin, the plot's original features consisted of a scattering of pine and other trees, which the architects opted to maintain. They decided that the ensemble would consist of two volumes: a two-level space for the residence and office and a single-level space for the music studio. Having two separate structures might suggest a significantly higher final cost, but the method of construction and the choice of materials ensured that the project was carried out at a low price. The house/office volume used wood as the predominant material and combined it with simple construction (i.e., wooden frames with a simple enclosure wall of one or two levels) that allowed the main work to be executed in only two weeks, which represented a considerable savings. The music studio, on the other hand, used reinforced concrete. Apart from being the ideal material for this type of building, it allowed for the use of prefabricated elements for the walls and ceilings, which meant a sizeable reduction in the time needed to complete this second volume.

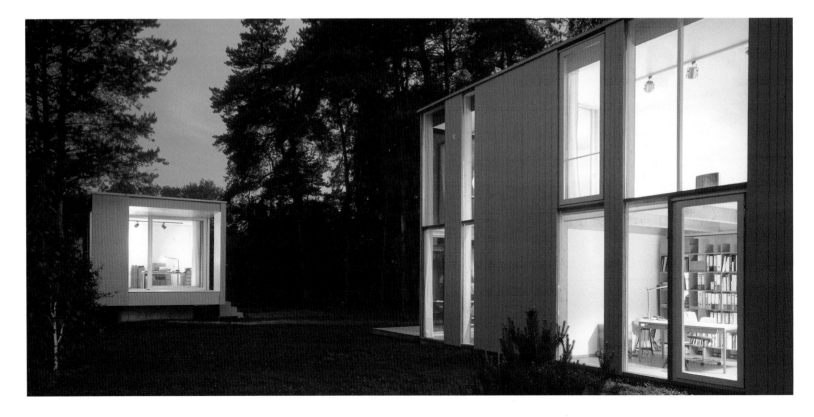

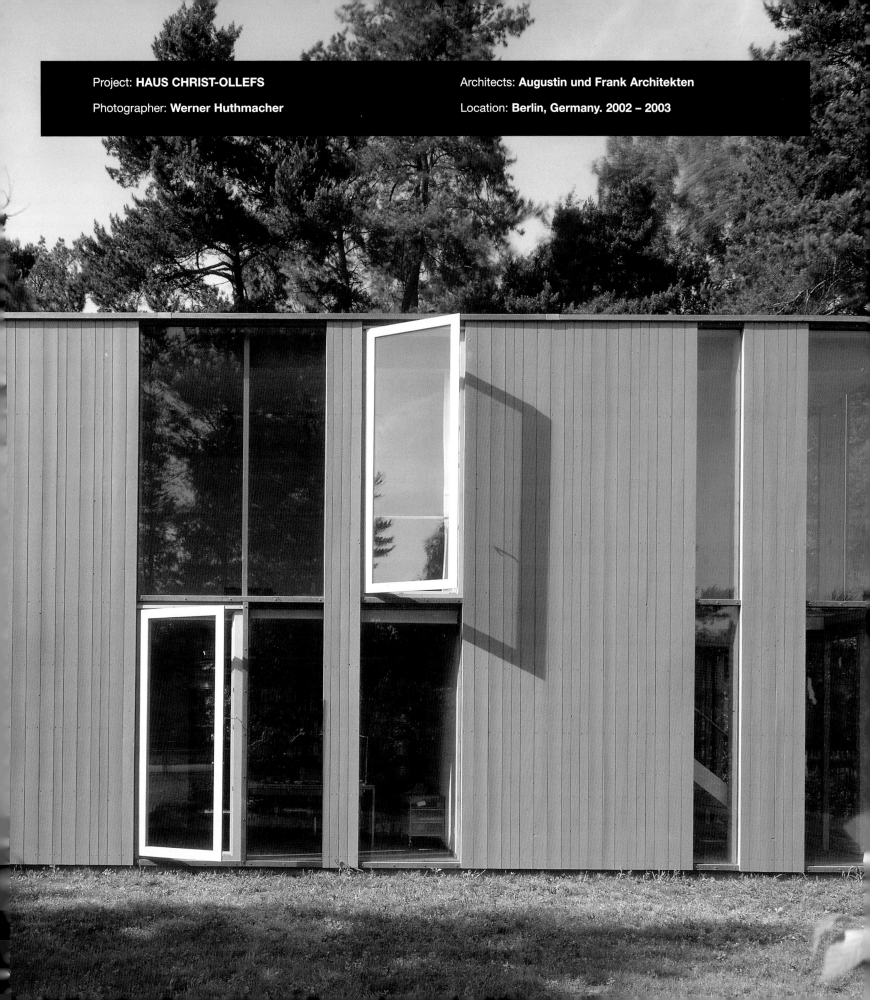

Project: **HAUS CHRIST-OLLEFS**

Photographer: **Werner Huthmacher**

Architects: **Augustin und Frank Architekten**

Location: **Berlin, Germany. 2002 – 2003**

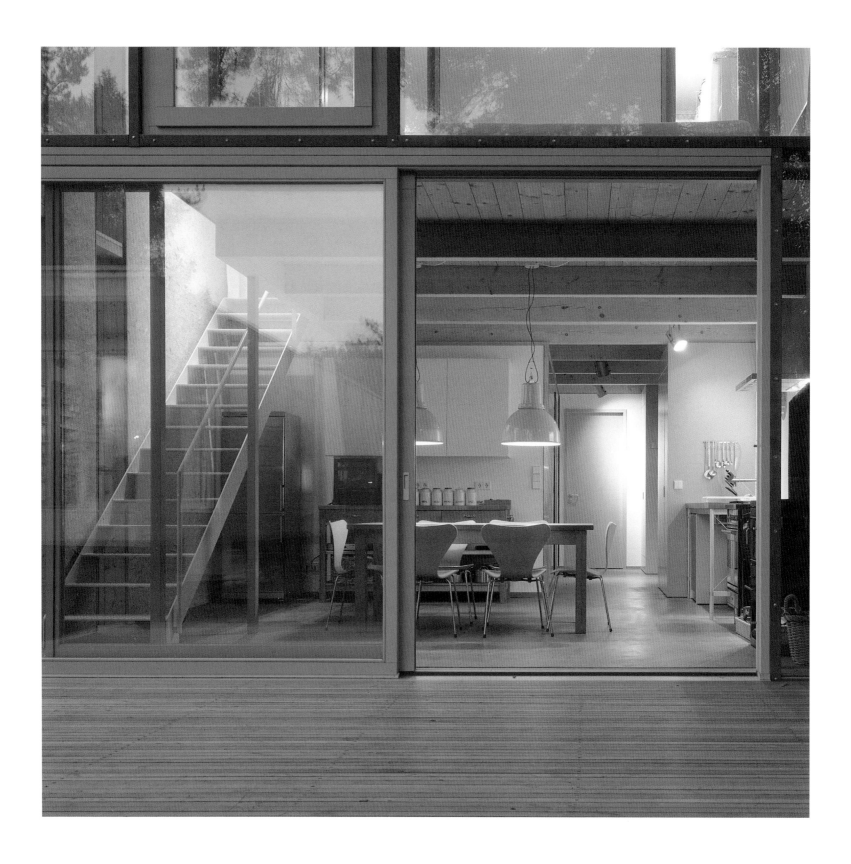

This functional program was divided into two wings: one is the music studio on a single level, the other the duplex residence/office. The visual relationship established between these elements unifies the whole.

The construction system used to frame this residence was based on wooden studs that offer one- or two-level support for the walls. The proposal makes the constructive work considerably less time consuming.

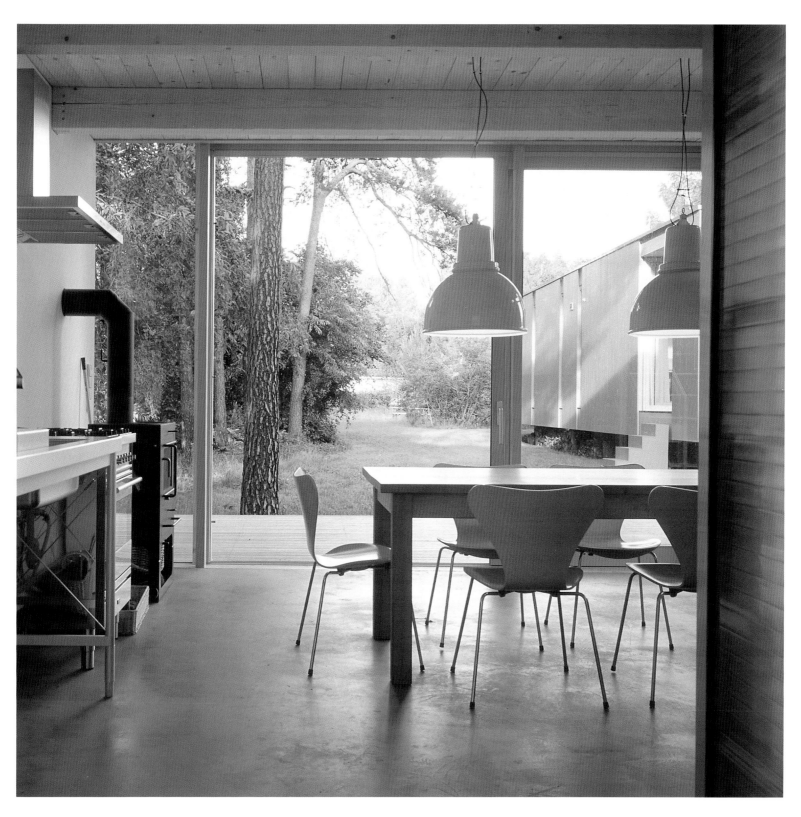

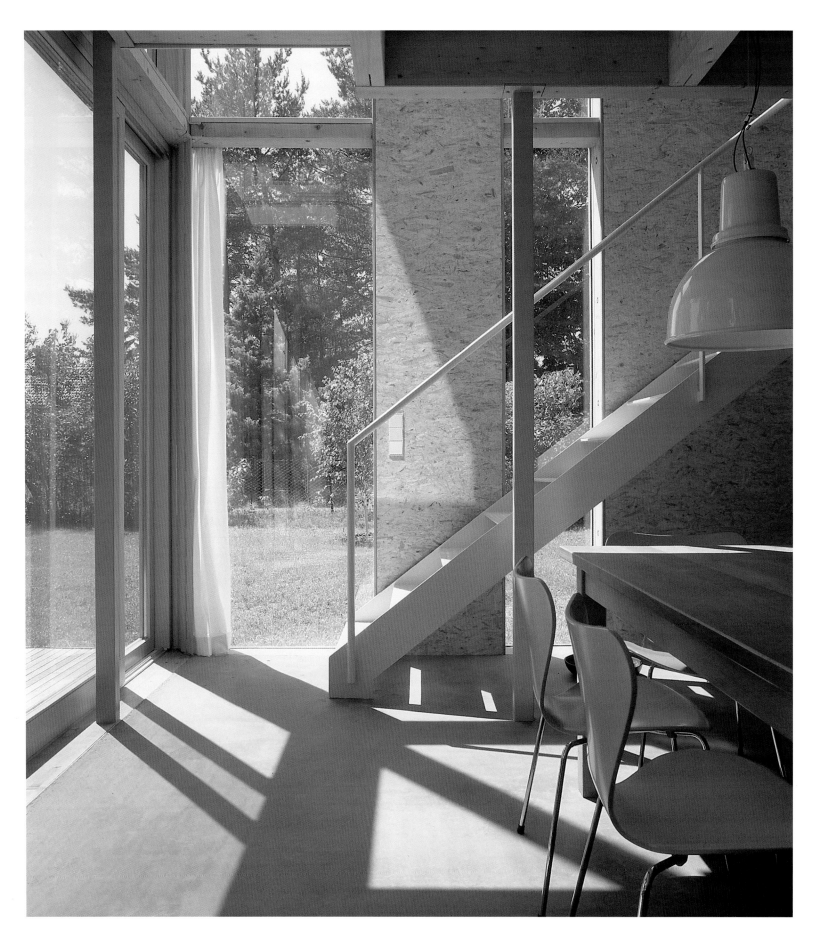

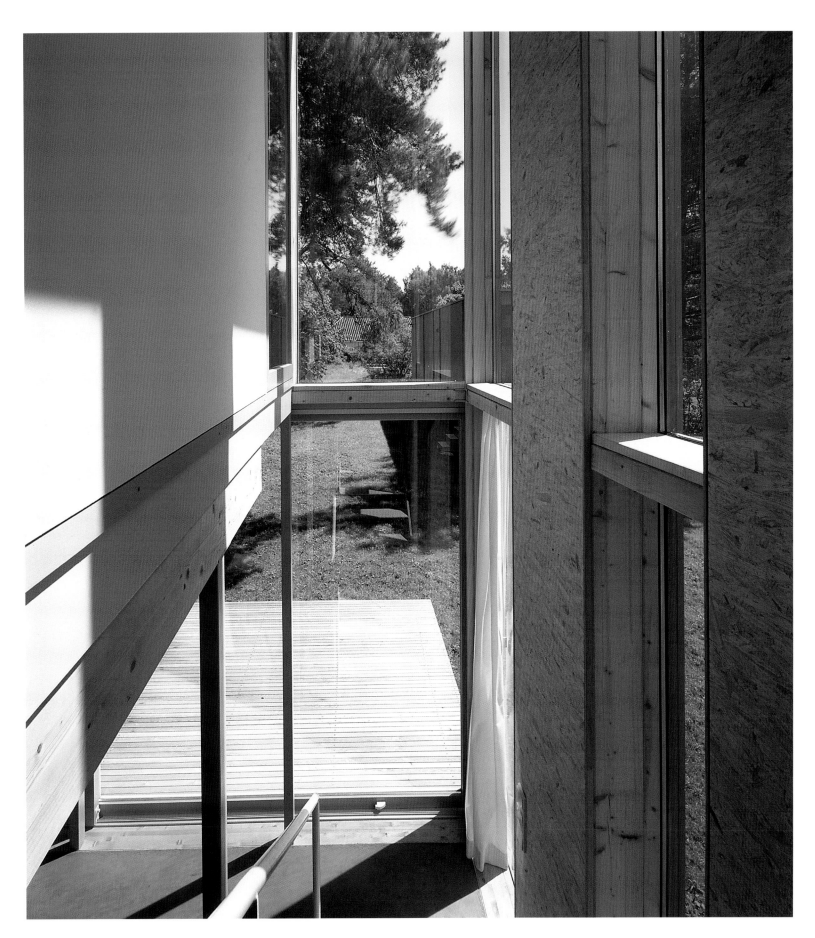

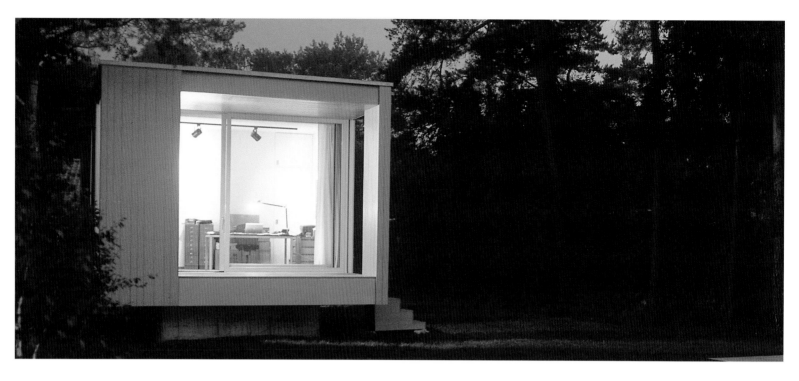

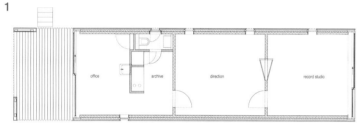

1. Studio plan

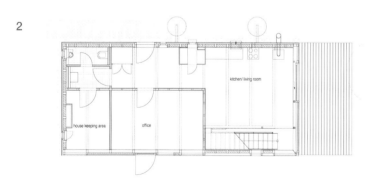

2. House plan

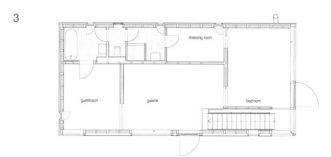

3. Upper floor house

0 1 2

Division of the program into two volumes makes it possible to pre-
serve the natural setting of the house, such as the attractive pines.

In the single-level division, which contains the studio, prefab concrete elements were used. This permits adequate insulation and also guarantees a certain ease of construction.

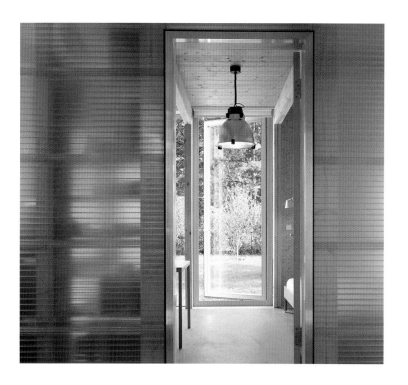

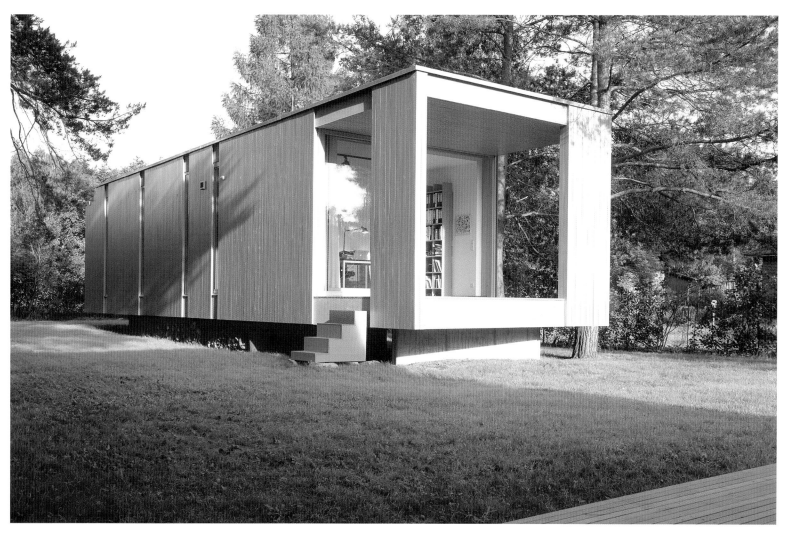

This commission consisted of the remodeling and enlargement of an old parking garage to convert it into an atelier and guesthouse. It was of the utmost importance to maintain the privacy of the adjacent homes, so the architects conducted a meticulous study of the views and fields of vision, both from and to the new project. They made use of the preexisting garage structure to fashion a lower floor akin to a socle, which housed three rooms. Atop this they built a prefabricated wooden atelier. Apart from the obvious advantages of using a prefabricated construction system, the costs of executing the work dropped considerably. They took great care with the views from the atelier, both because of its proximity to the adjacent residences and also to take advantage of its placement near the beautiful lake. To this end, they designed an enclosure consisting of vertical slats. Life-size models were even built to ensure visual permeability of the new space. Once the ideal models were chosen, the slats were mass-produced in wood to keep costs down. The material chosen determines the final image of this place for retreat, tucked away among the trees.

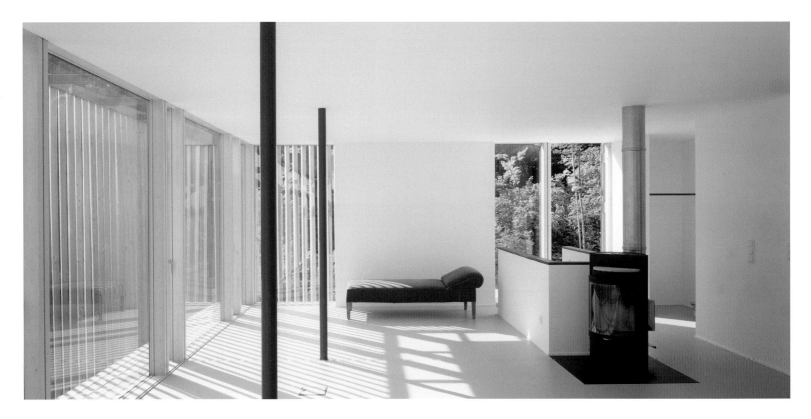

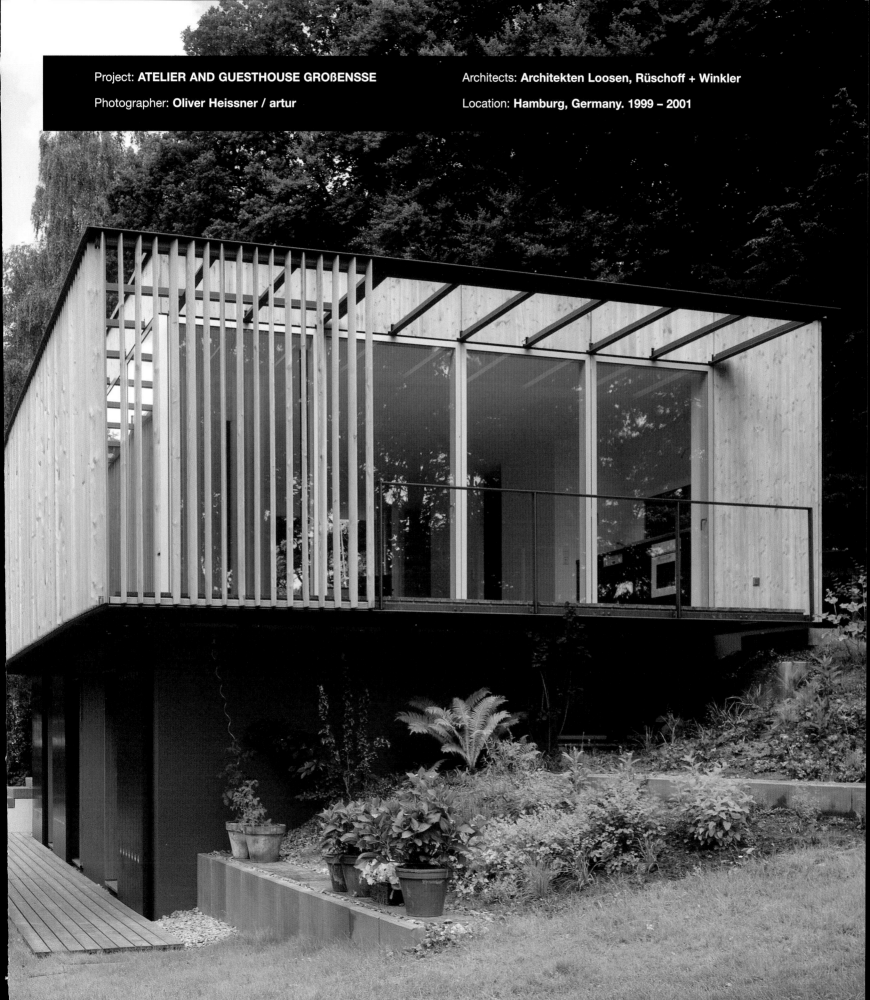

Project: **ATELIER AND GUESTHOUSE GROßENSSE**

Photographer: **Oliver Heissner / artur**

Architects: **Architekten Loosen, Rüschoff + Winkler**

Location: **Hamburg, Germany. 1999 – 2001**

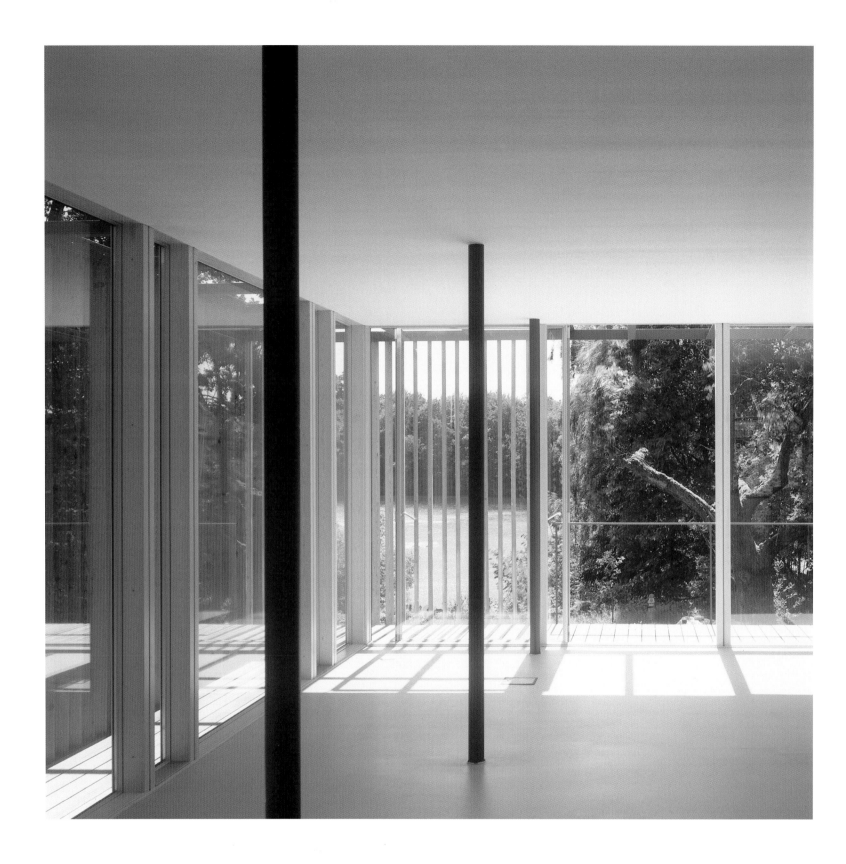

The wooden brise-soleils provide the formal image for this house. These elements—mass-produced on the spot—were planned as a visual screen for the interior, but still provide views of the surroundings.

Taking advantage of the existing structure as a foundation (structurally and functionally), the new wooden piece generates a dialectic of solid lightness.

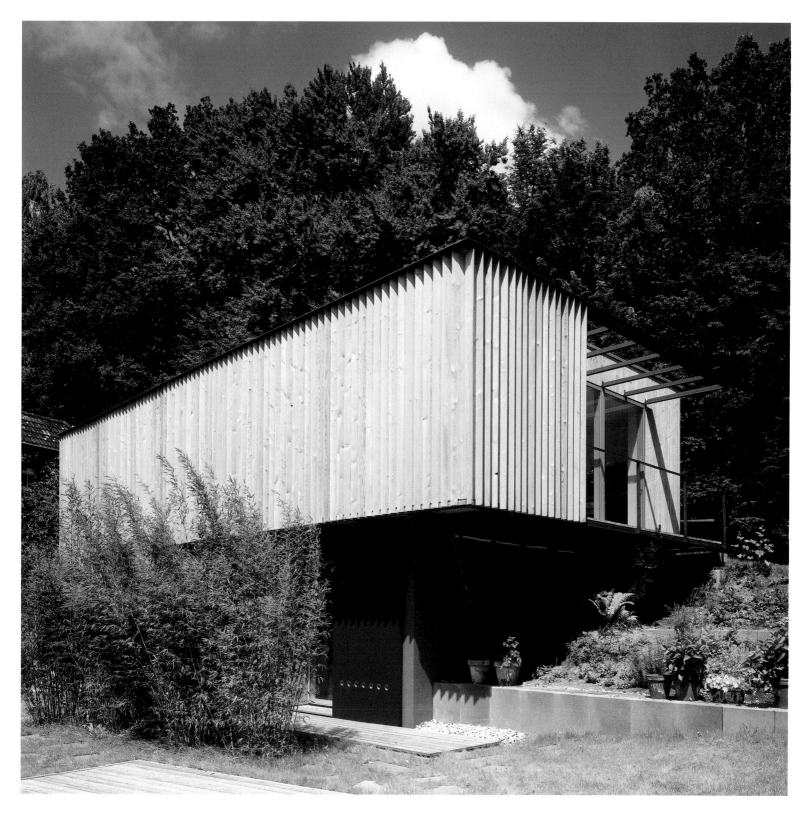

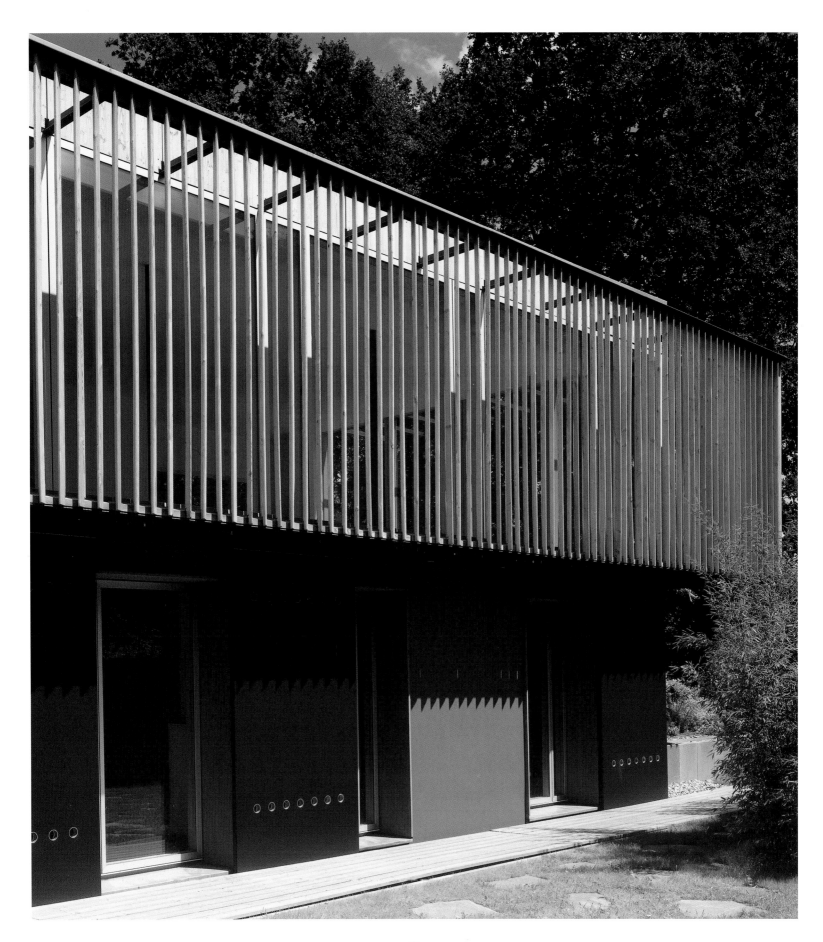

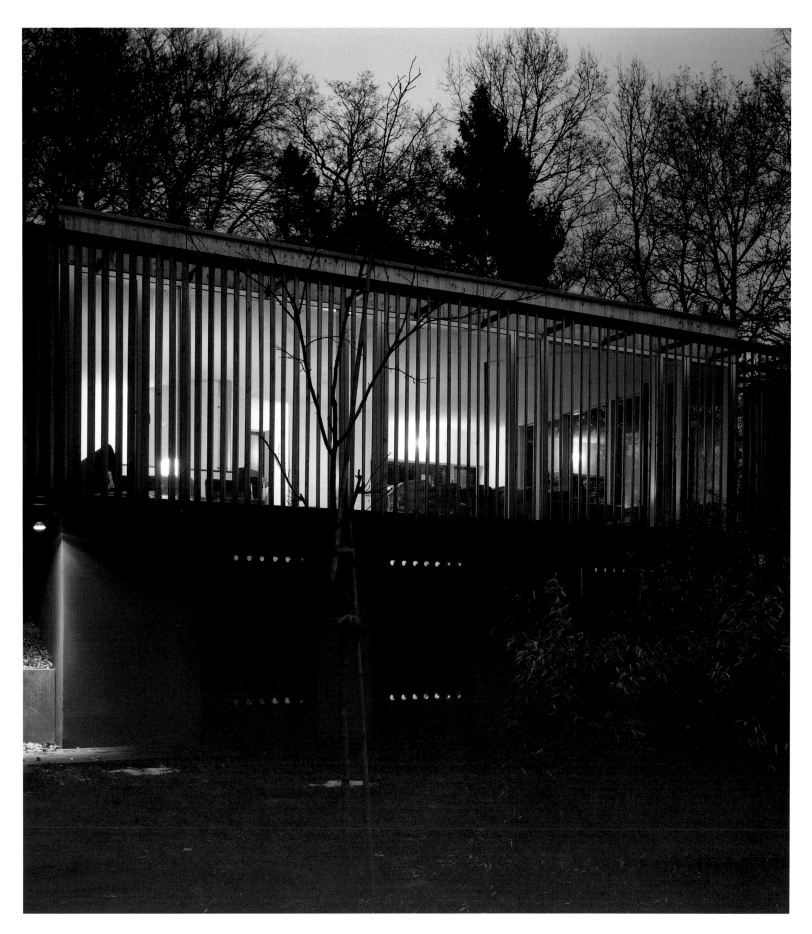

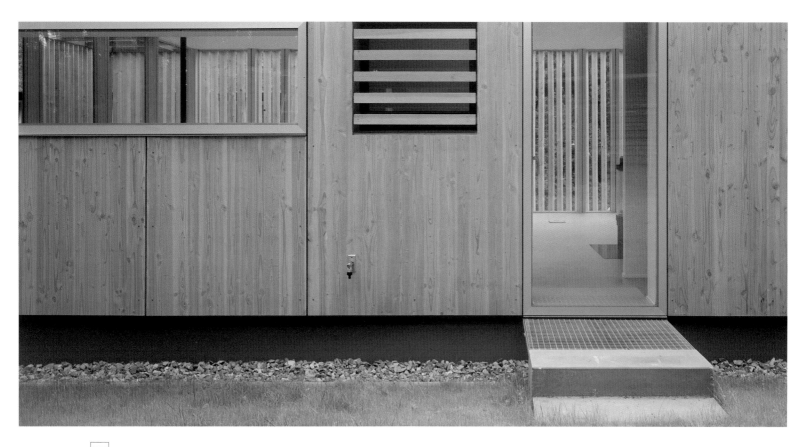

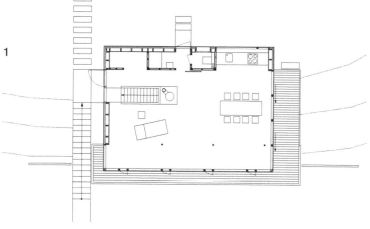

1

1. Ground floor

2

2. First floor

0 1 2

The simplicity of the project is clearly reflected in the walls, developed inside the limits of a square geometry.

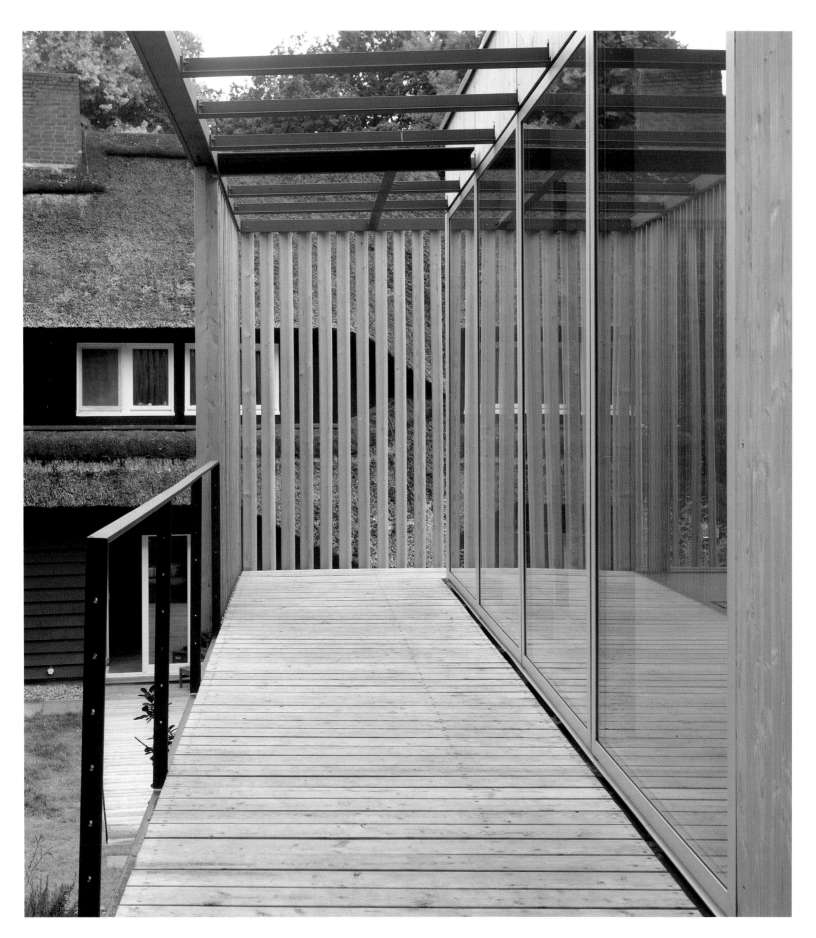

RENOVATIONS

APARTMENTS / HOUSES

This renovation project converted an 18-year-old building, which had been used as a photography studio, into a housing complex. The original building had a double structure but no specific characteristics: it had piled rooms with high ceilings side by side with other rooms with ordinary house ceilings. As a result, it had floors that were half the height of the ceilings of other rooms. This problem was not recognized, though, because the rooms were separated by walls. However, once the walls were removed and the floor positions defined the space, the architects discovered that the floor discrepancy could be converted into skeeped floors.

In the process of planning, the architects tried to come up with a method for renovation that was similar to the method they ordinarily used for new construction: to analyze the characteristics of the land in detail and try to maximize its usage by skillfully designing the building. The goal of the client was to add value to a space for more rental value in the market. Having this goal in mind, the architects conceptualized the space in detail by studying the lifestyle of prospective renters. During the planning process, they designed three different types of spaces for the three apartments, using their spatial characteristics as if they were hidden treasures in the building to be polished up. Together, the architects made a mixed design that emphasized the process of the conversion.

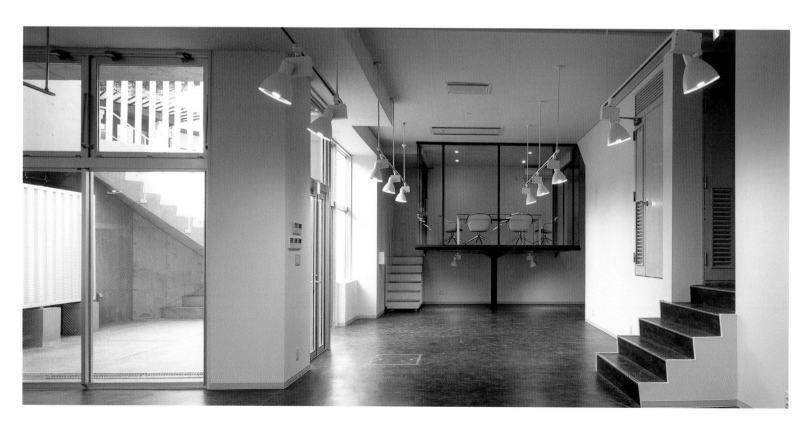

Project: **C MA-1**

Photographer: **Toshiharu Kitajima**

Architects: **Ikeda Kokubun Design Studio**

Location: **Tokyo, Japan. 2003**

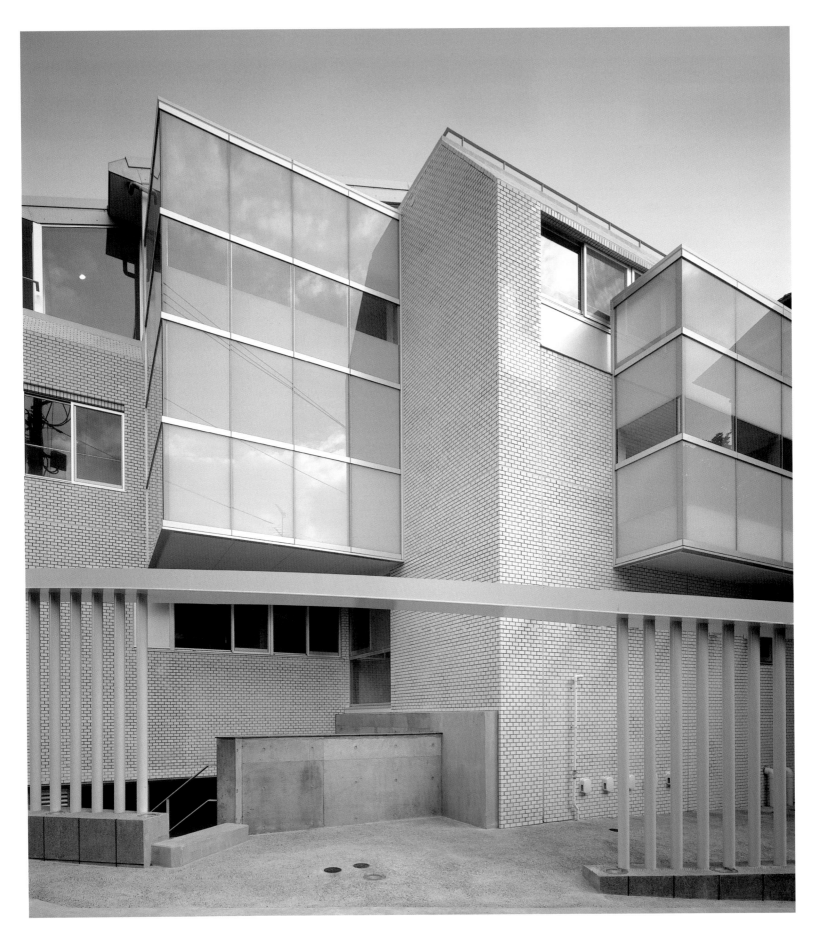

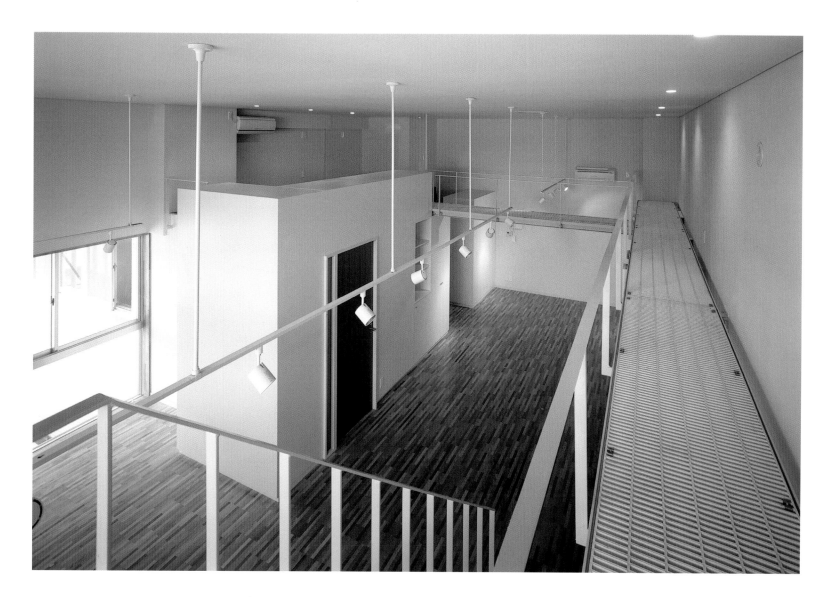

1

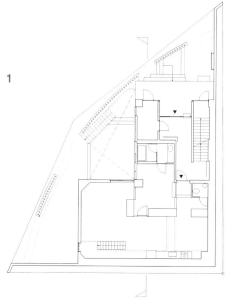

2

3

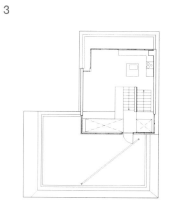

1. Ground floor

2. Second floor

3. Third floor

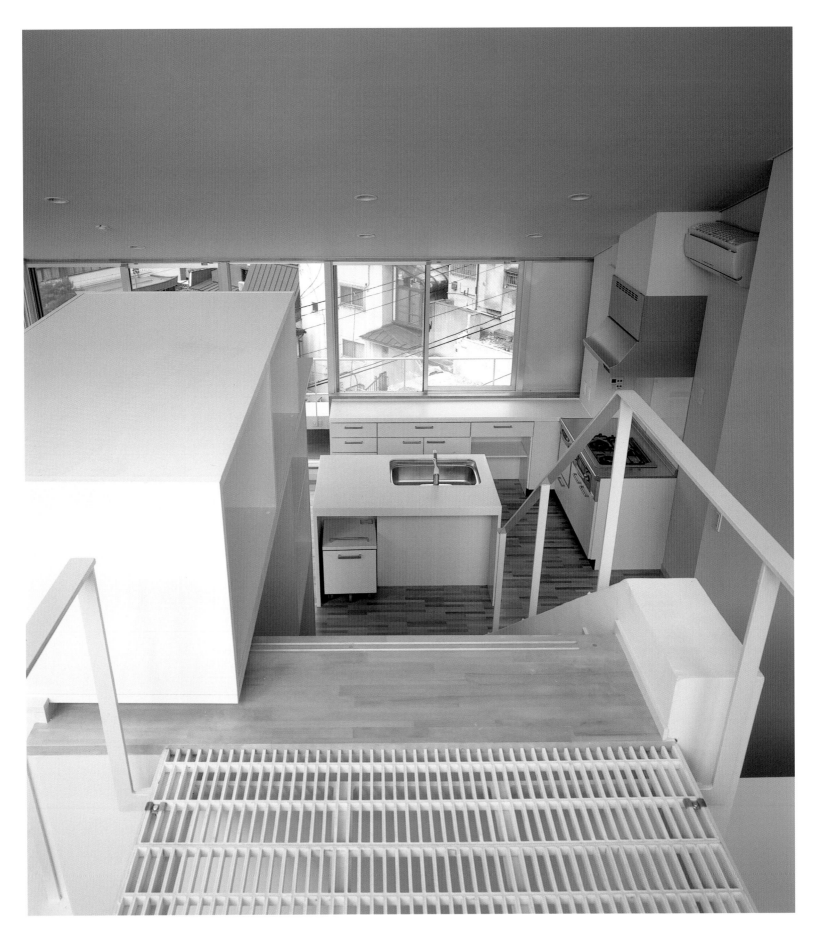

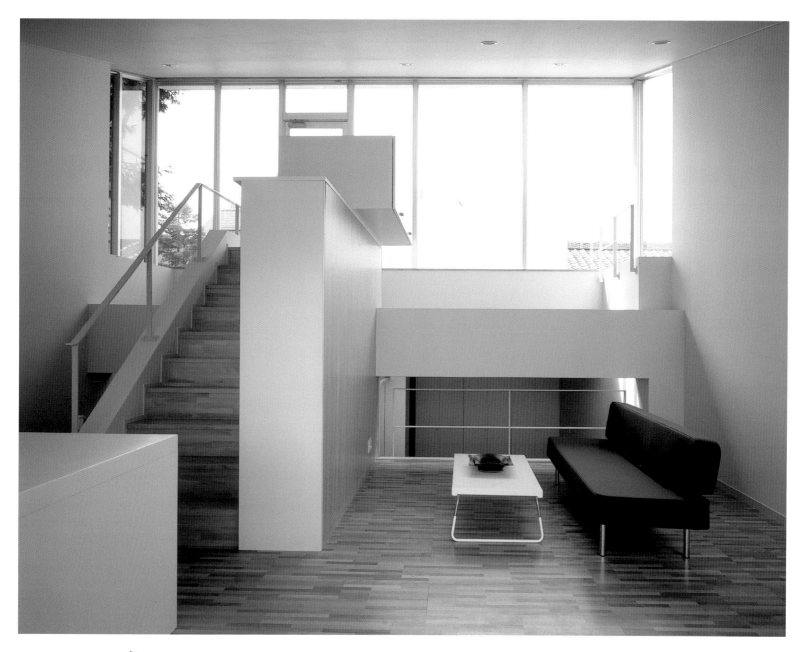

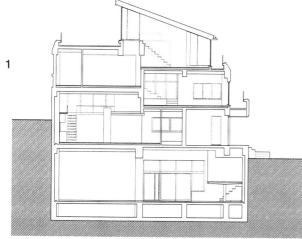

1. Section

The apartment on the top has alternate floors that connect to the newly created openings in the roof and the outer wall. The inclined steel roof made the roof terrace on the upper level a part of the apartment's alternate floor scheme.

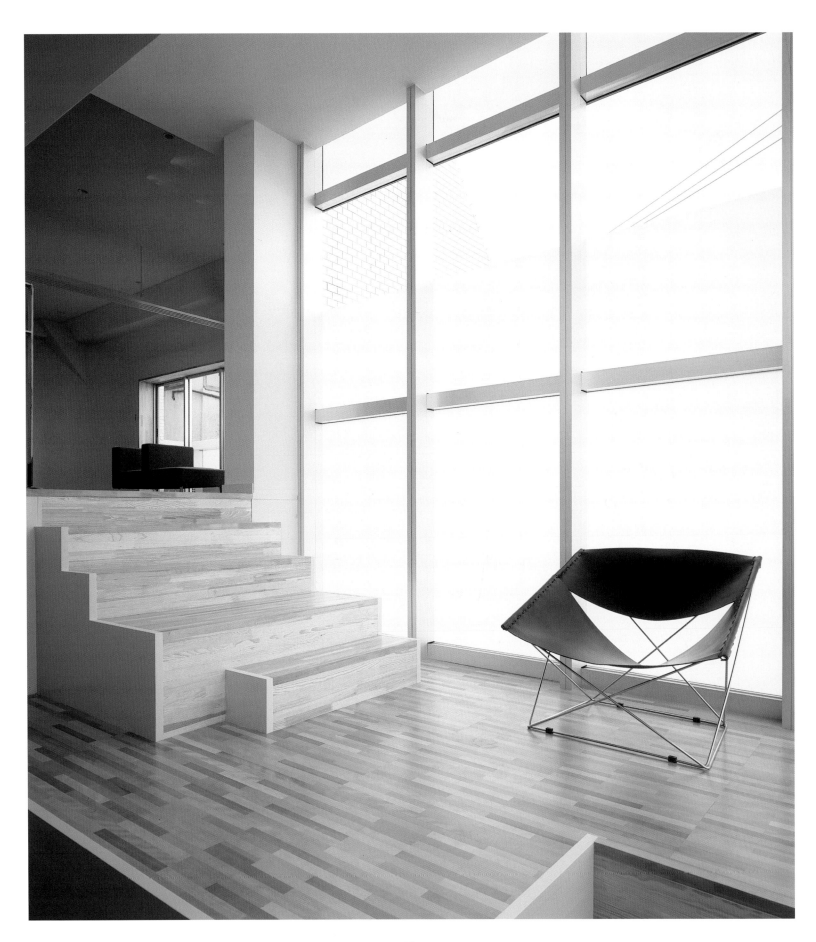

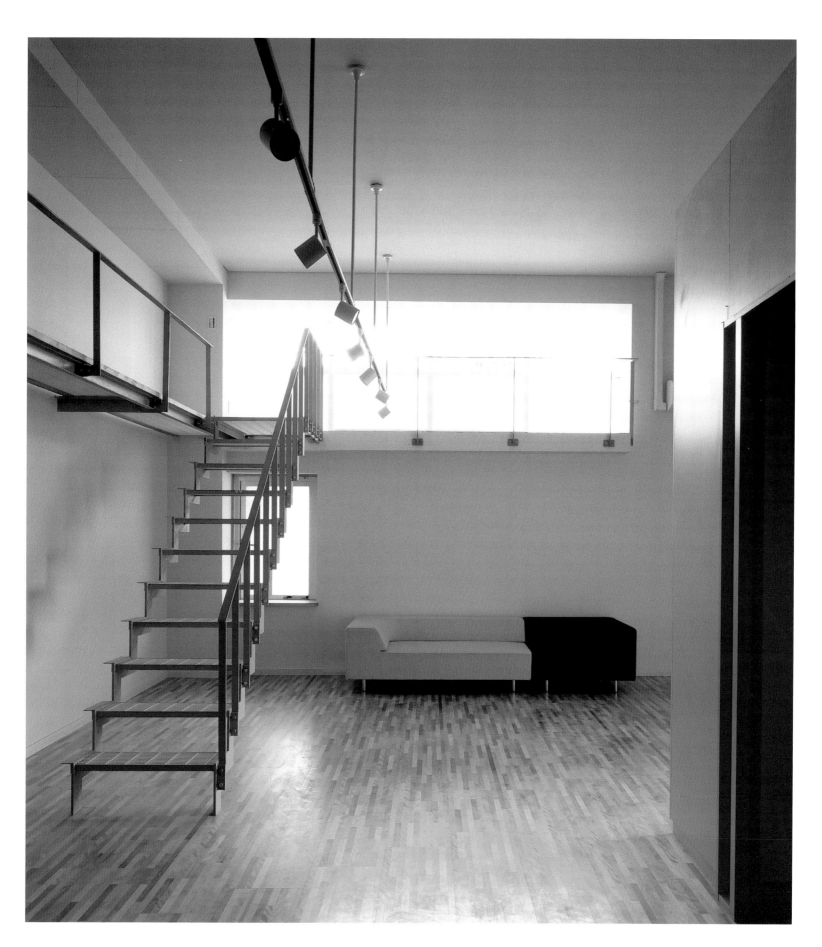

This project has two functions: it needs to serve as a private loft dwelling as well as a work/meeting/entertainment space showcasing technology for digital distribution and film projection. The entry opens along a 14-foot-tall translucent, curved, and sliding LUMAsite wall, which sheds light into the narrow space. The residential space is hidden behind a massive, pivoting walnut wardrobe set into the translucent wall.

One ascends a maple and steel spiral stair cuffed onto a cast-iron column to reach the suspended steel and glass mezzanine, which functions as a seating area to view a 16-foot retractable movie screen. From here, a drawbridge allows access to a hidden computer server/digital projection room. A vertically sliding translucent panel, counterweighted by a stainless steel backsplash, conceals the kitchen. Cork floor, delineated by a grid of zinc panels hiding fiber-optic cable, runs throughout the main space. A powder room, lined with biofiber panels of recycled newspaper, wood chips, and custom, built-in stainless steel details, reminiscent of an airplane bathroom, is tucked under the server room.

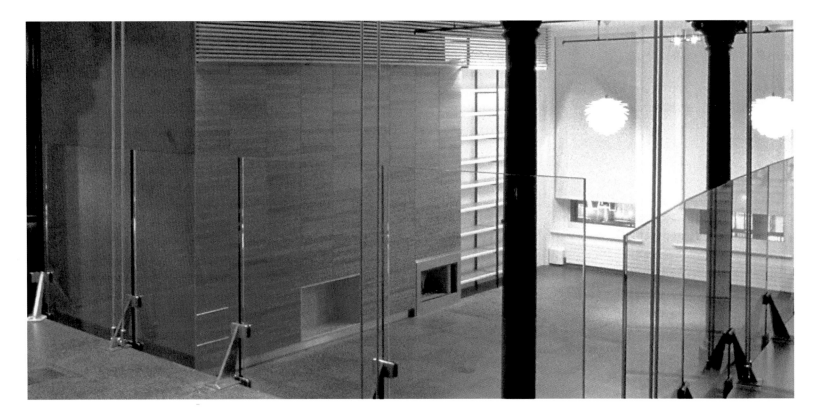

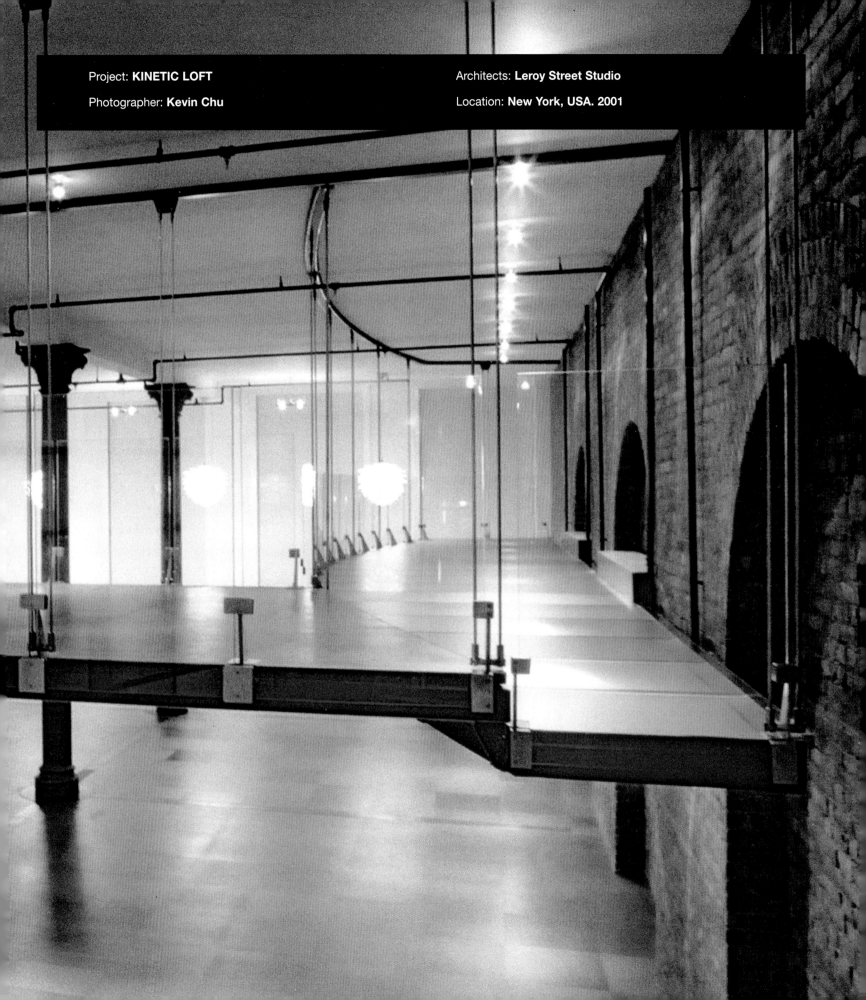

Project: **KINETIC LOFT**

Photographer: **Kevin Chu**

Architects: **Leroy Street Studio**

Location: **New York, USA. 2001**

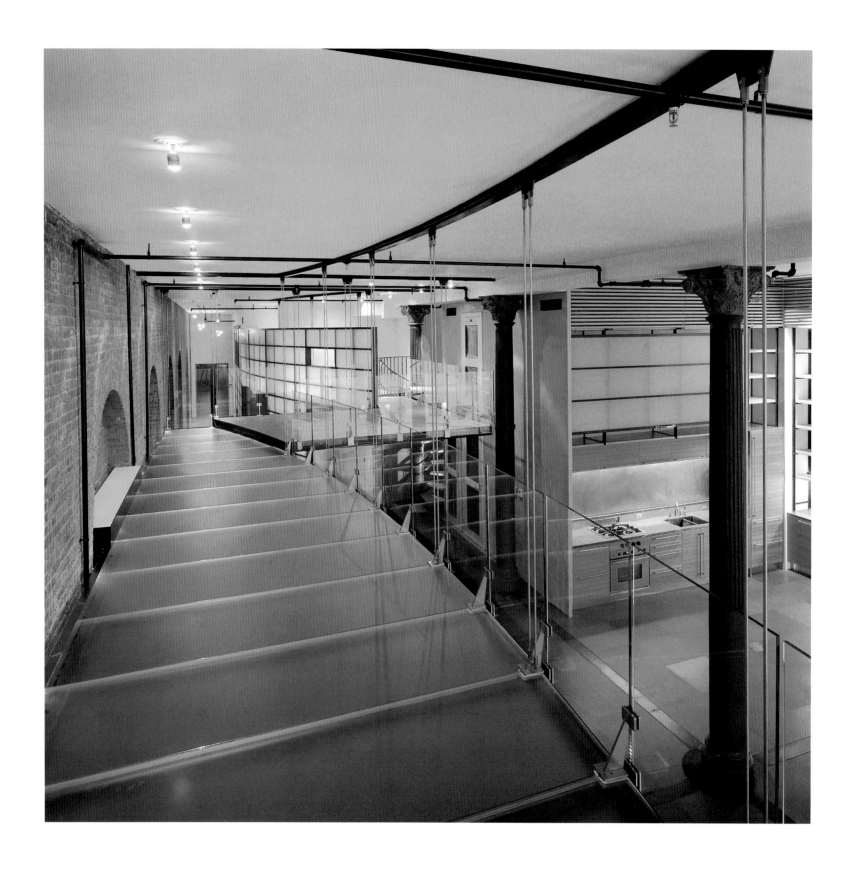

The residential area, which also includes the kitchen, develops behind a large, full-height wooden cabinet wall.

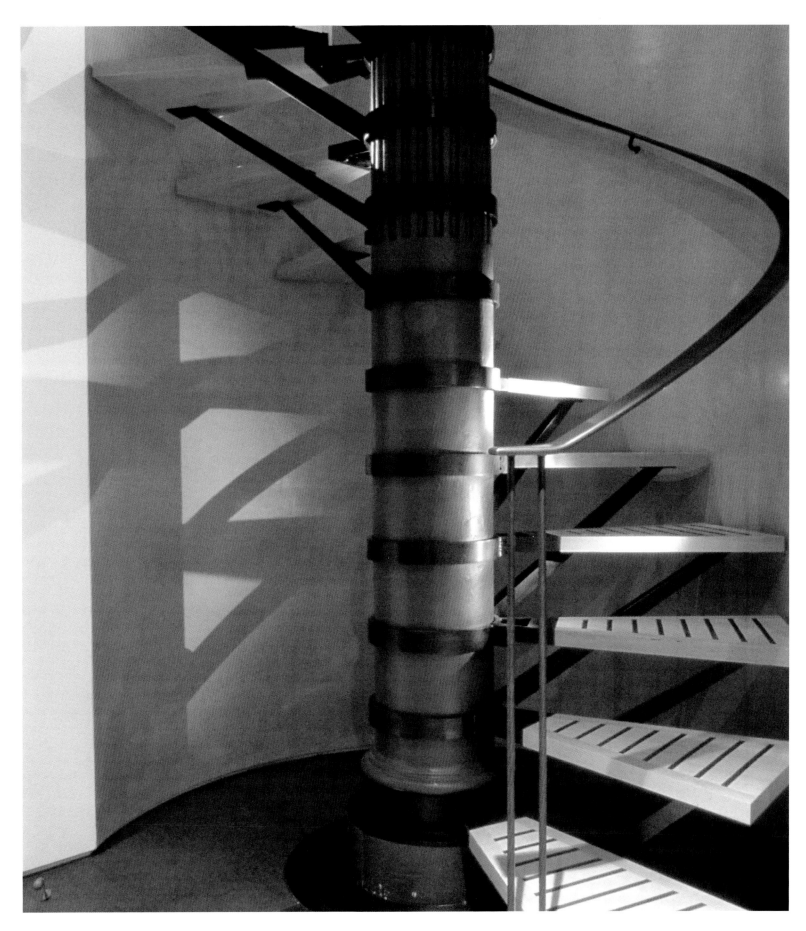

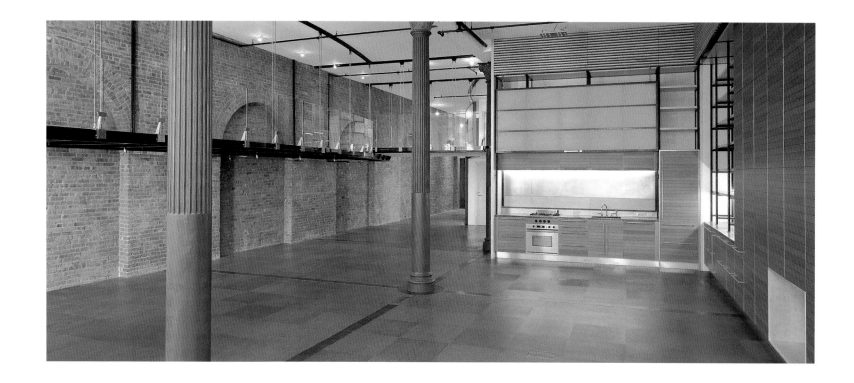

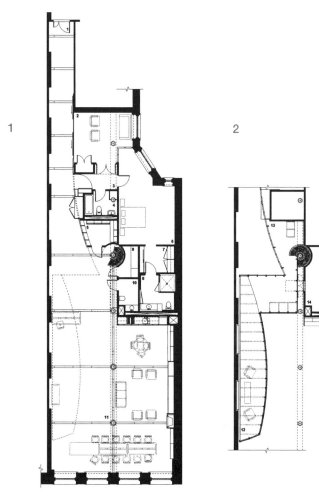

1. Ground floor

2. Attic

While this loft has two uses, the visual and spatial relationships are extremely important to the design. This direct relationship enables illumination of the attic from the main space.

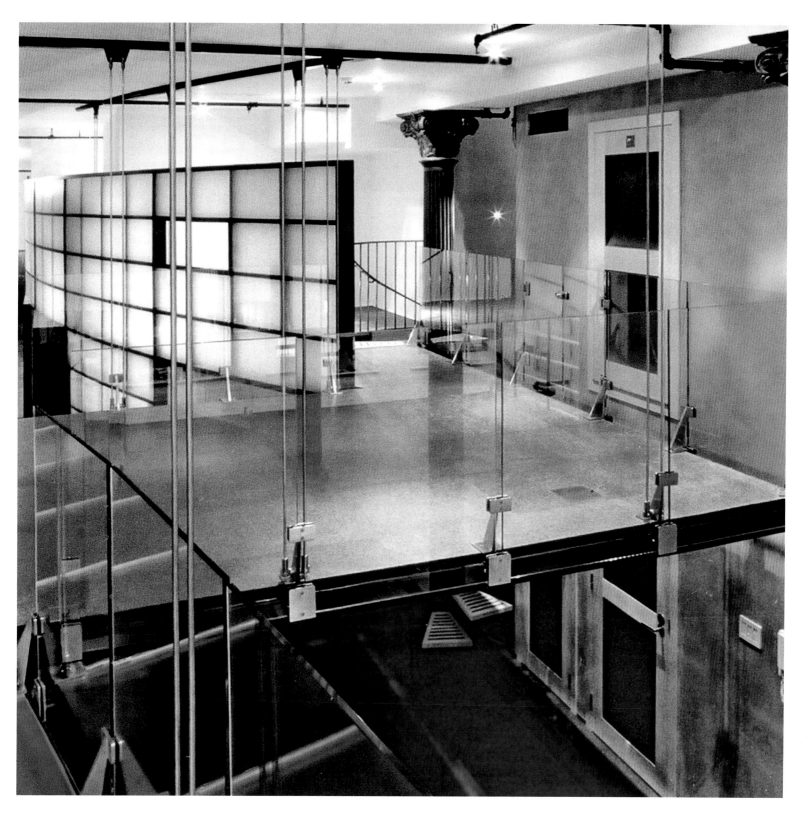

Projects that unify various spaces have the vitally important task of studying the new relations between the elements to create dwellings that work as a single unit. In the Eisenman Davidson Apartment project, this is achieved simply. The project called for the joining of three apartment units, each working in strict unison into a single three-room entity, with a library and room for the usual living activities. The ingenious project proposal unifies the space by reconfiguring the functional relations among the different rooms. The apartment had to be unified both structurally and via the treatment of walls, ceilings, and floors. This new spatial dynamic is driven by the interaction of interior and exterior space; the windows frame the skyline and provide attractive views of Lower Manhattan. The simplicity of the intervention here and the materials used achieve an architecturally cost-effective project, allowing the owners to invest more in furnishing their new home.

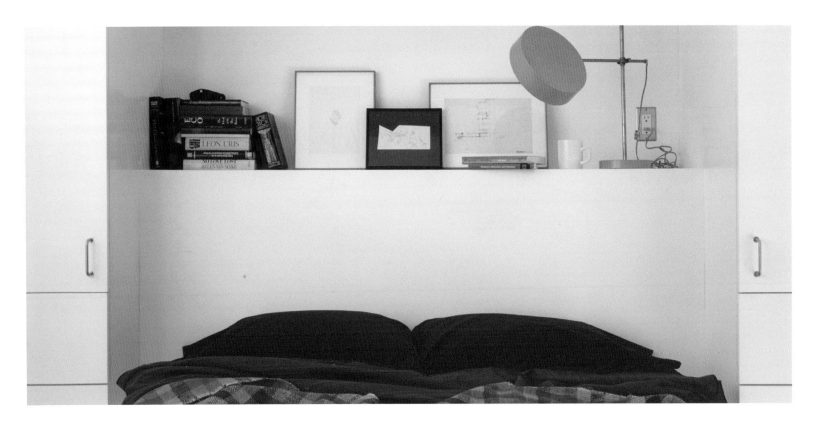

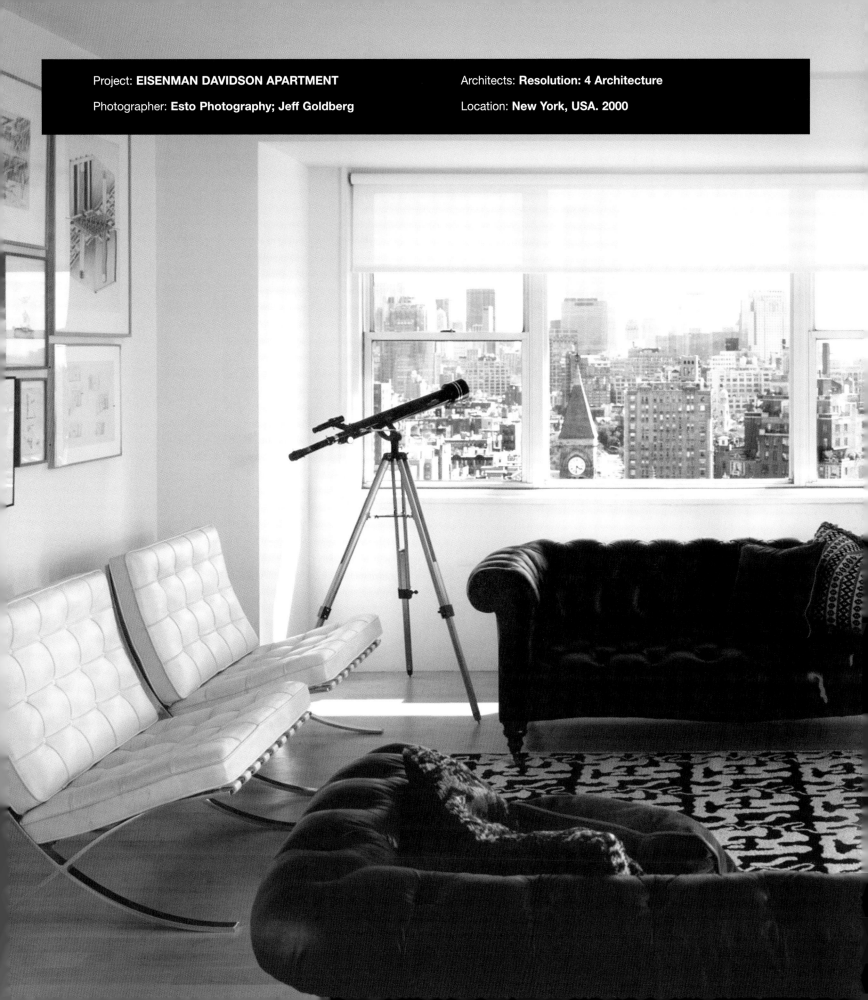

Project: **EISENMAN DAVIDSON APARTMENT**

Photographer: **Esto Photography; Jeff Goldberg**

Architects: **Resolution: 4 Architecture**

Location: **New York, USA. 2000**

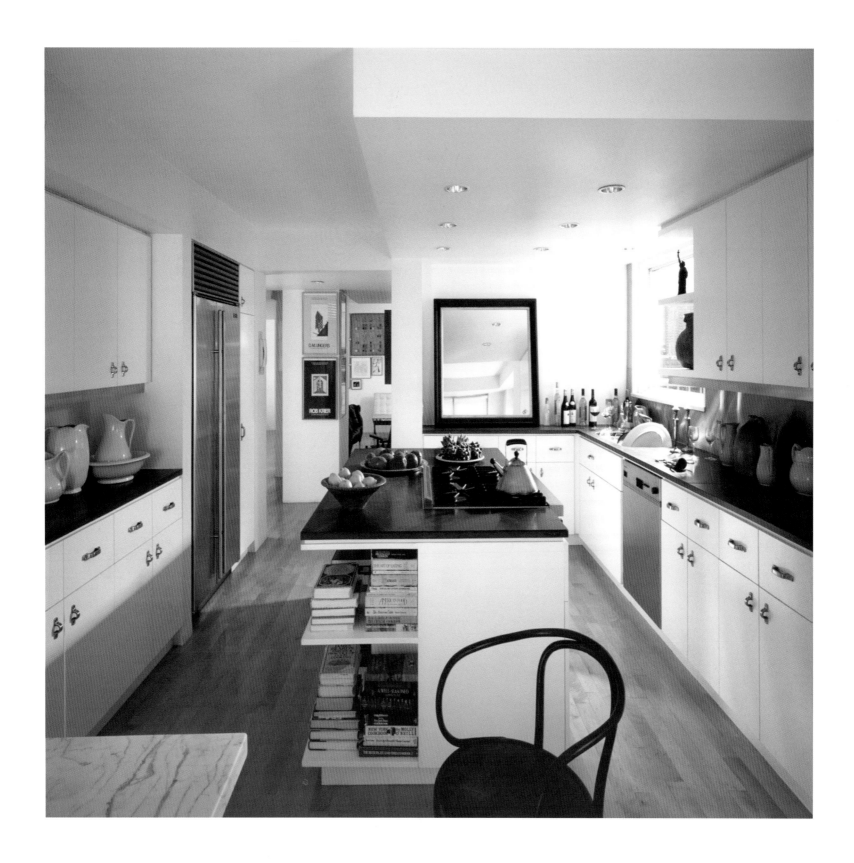

Homogenization of surface treatments unifies the project, hence, the walls, floors, and ceilings are either painted or finished in the same materials.

The project employs a simple but unified architecture that allows the owners to invest more in interior decoration.

1. Axonometry

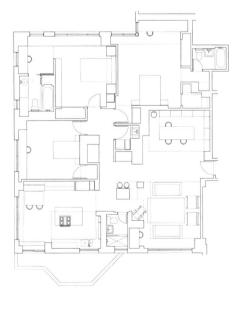

2. Plan

0　1　2

The outside dimensions were already determined by the three existing spaces. Unification came about via specific interventions that kept to the original plan.

The necessity of a cost-effective budget for this building in Barons Court, Kensington made the use of inexpensive materials vitally important. Introducing unusual materials also cut costs on other items of the project. The architects proposed large, full-height storage walls built with sheets of translucent polycarbonate. A more economical material than glass, polycarbonate also served the purpose of "containing" fluorescent lamps. This made these walls into luminous planes that subtly define the program's uses. Opaque glass sliding doors maintain the diffuse character of the spatial limits. In addition to saving space, these doors help to distribute natural light through the separate rooms, creating an attractive continuity based on flexibility. One of the few "solid" elements in the house is the furniture used in the kitchen. Constructed of wood units with birch veneer, they have an opaque solidity that instills a more precise definition to the space. The end result is a single space in a house delineated by opaque planes, contrasting with the transparency of the other materials.

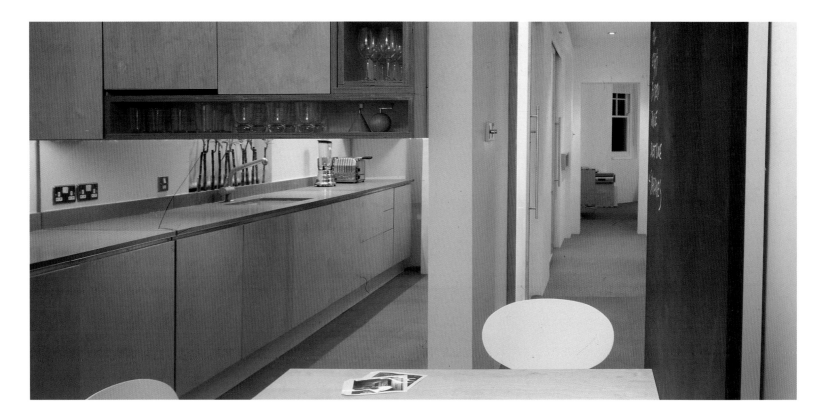

Project: **FARADAY MANSIONS**

Architects: **AJMK Architects**

Photographer: **Nicholas Kane**

Location: **London, United Kingdom. 2002**

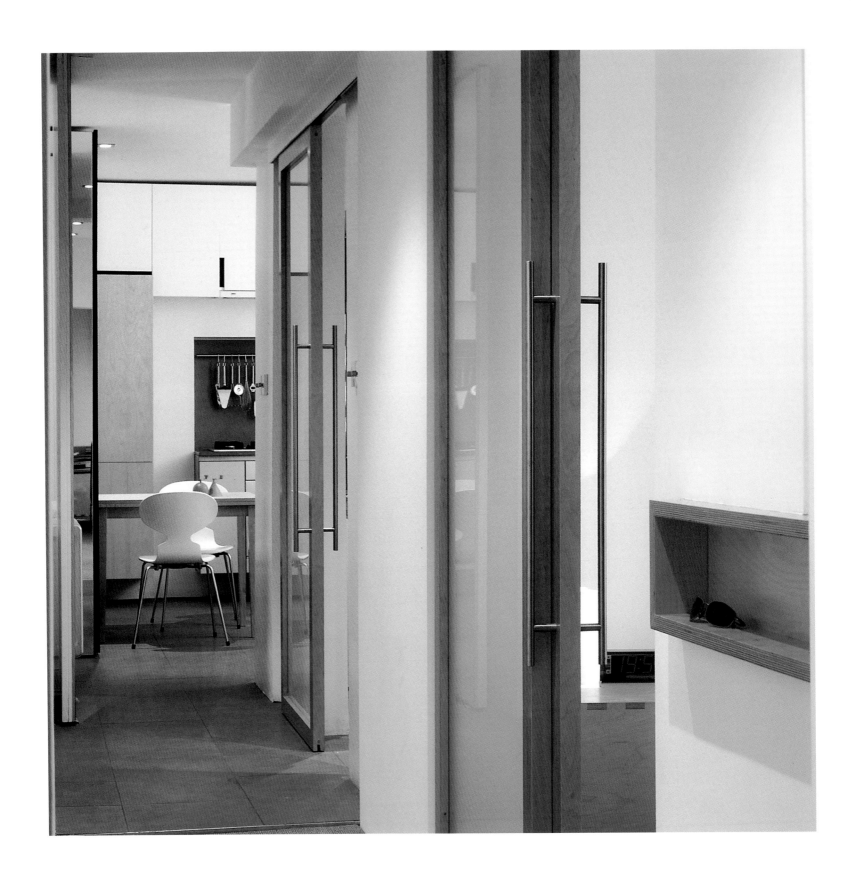

To contribute to light diffusion in the house, sliding glass doors were used. This provides a considerable amount of flexibility, both physical and functional, in space use.

In different situations, polycarbonate was used as a more cost-effective substitute for glass. In some cases, this involved fluorescent lighting containers, which produced very attractive results.

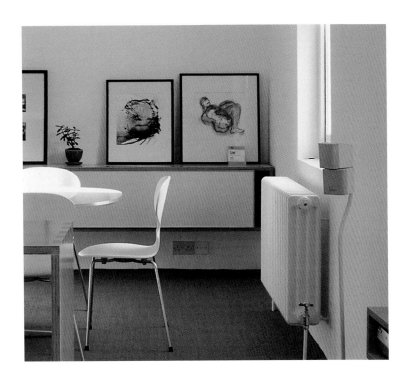

The austerity and simplicity with which the place was occupied, both in terms of furnishings and interior design, reinforced the low-cost framing of this house.

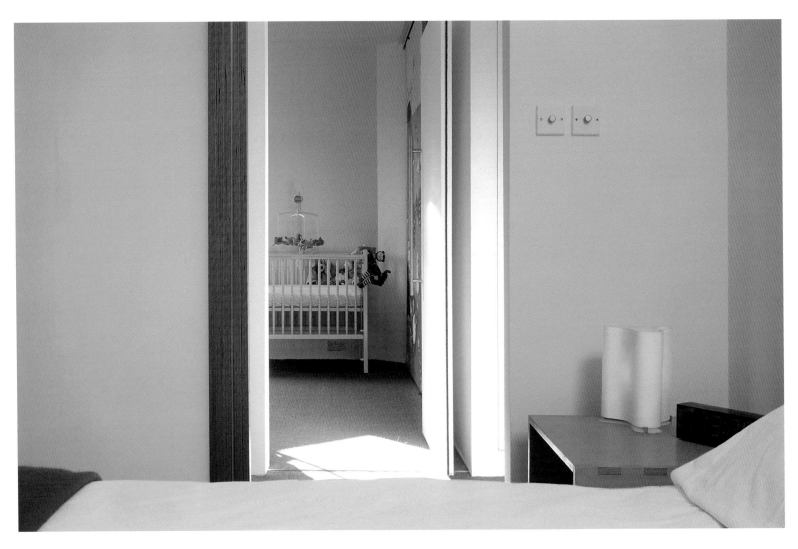

Opting for polycarbonate made it possible to create attractive wall surfaces with different and novel uses.

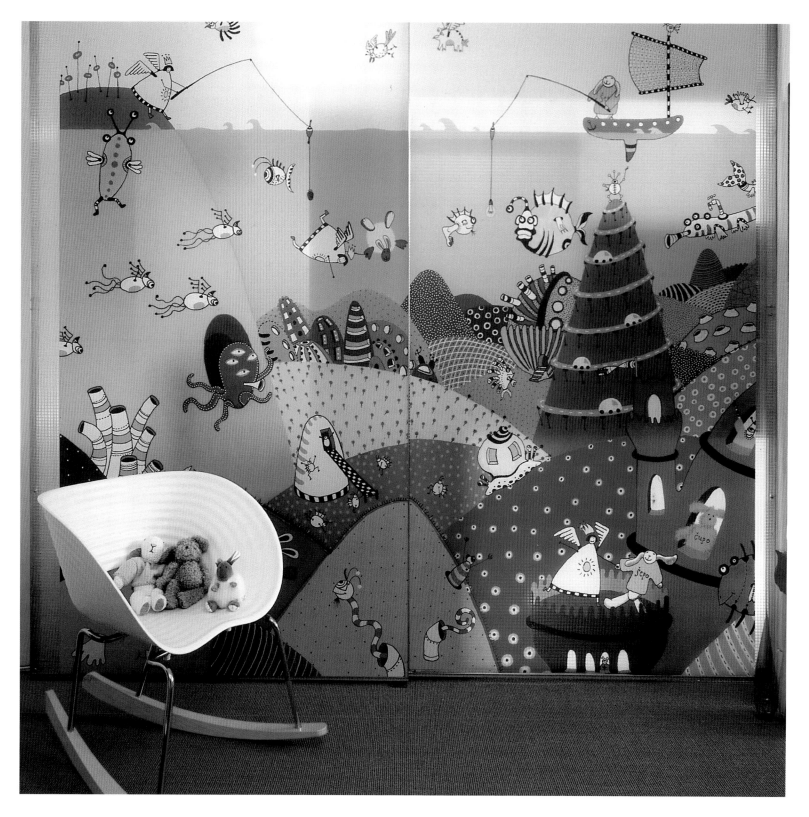

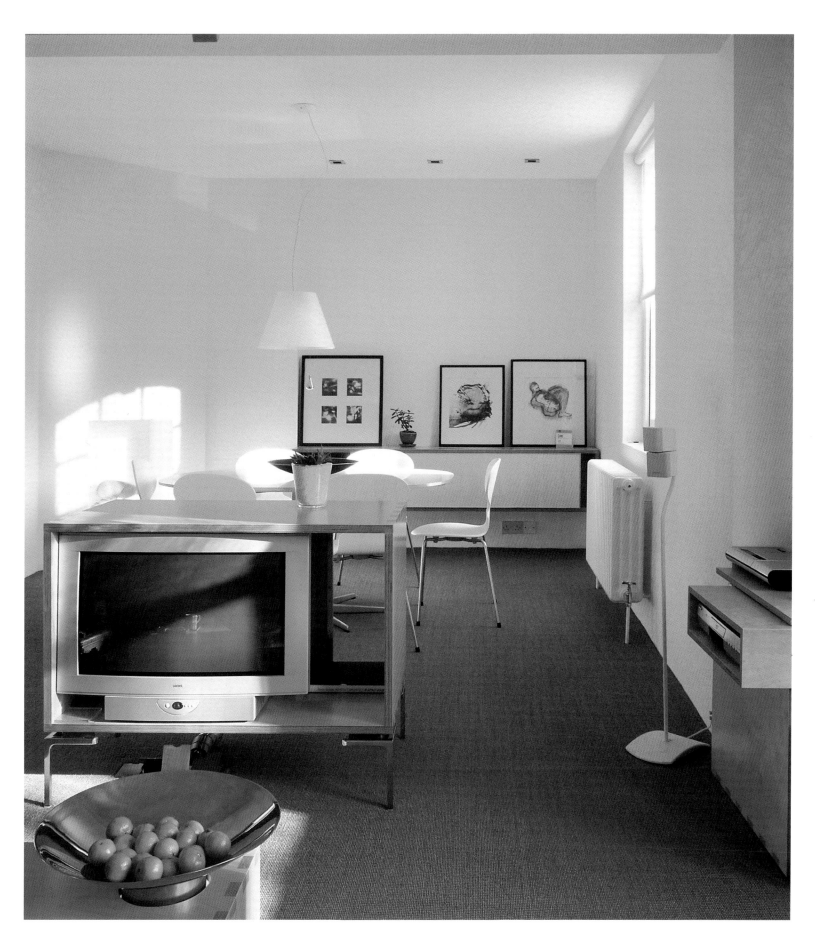

One of the requirements of the renovation for this 725-square-foot apartment was vast storage space in the form of shelving and closets. Among other things, there was the need to stow a huge collection of more than 10,000 CDs. To meet this functional need, the architects fashioned "storage walls" in the form of continuous shelving on the bottom floor. This also acts to unify a bright and spacious main area that combines the living room with the dining room and the kitchen. On the second floor, closed closets serve as the storage units in the more private rooms such as the bedroom and bathroom. These "storage walls" were prefabricated in workshops, which allowed for considerable savings. Likewise, the use of ready-made, prefabricated furniture facilitates the apartment plan, which allows tight control of the project's budget. Additionally, these materials soften and simplify the predominant bare concrete, which is used as both a formal and structural element.

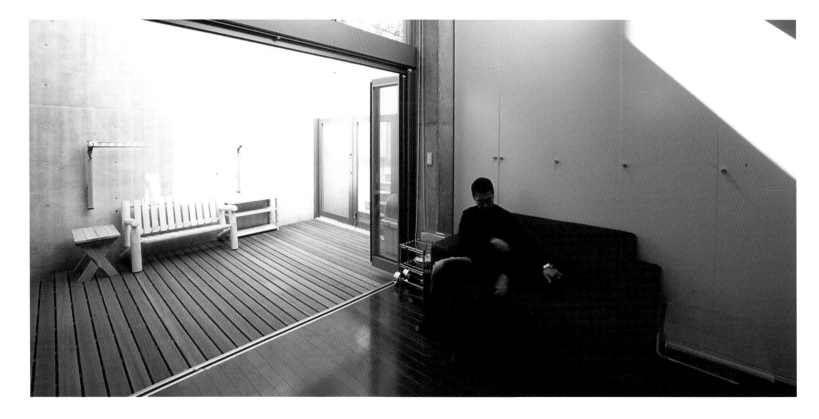

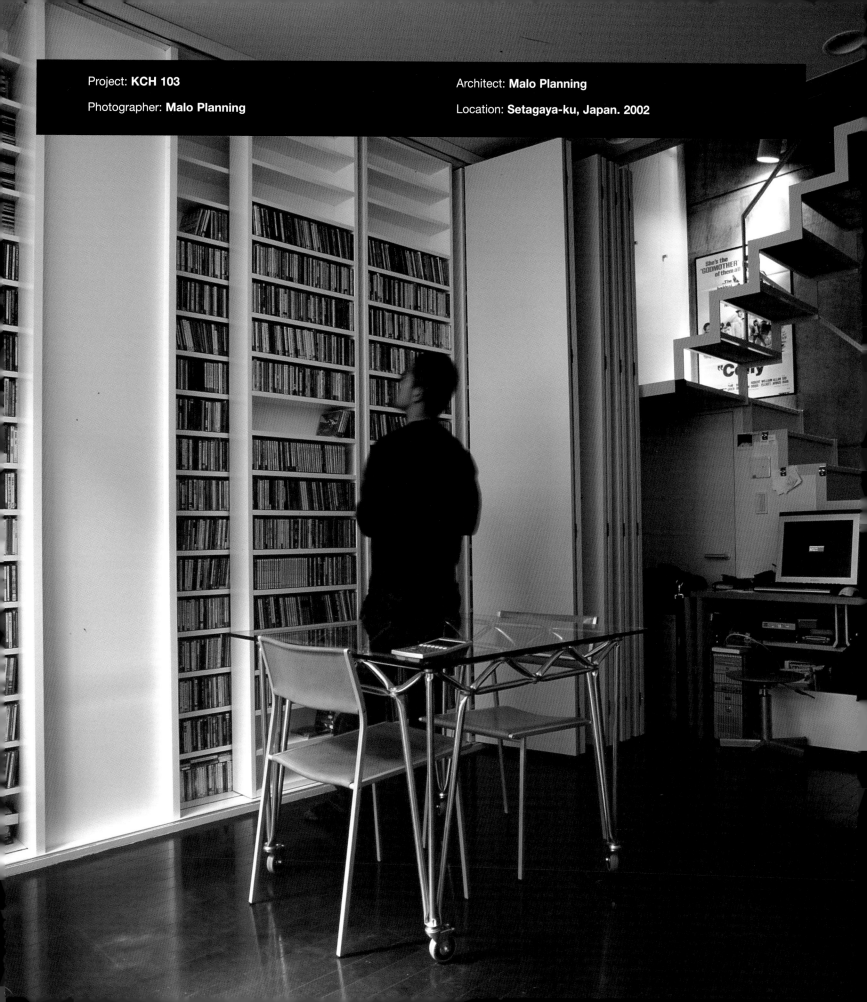

Project: **KCH 103**

Photographer: **Malo Planning**

Architect: **Malo Planning**

Location: **Setagaya-ku, Japan. 2002**

The functional requirements of the dwelling, which included a need for large storage areas, generated the project's main idea: building "storage walls" without losing spatial unity.

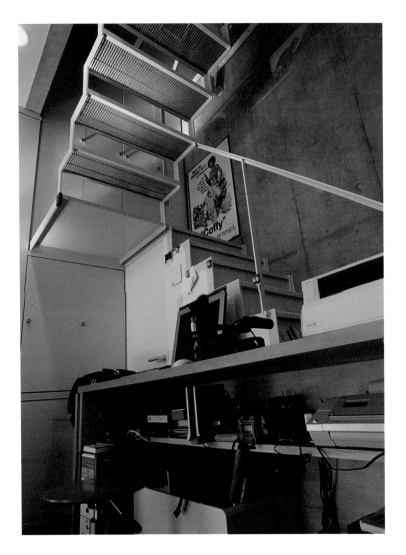
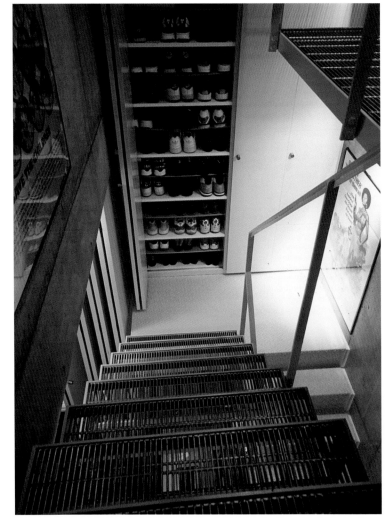

The furniture used in cabinets and shelves was produced in the work-shop. This made the project considerably more cost-effective and also cut down on work time.

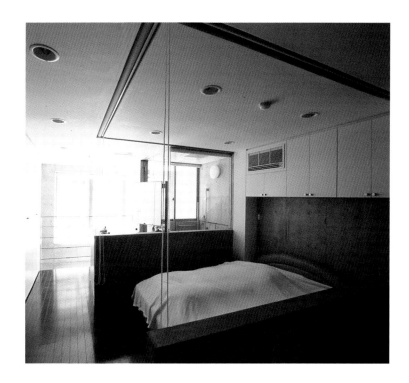

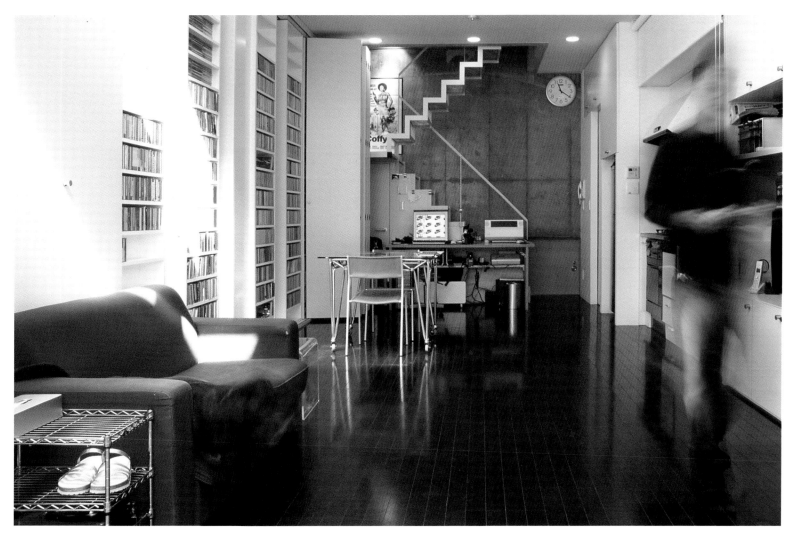

Enlargement projects that attempt to fit a preexisting space within a new project often require extensive work and a huge investment. In this project, however, the formal concept of the design as well as the materials used permitted the enlargement of this small apartment from one to three bedrooms at a reasonable cost. The plan called for the placement of three bedrooms and two bathrooms on the original floor and a diaphanous space on the additional floor, where the kitchen would take prominence. The project was enriched spatially with vistas and a preexisting terrace. In order to comply with current regulations, however, the terrace had to be removed. As a substitution for this attractive element, the architects installed a 6.5 x 10 foot retractable skylight, which brings the exterior into the interior space. This element and other splurges were counterbalanced by the materials and the austere elements used. The staircase (built in strict compliance with current norms) and the zinc kitchen range are the only bold elements in the space. The simplicity of materials such as zinc, maple, and white tiles within a context of white walls complete the aesthetic.

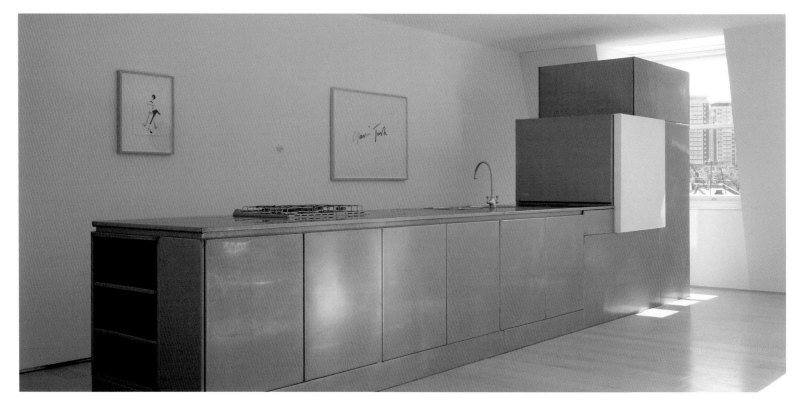

Project: **LEVINE APARTMENT**

Photographer: **Nicholas Kane**

Architects: **Buschow Henley Architects**

Location: **London, United Kingdom. 1997**

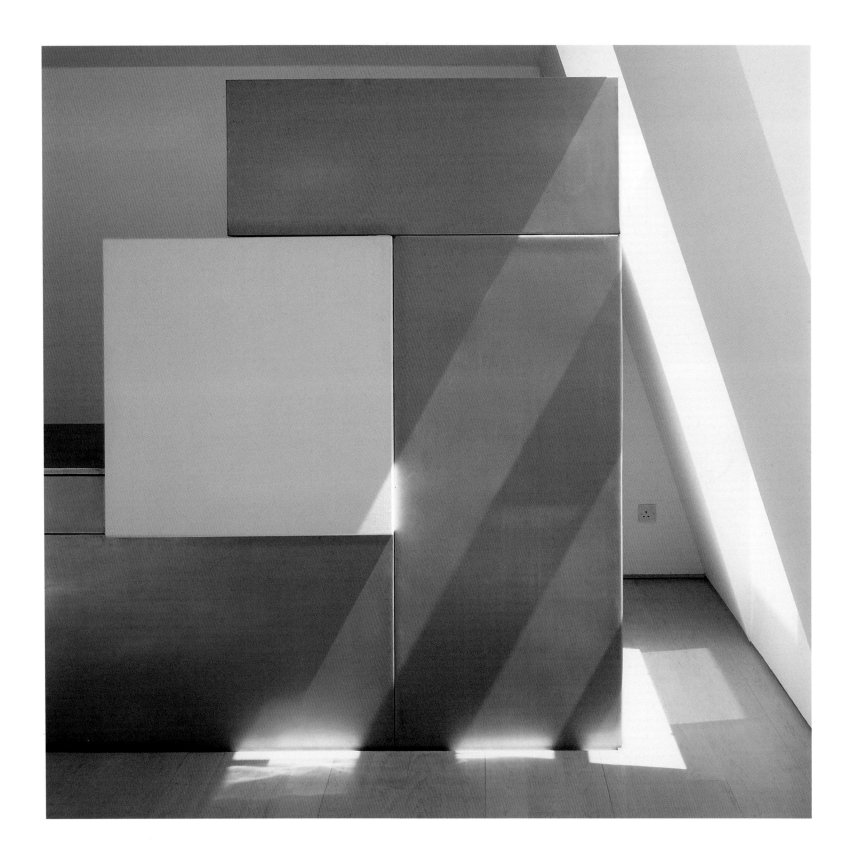

The range of materials used was minimized to zinc, maple, and white tiles in a white-walled context of light-filled space. The furnishings were reduced to their minimal expression.

The scale is one of the main focal points in a highly austere space.

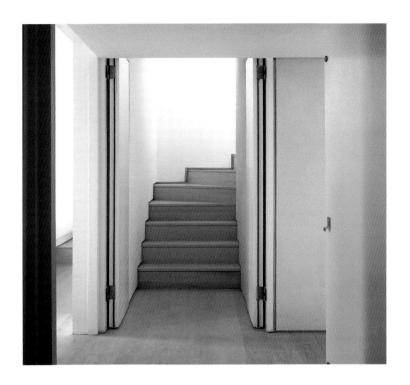

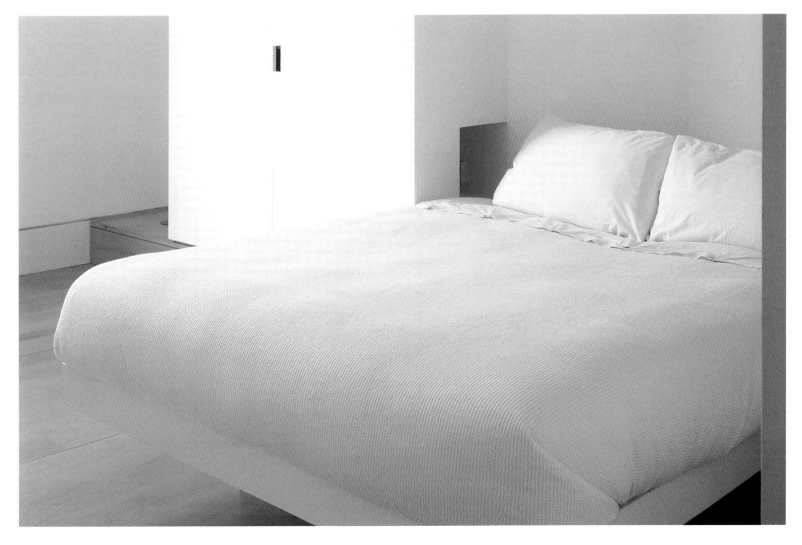

When an intervention is undertaken in a preexisting construction, it is of the utmost importance to take advantage of the former structural and aesthetic conditions. This is critical not only architecturally, but also in regards to budgeting. Here, the aim was to fashion an apartment residence from a preexisting structure of concrete and bricks. The commission was to maintain the same "container" and use the same predominant materials. As a consequence, the project is premised on a brick structure and only a few striking interventions.

Different elements are used to separate the spaces. The main space, placed in a context of concrete floor plans, is divided into five islands, which correspond to the distinct ambiences of the home: living room, dining room, kitchen, bedroom, and bathroom. Acting as a kind of blueprint, the floor also helps to organize the inhabitable space within this irregularly shaped container. The furniture is the final brushstroke that completes the functional and spatial definition of the project. The architects stayed within the budget, which was tightly controlled from start to finish, and built a 1,935-square-foot apartment residence at a cost below what is customary for an apartment of that size.

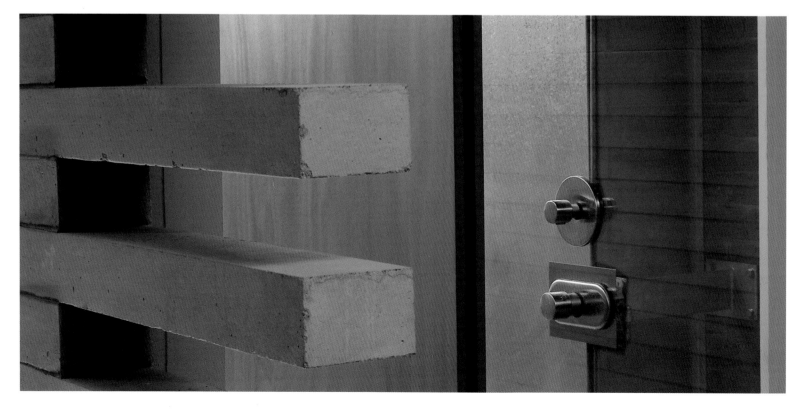

Project: **MICHAELIDES APARTMENT**

Photographer: **Nicholas Kane**

Architects: **Buschow Henley Architects**

Location: **London, United Kingdom. 2000**

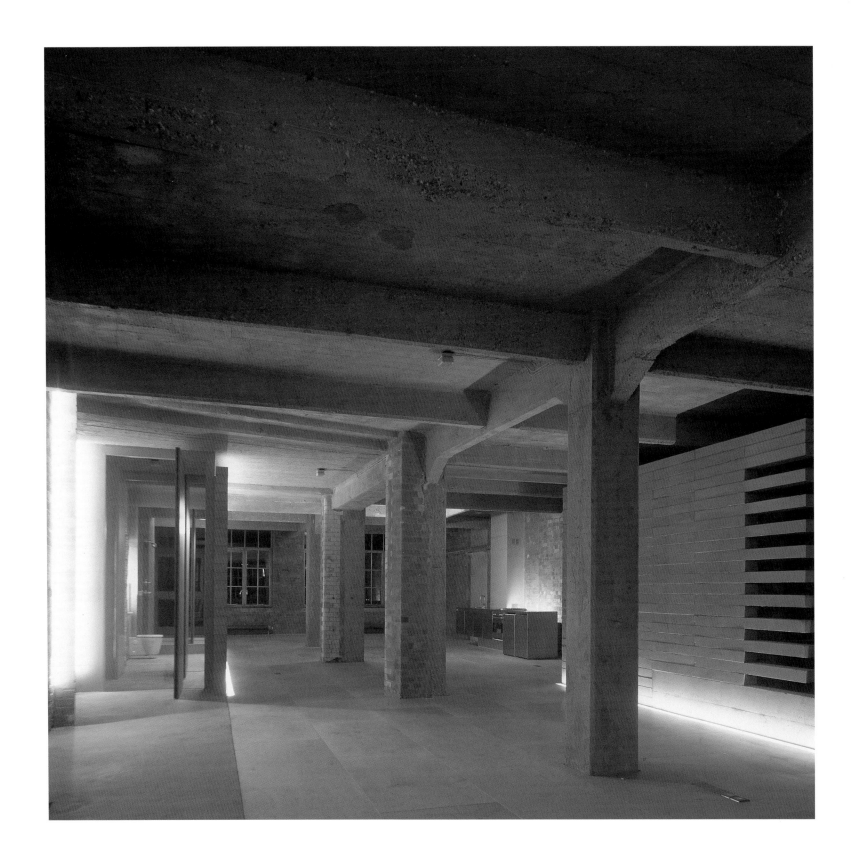

The different rooms in the house are mainly defined by two elements:
the extant columns and beams and the concrete walls called for by
the planners.

The decision to use few additional elements in the space enables carefully studied details in the concrete walls and attractive effects, such as the illumination, to flourish.

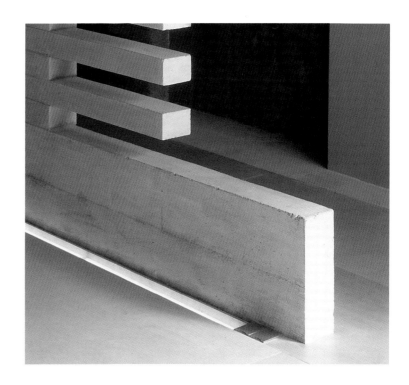

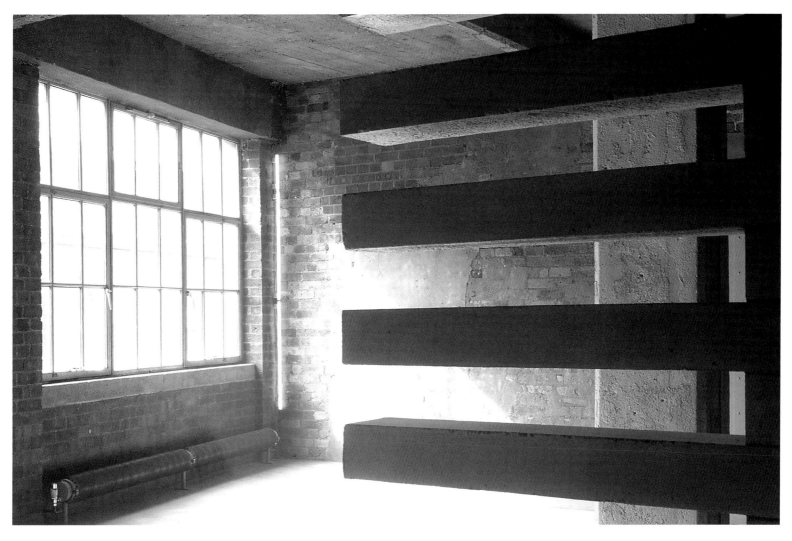

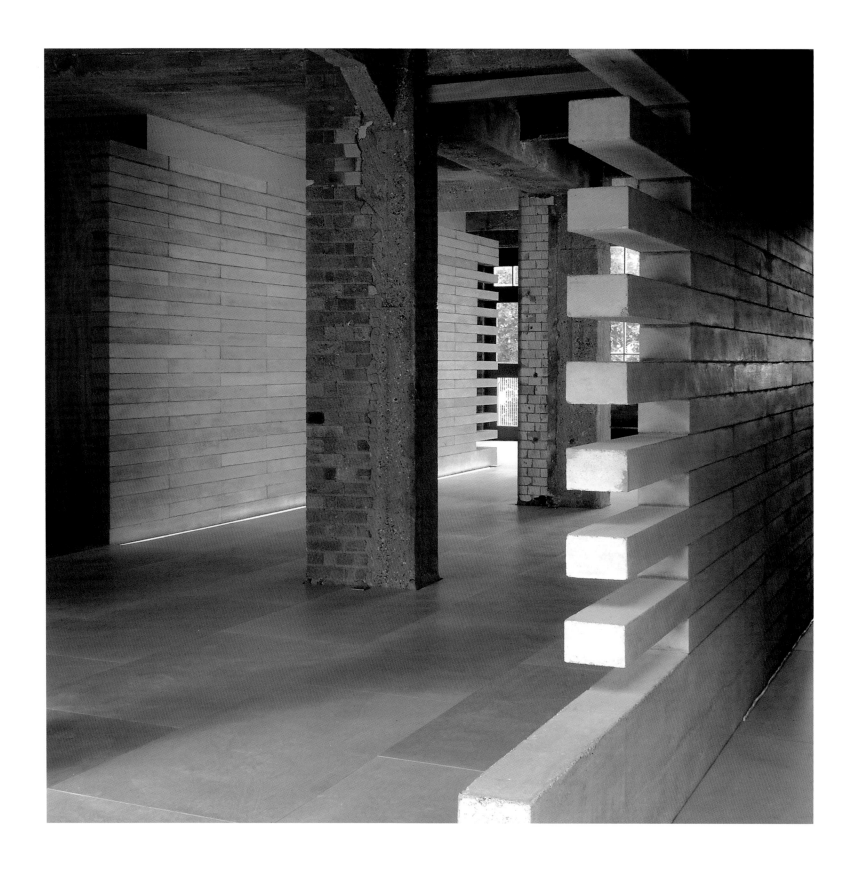

The extant structure used brick and concrete, which designate the overall aesthetic. This same image is kept dominant in the finished house.

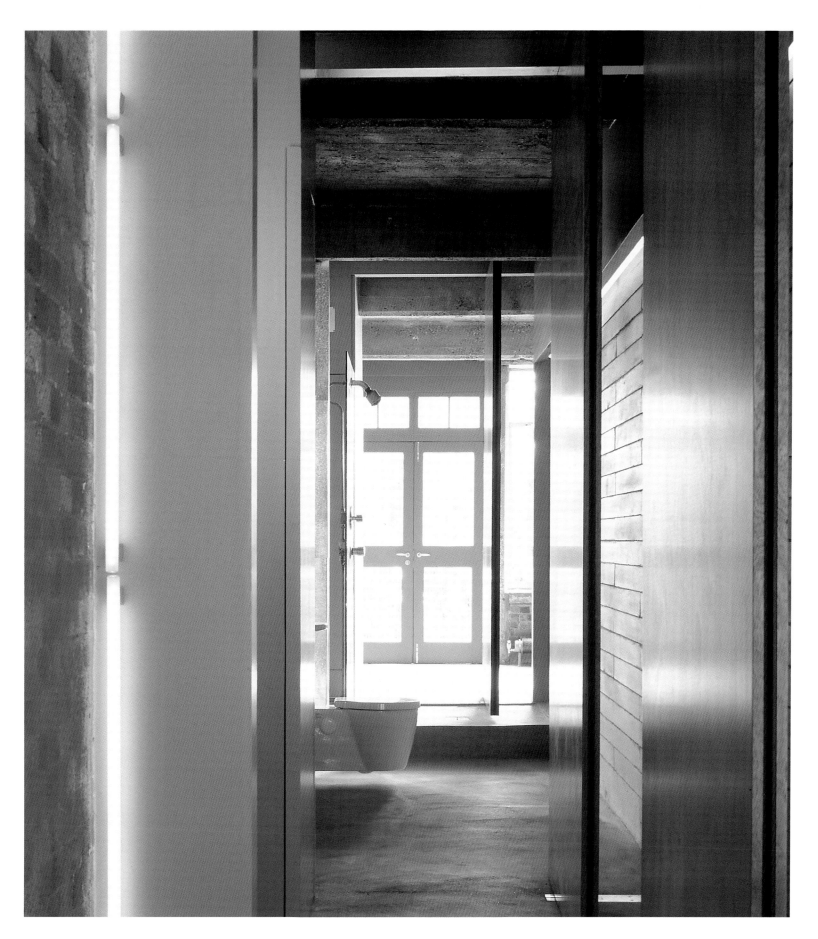

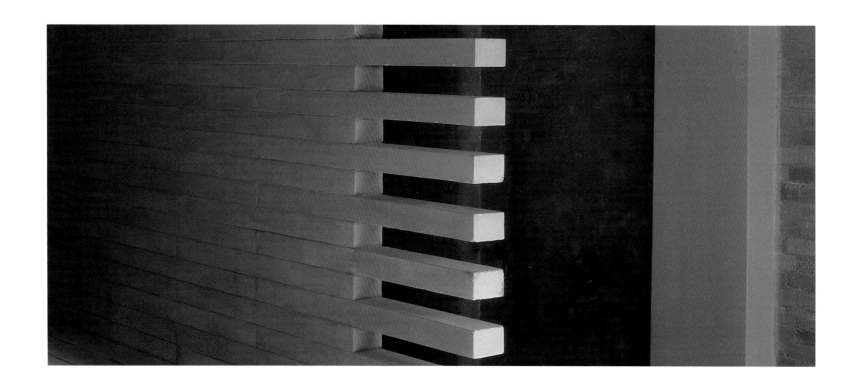

1

2

1. Detail

2. Plan

The lack of regularity in the original space becomes orthogonal via the webbing in the flooring. This webbing is reinforced by the concrete planes.

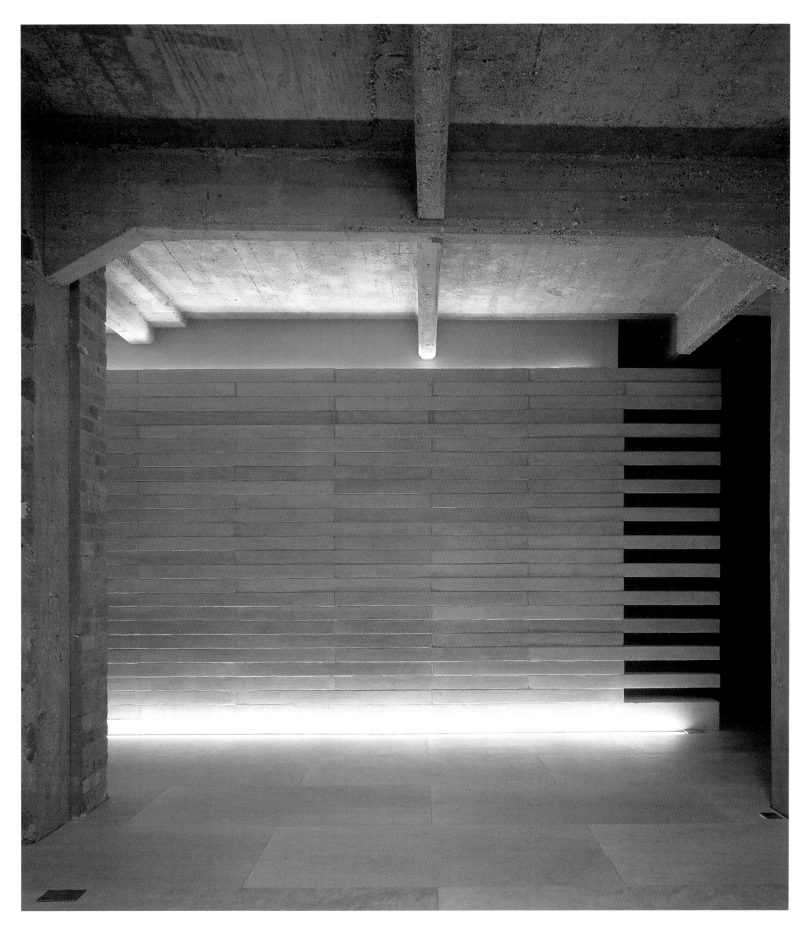

The innovative character of this dwelling stems in large part from the particular features of the space itself. It is located on the roof of an old building, and the architects took maximum advantage of the existing conditions: the location, volume, height, and above all the qualities of the light. Although these characteristics implied certain challenges at the architectural and economic level, the proposal presented a novel solution that concentrates the project's energies on spatial quality. The main idea was to plan small "living units" that adapt to the ground plan of the extant volume and generate an attractive spatial sequence. Each one of these units—of irregular geometry—masterfully employs the incoming natural light, which is then converted into radiant elements of artificial light projected via glass bands to the exterior when there is activity inside the attic. The intervention's other aspects, such as detailed work and materials, were resolved within the limits set by the execution of the work. This project demonstrates how the skillful use of the characteristics of a previously existing place can empower a controlled investment without affecting the architectural proposal.

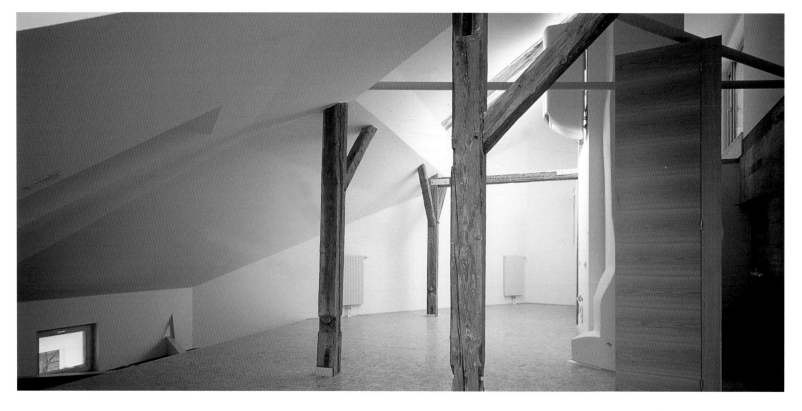

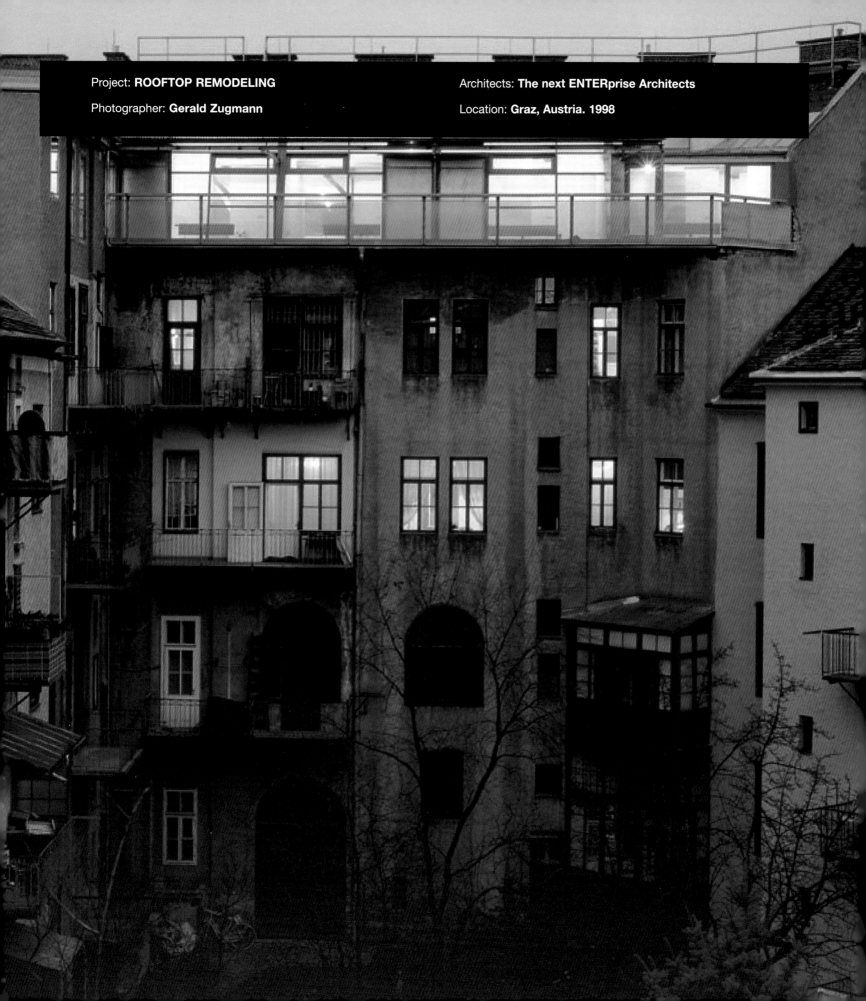

Project: **ROOFTOP REMODELING**

Photographer: **Gerald Zugmann**

Architects: **The next ENTERprise Architects**

Location: **Graz, Austria. 1998**

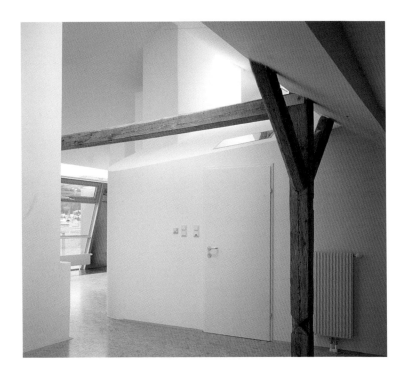

The existing structure was left visible. The choice provides an attractive combination of materials to define the aesthetics.

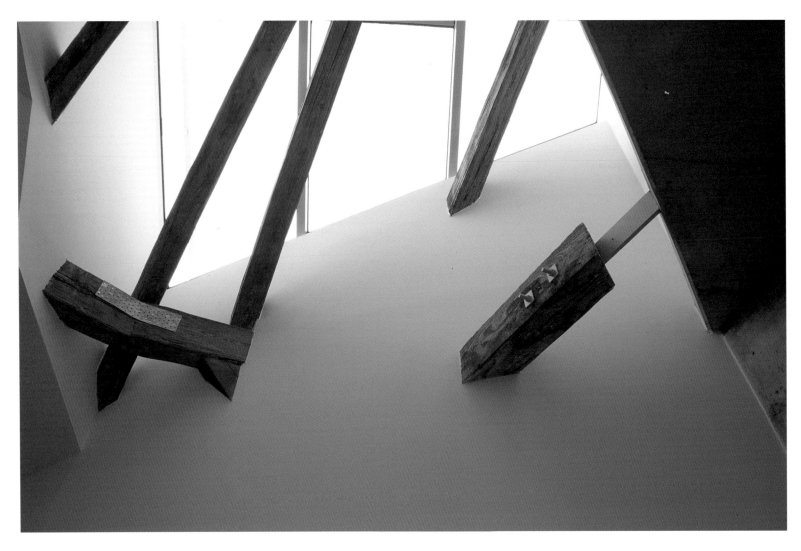

Using the existing qualities of the structure enabled the design's maximal use of natural light to flow into the whole house.

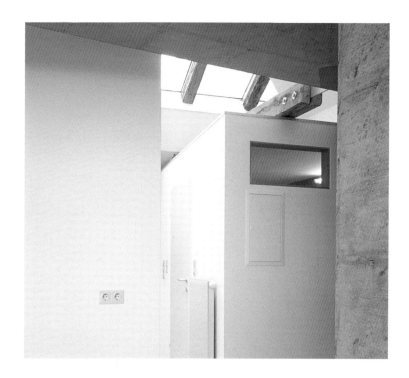

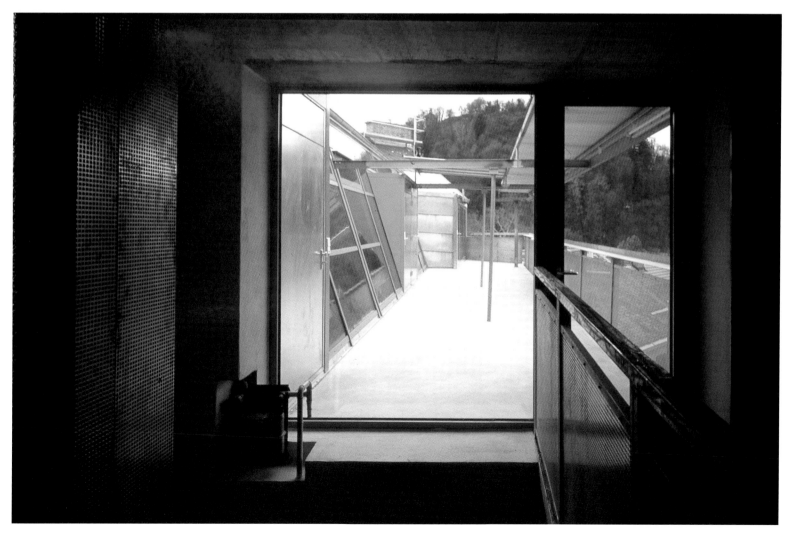

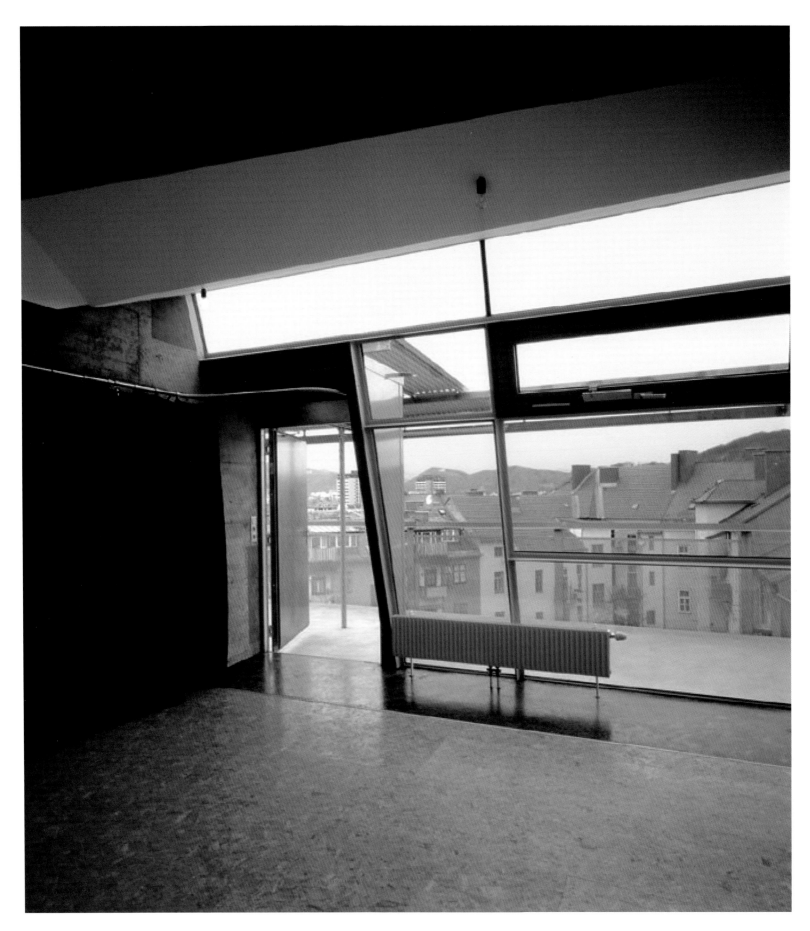

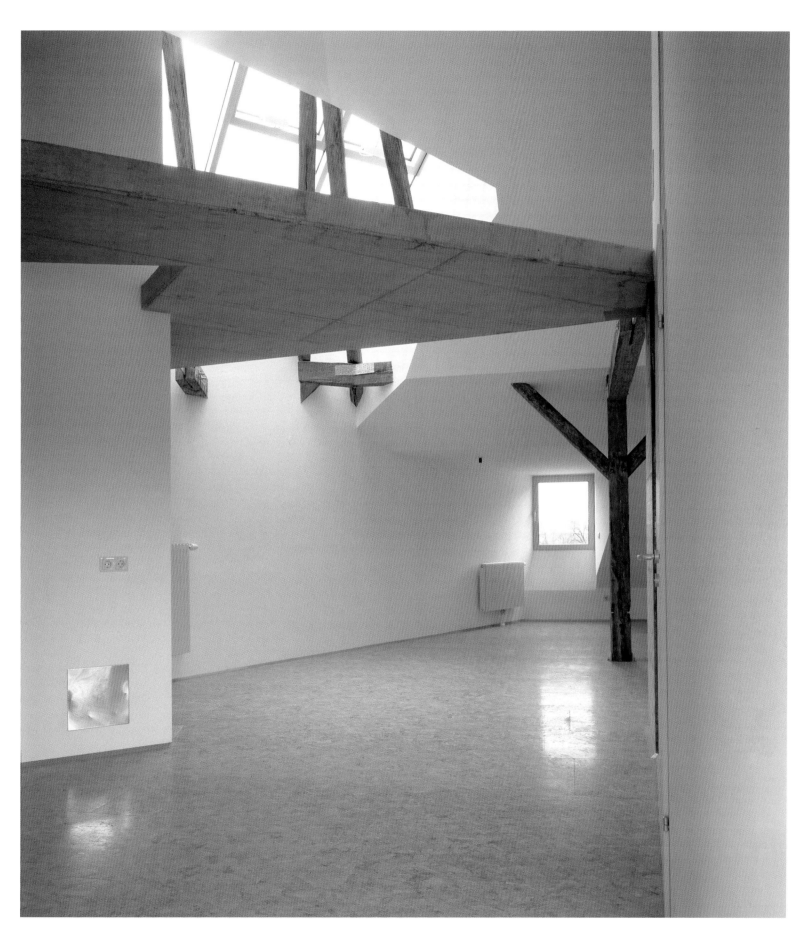

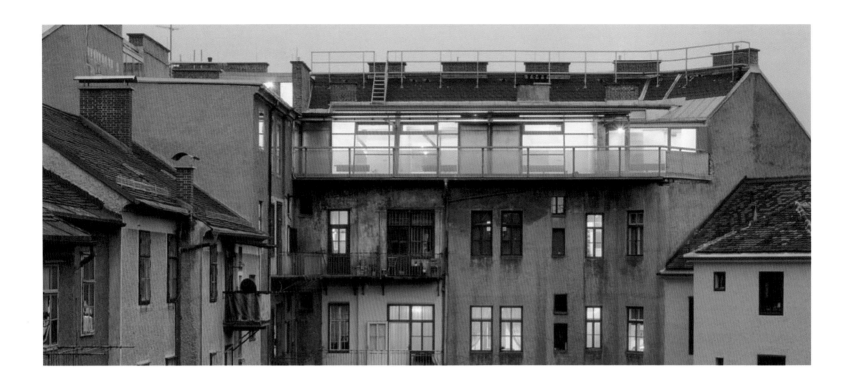

1

1. Section

2

2. Floor plan: Top floor

0 2 4

The plan was reorganized into small spatial units that were progressively adapted to what was already standing. New interventions were limited to working with geometry already designed.

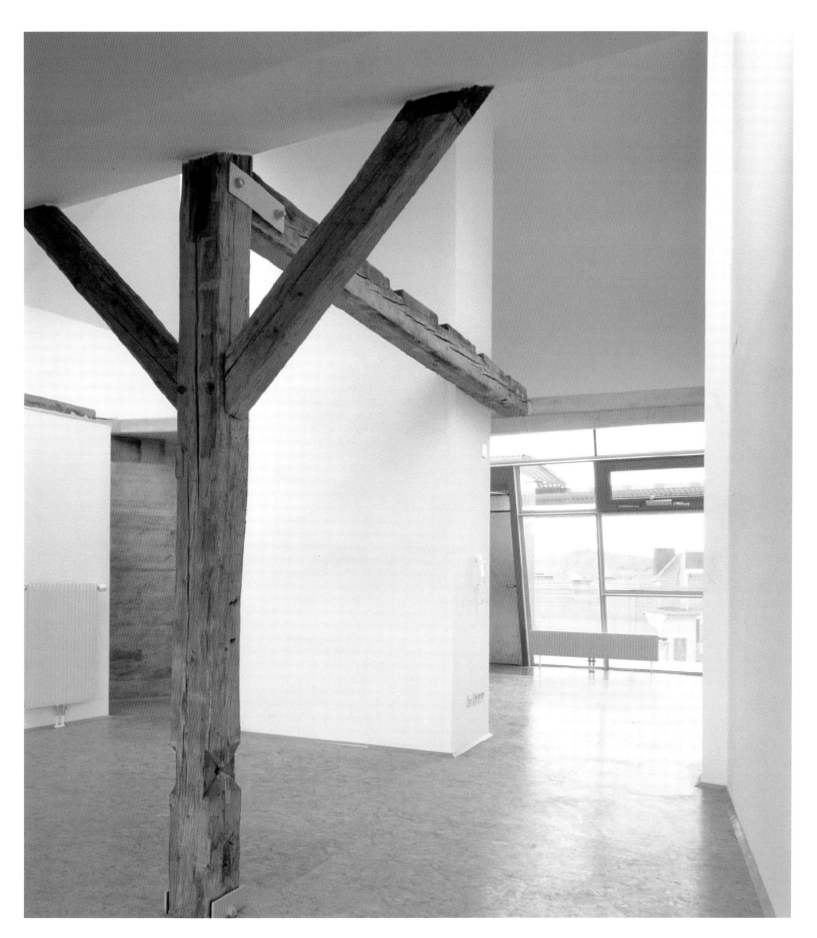

One of the design premises for the alterations in this home was to take full advantage of the small amount of natural light available in the existing structure. The key to achieving this was to knock down the existing walls and part of the loft, creating an attractive, split-level studio that captures natural light. The proposal for the use of materials was a central part of the economy of the project. The restoration of the existing structure exposes the brick walls, which combine with the earth-colored stoneware flooring. The use of neutral furniture reinforces the air of simplicity: like the vertical or horizontal planes built into the walls, they create specific focal points. In certain spots, more muscular elements are introduced, such as the tables in the dining room and kitchen that fit into the stone walls, echoing the design of the steps leading up to the studio. The use of glass blocks in some planar elements, such as those in the bathroom, transform those spaces into oversize lanterns that project light into the dining room. The concealment of the major part of the light fittings completes the simple aesthetic of lighted space.

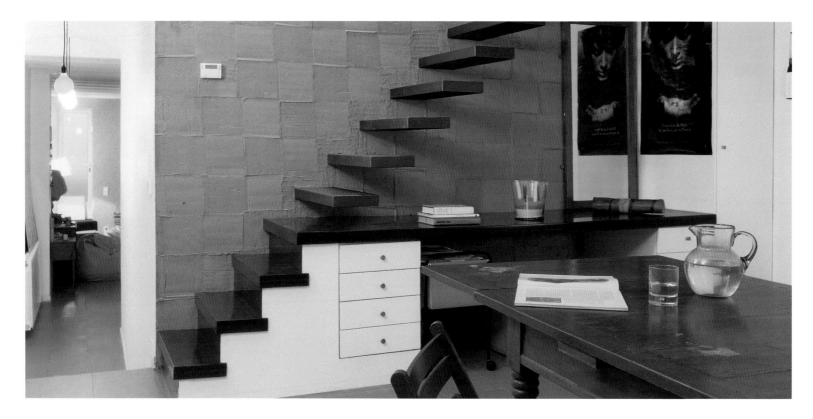

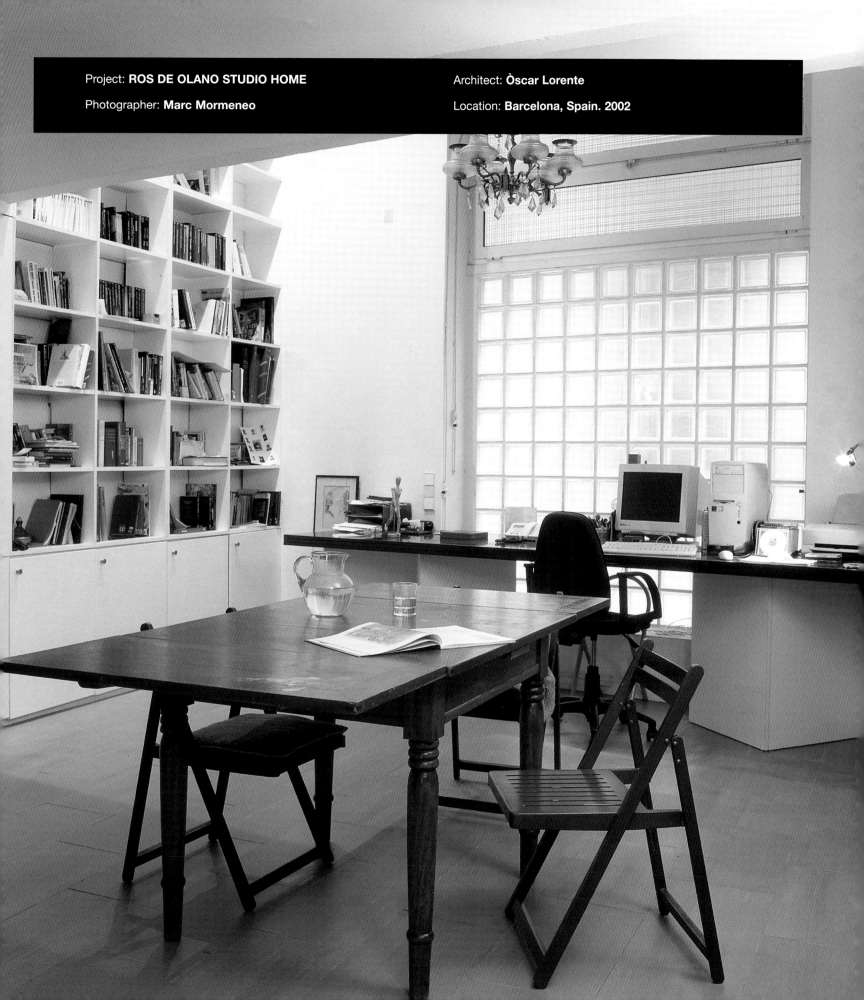

Project: **ROS DE OLANO STUDIO HOME**

Photographer: **Marc Mormeneo**

Architect: **Òscar Lorente**

Location: **Barcelona, Spain. 2002**

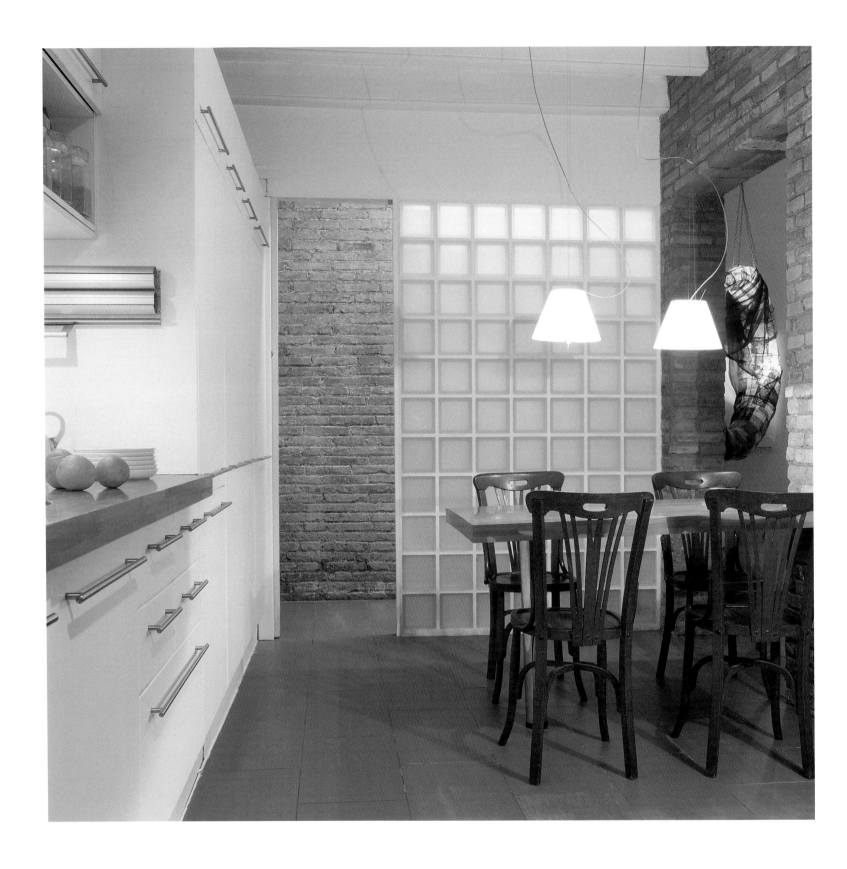

In this house the furniture intentionally defines the interior. The planes made by tables fill the space to permanently outline kitchen and dining room spaces.

Occupation by the minimum amount of furniture possible in the bedroom zone avoids interference with the architectural concept of the space as light channel.

1

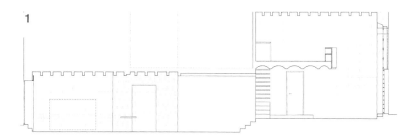

1. Section

2

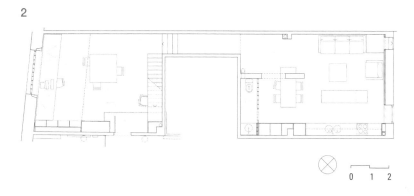

2. Floor plan: Level 1

0 1 2

In both plan and section, this project respects the geometry of the previously existing space. The main intervention in the section was the design of the attic.

RENOVATIONS IN CONSERVATION ZONES

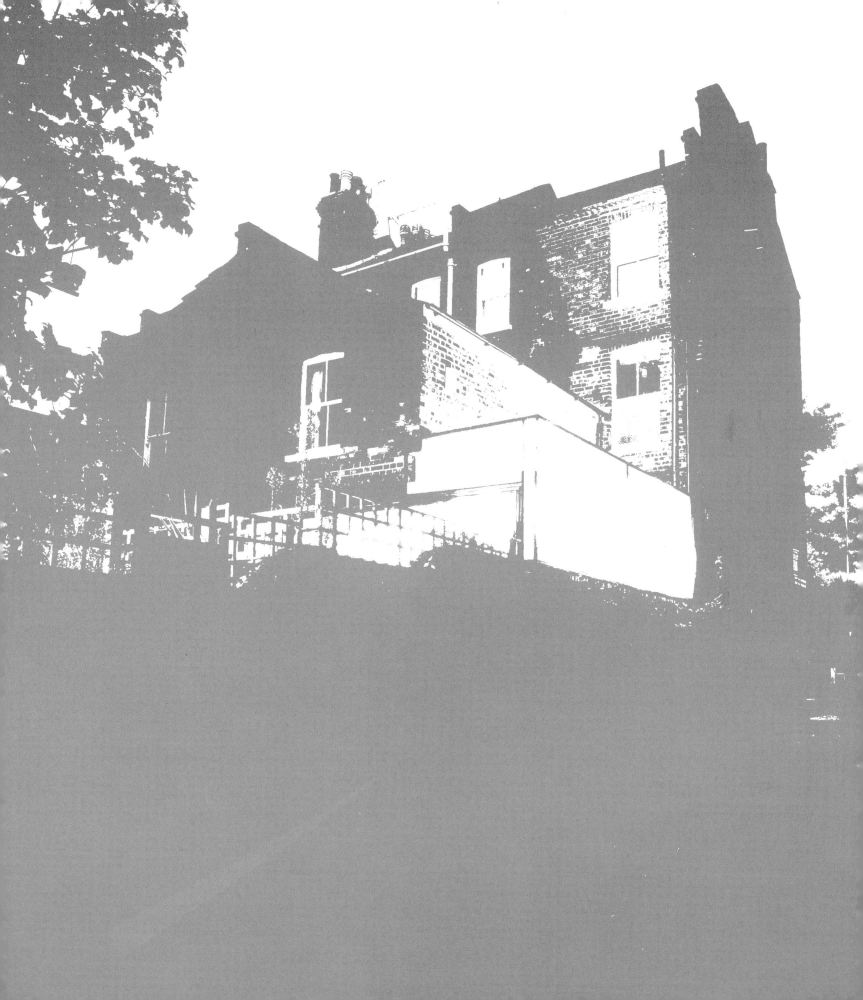

This dwelling is part of a large-scale intervention that involves the construction of five apartments in a 19th-century house in Kensington. Because of the building's historical conditions—it is located in a protected area subject to conservation—the building code limited the degree of refurbishing. Thus, the proportions and type of windows in the façade had to be kept the same. The architects met the difficulty of this situation by designing a project based on light. The trajectory of the building's interior is defined by a "floating" staircase that leads from one apartment to the next. The resulting feature is of high quality, and its construction method made it a cost-effective investment. The construction of this vertical element is based on a smooth box that contains a simple metallic structure, with a staircase made of a single piece and slotted into the container from above. Once inside the apartment, light remains the guiding thread in the design, both in the structural treatment and in the planar materials. Curved beams overhead facilitate the diffusion of light, while a combination of wood and translucent materials enhances the way natural light flows into the dwelling. This intangible "material" thus creates attractive spatial effects, which by their nature add nothing to the cost.

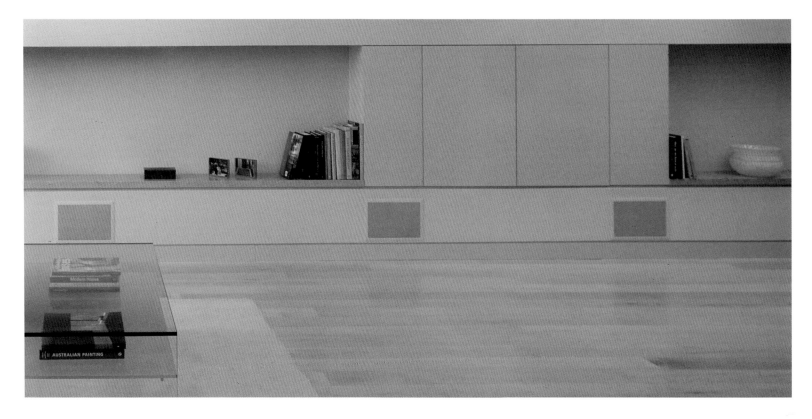

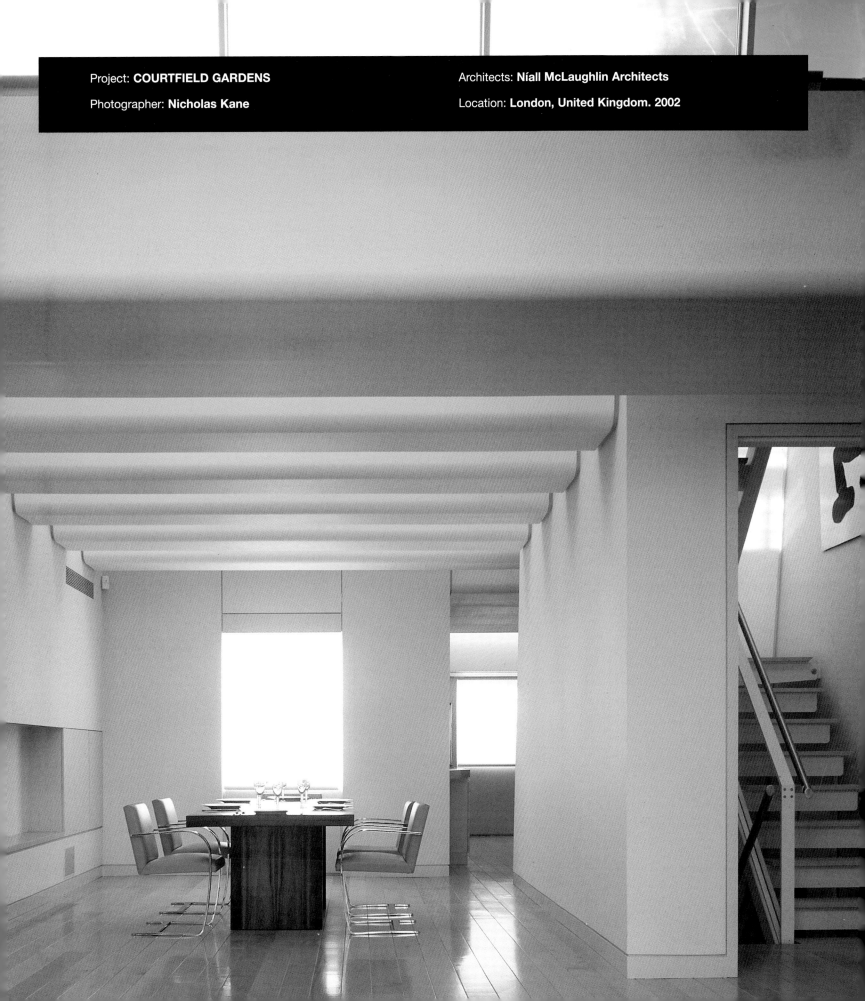

Project: **COURTFIELD GARDENS**

Photographer: **Nicholas Kane**

Architects: **Níall McLaughlin Architects**

Location: **London, United Kingdom. 2002**

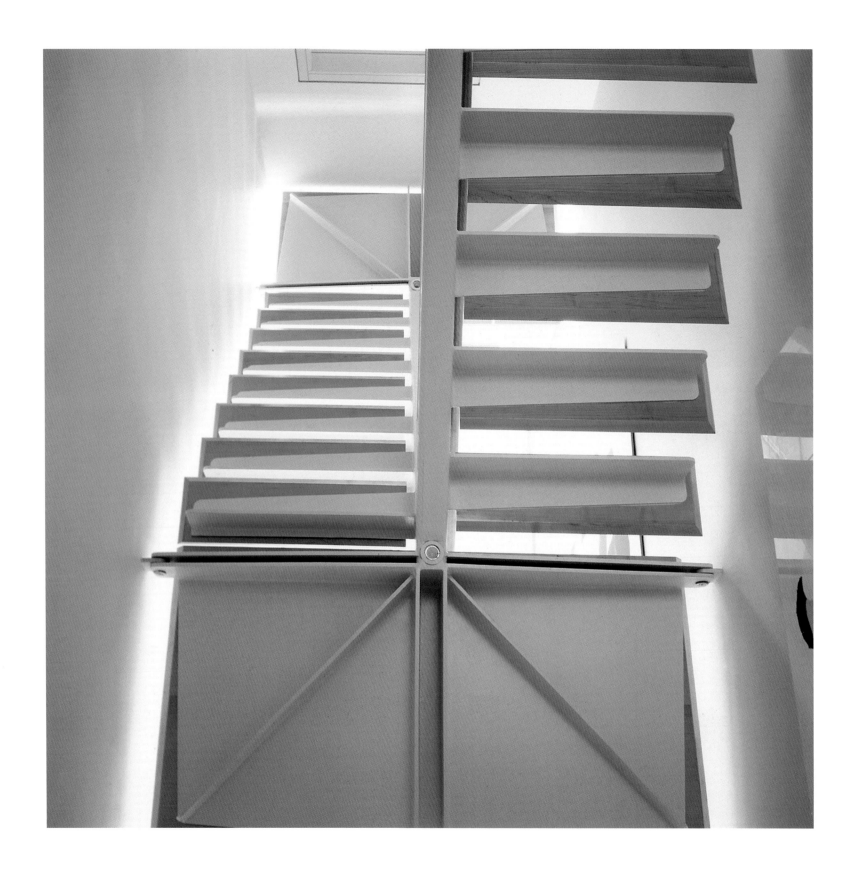

The "floating" stair connecting the building's levels is one of the most attractive elements in the project. While the result is of excellent quality, the building method is simple.

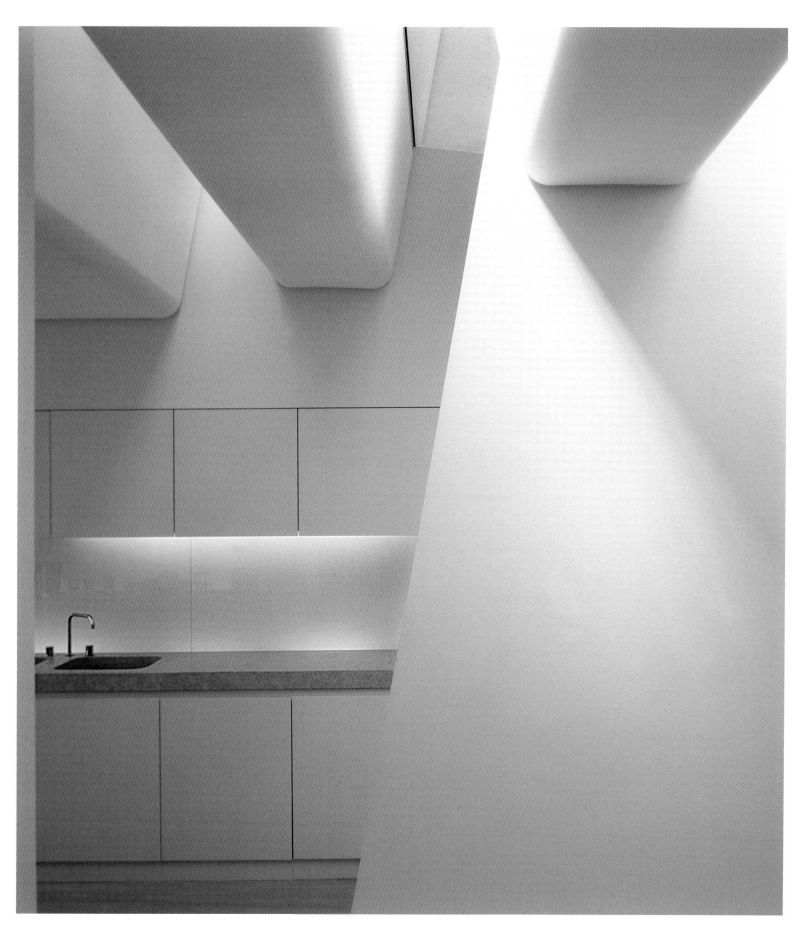

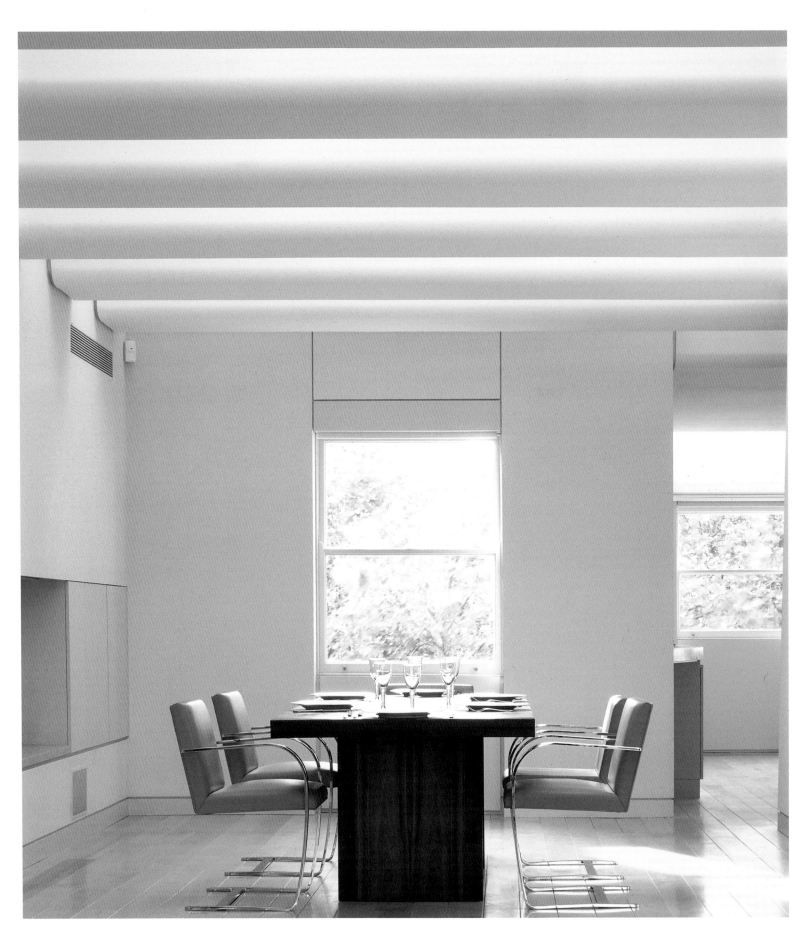

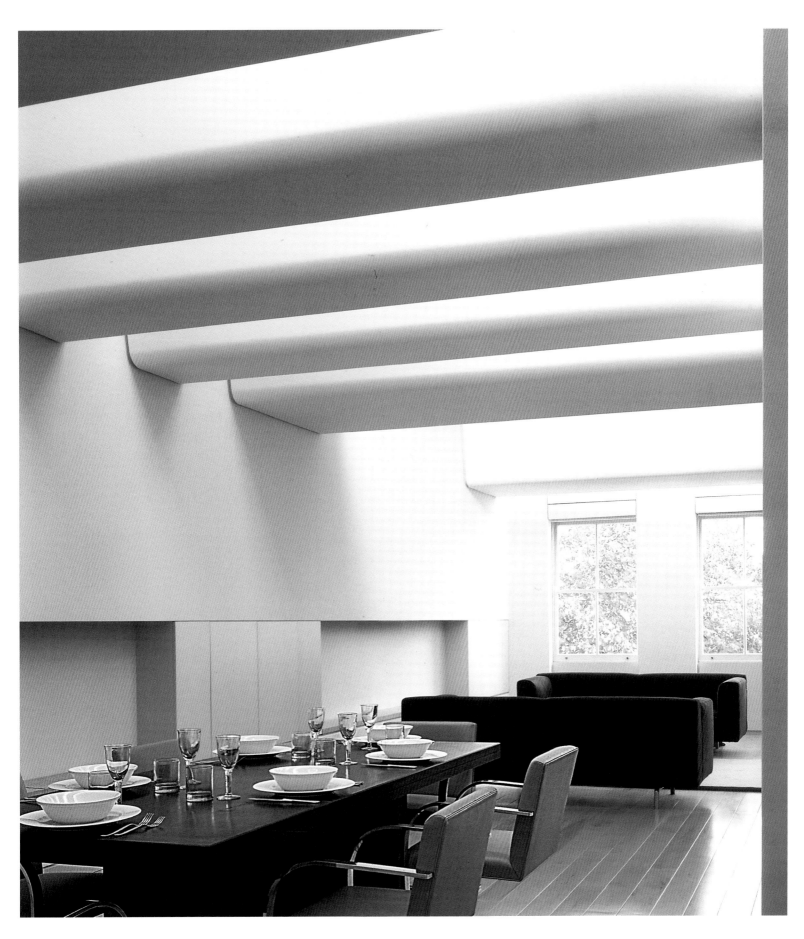

From the outset, a projected housing extension implies a formal and spatial compromise with the extant architecture. This occurs because the aesthetic and structural lines of the latter are frequently highly diverse in comparison with the new plans. On many occasions, this fact translates into large investments, whether because of the obligation to reinforce the old structures or due to the building proposals adopted in the quest to make the new plans adequate to preexisting structures. Thanks to an intelligent proposal, however, the amplification of this Victorian house required no expensive investment. This project is located in Highbury Fields, an area subject to conservation in a part of Islington, a northern borough of London. The extension consists of a simple glass pavilion built behind the house. This expansion is structurally independent, which avoids great interruption in the old dwelling, whether formal, structural, or spatial. Two metal beams brace the new wing, enabling a total opening up of the garden and generating a new spatial dynamic. Oversize glass door-windows reinforce the new link with the garden and fully define the house's contemporary function.

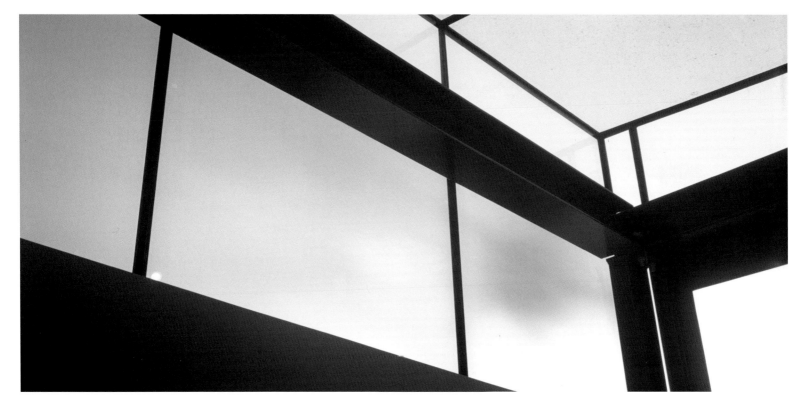

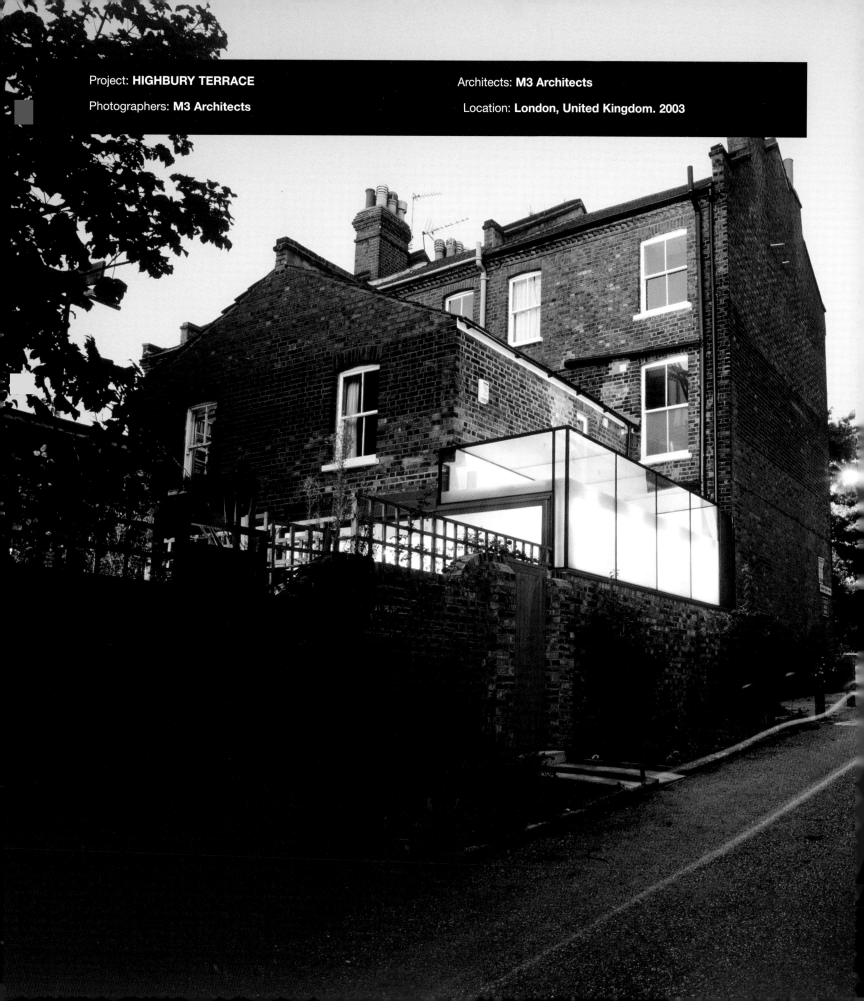

Project: **HIGHBURY TERRACE**

Architects: **M3 Architects**

Photographers: **M3 Architects**

Location: **London, United Kingdom. 2003**

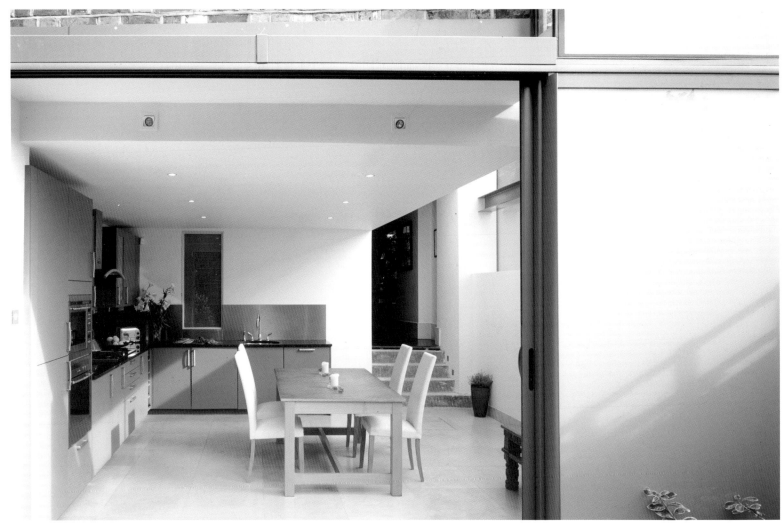

A glass pavilion was added at the back of the house. This is independent both formally and structurally. Its bearing system is based on an economical metal frame.

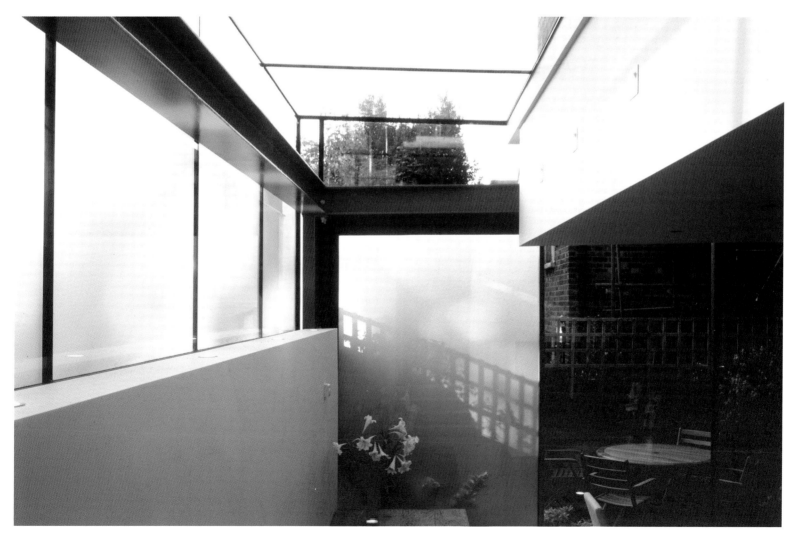

1

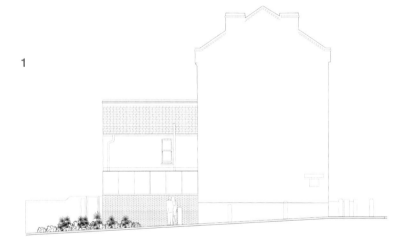

1. Elevation

2

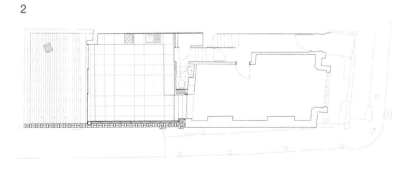

2. Ground floor

The structural plan achieves visual and physical freedom, which generates a new spatial relationship with the garden and modifies the function of the original plan.

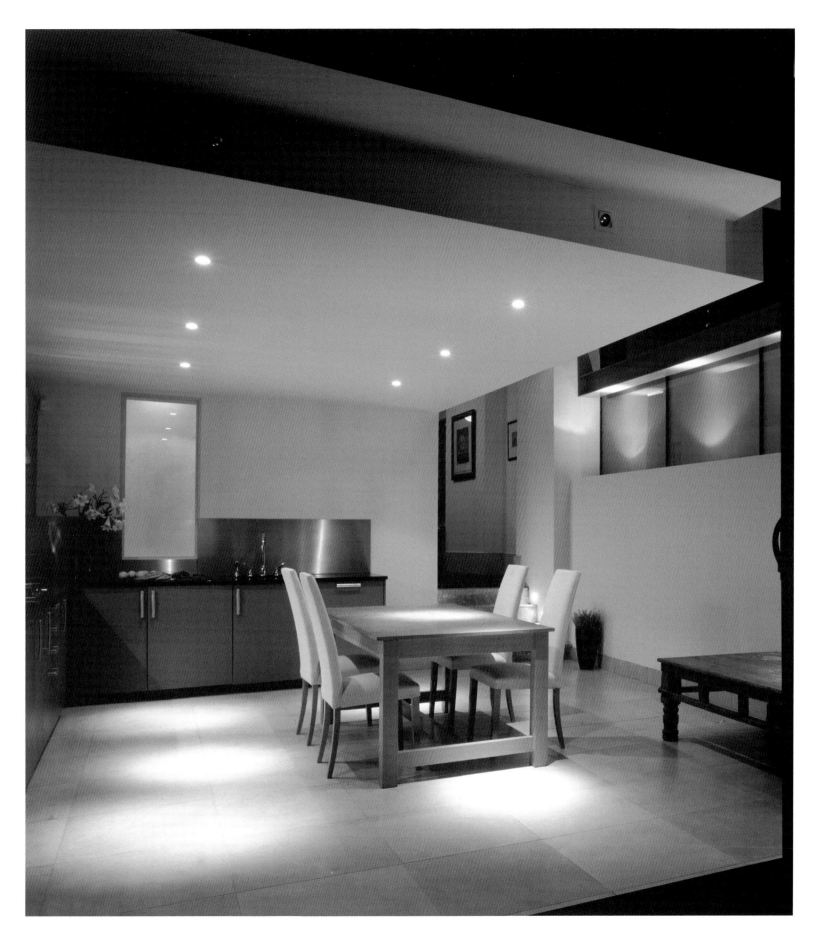

The commission for this project specified the unification of two existing houses, raised in the 1960s, into a single house. The clients requested an abstract white structure, with large openings that would allow vistas from the rooms. The design was thus marked by an abstract architecture with large, deep apertures that enable visual continuity among the different parts. Yet, while the project's research was based on the client's architectural needs, the prevailing austerity makes the purely architectural result—which implicates only the spatial proposal, without including the furniture—a controlled investment.

The clients' wishes yielded a space in which light is channeled into the dwelling via different architectural methods. The exterior blinds or screens act as planes that reflect the clouds and the trees. Different types of light enter into the interior, enhancing and reaffirming its abstract quality: from the light of the room in question, to that which is the product of exterior reflections, to that projected by the other rooms. The whole house acquires an austere character with an attractive spatial dynamic marked by the ambiguity of physical and visual limits, where light itself suggests circulatory patterns.

The volumetric reorganization of the building generates a new geometrical dialectic between the old house and the new intervention, where white is the predominant color. The design has cut through the walls and floors to reveal the internal forms.

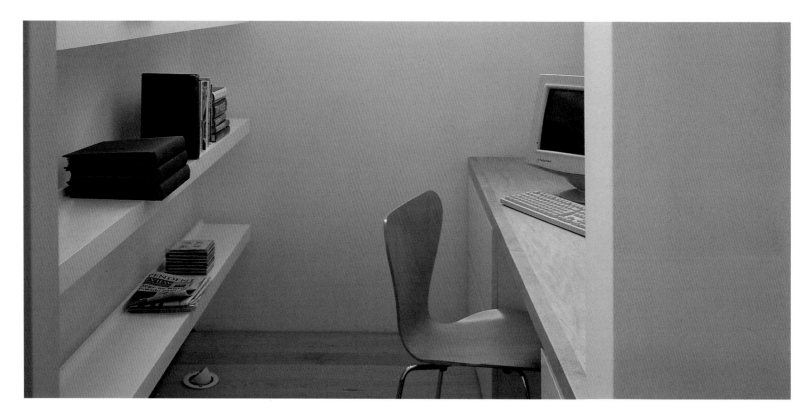

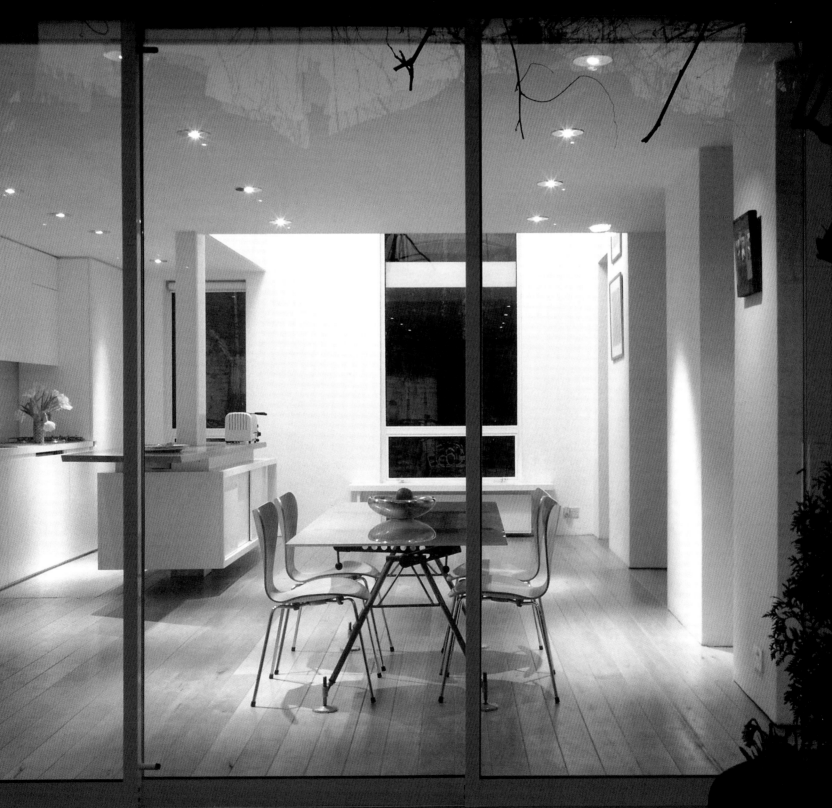

Project: **FITZMAURICE HOUSE**

Photographer: **Nicholas Kane**

Architects: **Níall McLaughlin Architects**

Location: **London, United Kingdom. 1998**

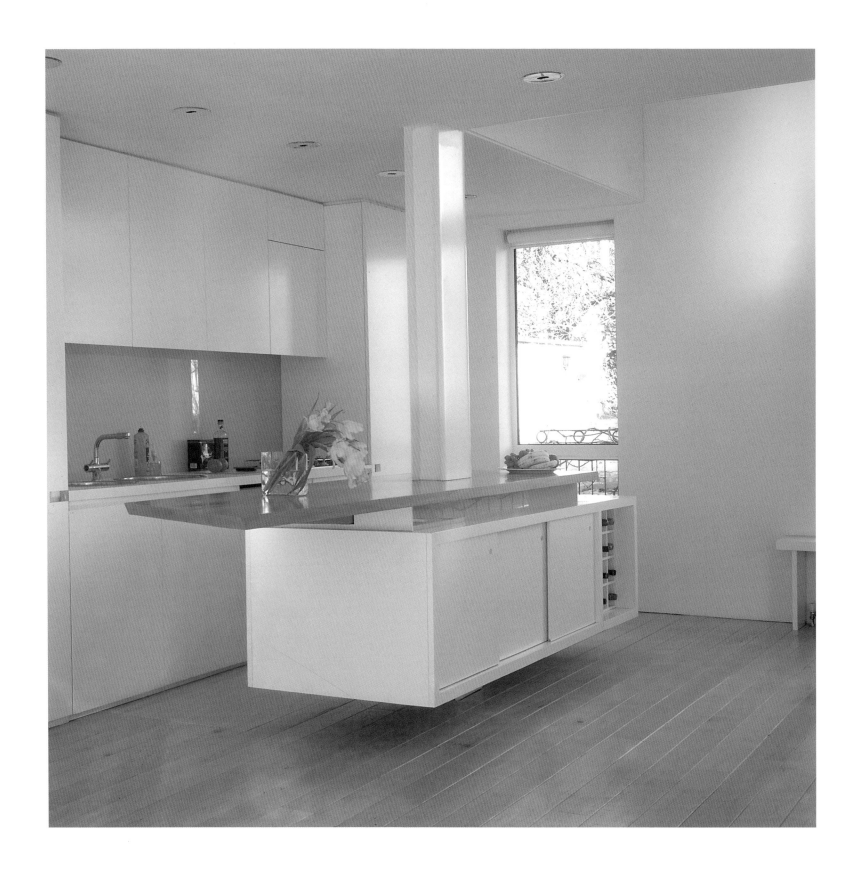

Light Is one of the project's main structural elements. In each of the spaces, the idea was to introduce natural lighting. This is clear in the kitchen, whose work island is flanked by an oversize window.

The quest for natural light generates an interesting play of reflections, both in the space itself and in those that come through the different apertures.

The abstraction achieved here is intensified by the absence of clear spatial limits like walls, in place of which we find lights in the ceiling that only suggest spatial functions.

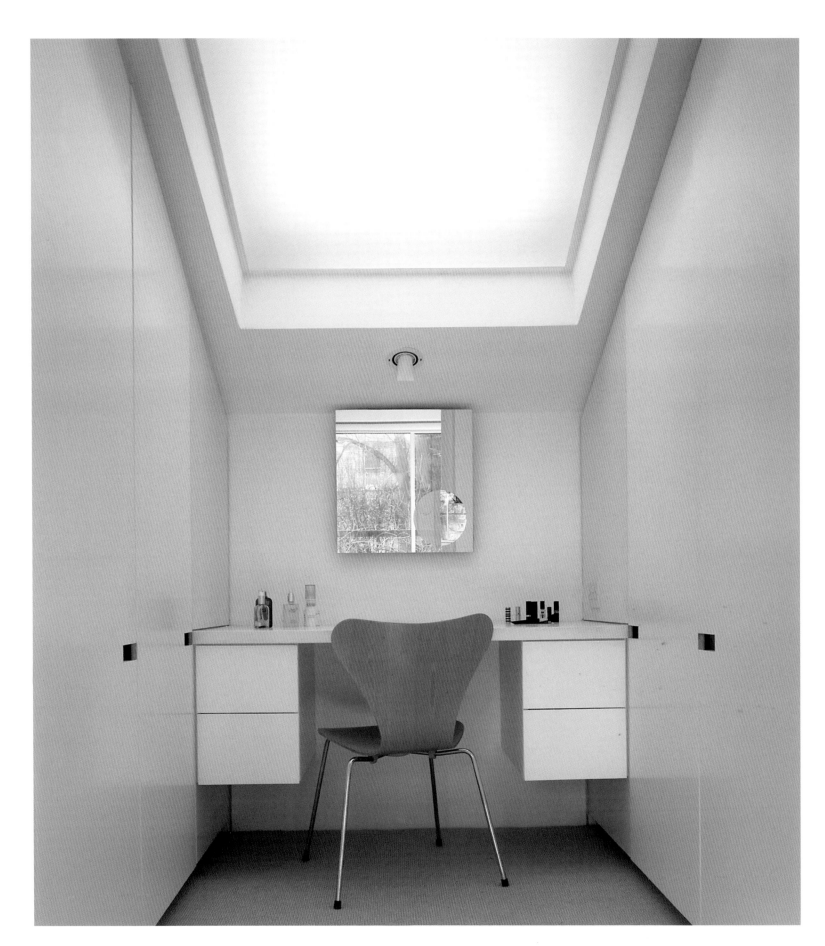

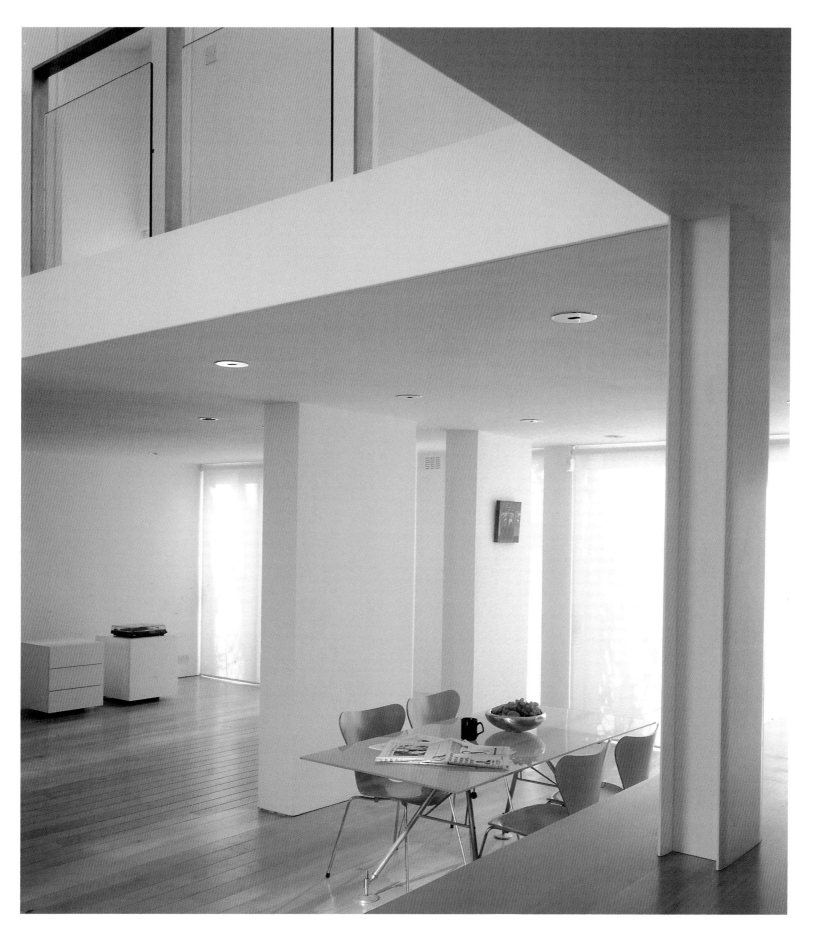

The commission for this project consisted of rehabilitating a house in the heart of Arlington, London, in compliance with heritage conservation laws. The initial plan was to enlarge the back area of the residence. With this goal and by taking advantage of the preexisting terrace, the architects projected a new space that was delicate and transparent. They fashioned an enclosure that affords both the use of the physical space and enjoyment of the view. By building a simple, economical, and metal-framed structure from standard materials and parts, they controlled costs. Thanks to the structural features of the materials used, the addition is not only cost-effective but also architecturally unimposing. In addition to the enclosed space, it also provides a second, completely open level that is accessed by a metal staircase. Consequently, the residence is privileged with the addition of a lovely new space without great expenditure.

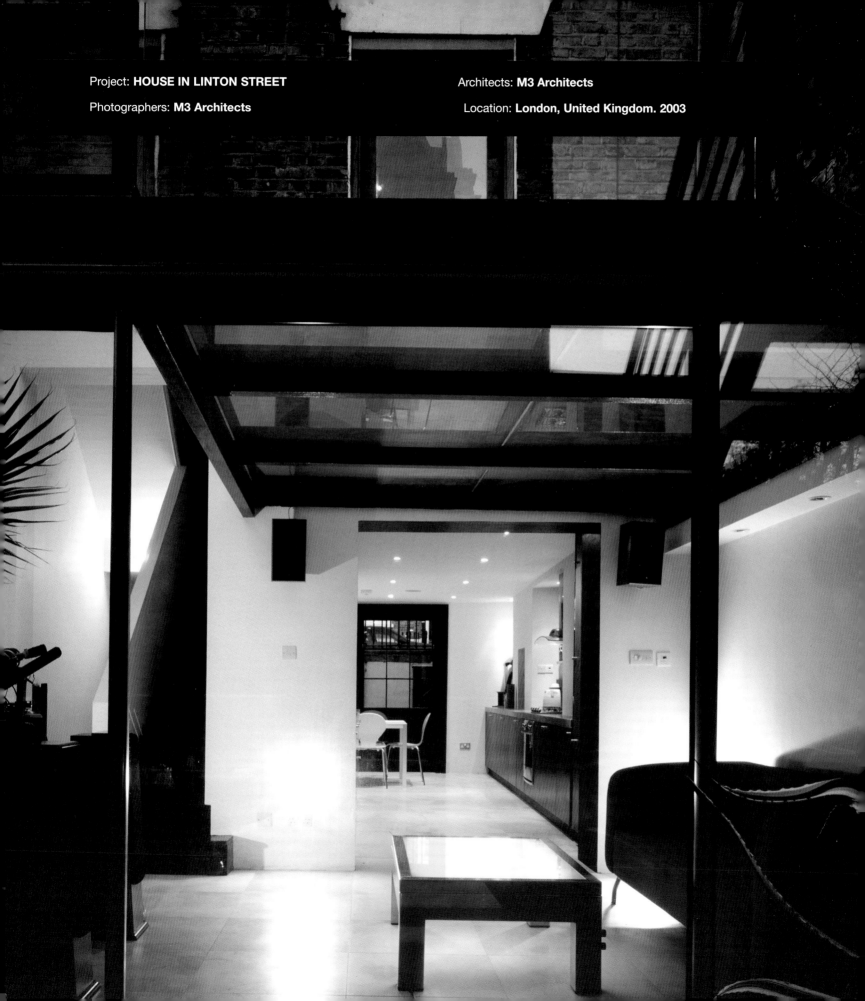

Project: **HOUSE IN LINTON STREET**

Photographers: **M3 Architects**

Architects: **M3 Architects**

Location: **London, United Kingdom. 2003**

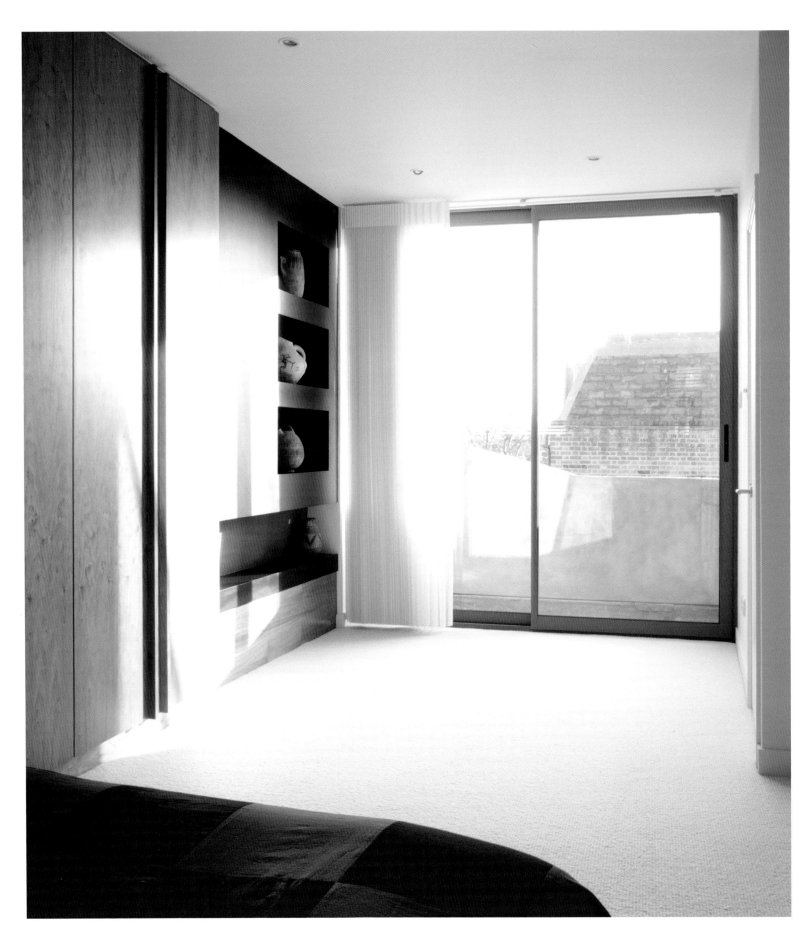

While the initial intervention was at specific points and aimed at the back of the house, its construction implicated modification of other already existing places, such as the kitchen, which was given a more direct role in the new space.

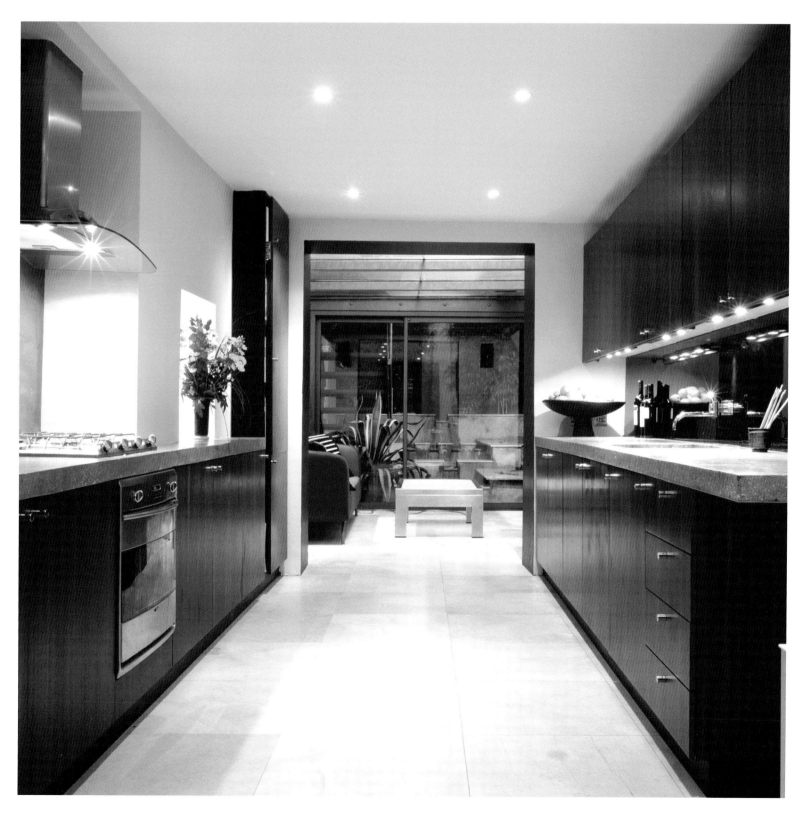

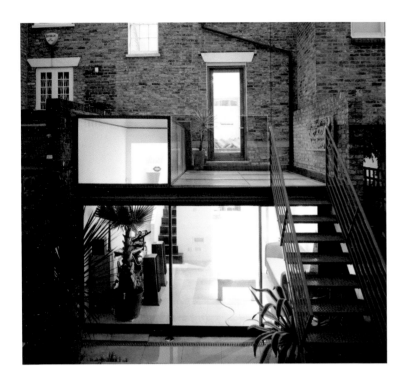

Raising the new volume meant maximum use of the old: in addition to meeting the spatial needs of the extension project, a second level was used as an open-air terrace.

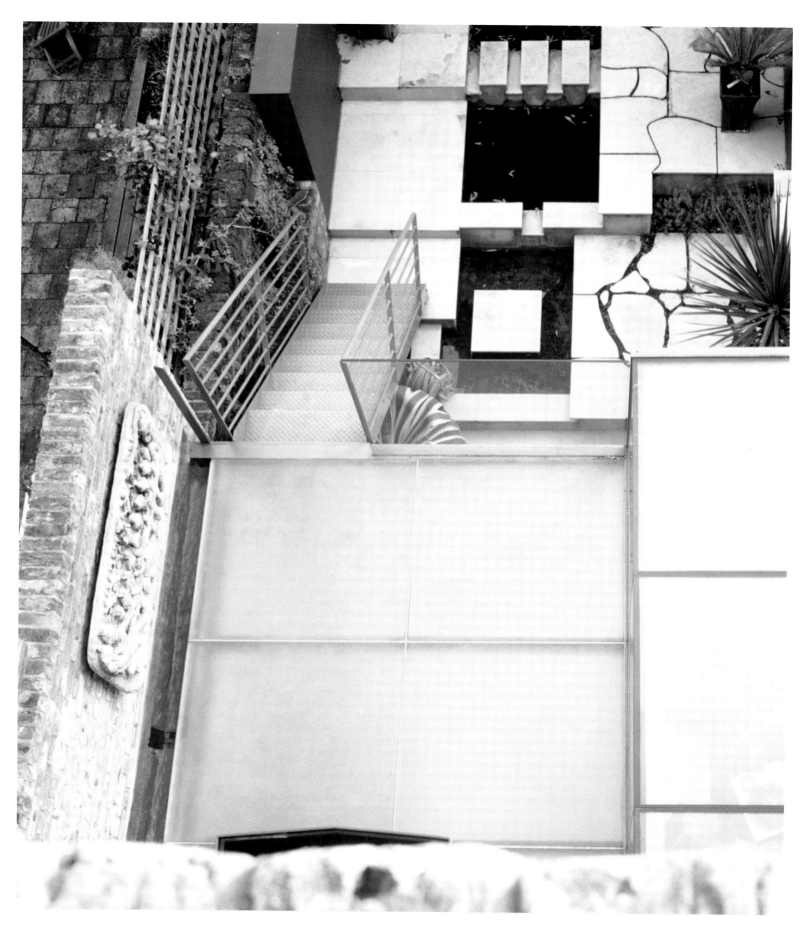

This project was subject to a number of conditions. On the one hand, it required the construction of a new ground plan with an ample functional program that included two living rooms, a dining room, a kitchen, three bedrooms, the possibility of a studio, and a full-size bath on the ground floor alone; on the other hand, it had to meet the stipulations of the legal code where it was sited, a place subject to conservation laws near the Essex coast. As a product of the economic requirements and of the aesthetic and architectural needs, a proposal was designed for the construction of a simple, geometric plan whose austere formal expression is based on a sloped roof. These project decisions kept the construction within a very limited investment, considering the result (the total cost was considerably below that of a house of these characteristics). The proposal both for the materials (revealed brick, black-stained wood, and natural slate) and for the structure (load-bearing perimeter walls in combination with metal beams) only reinforces the accessible character of the house.

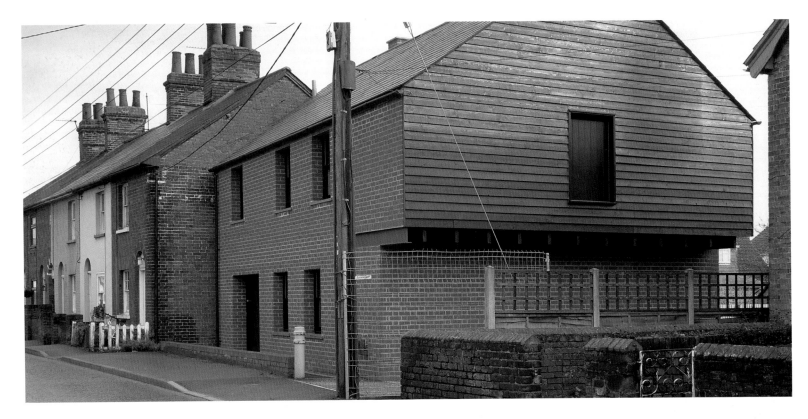

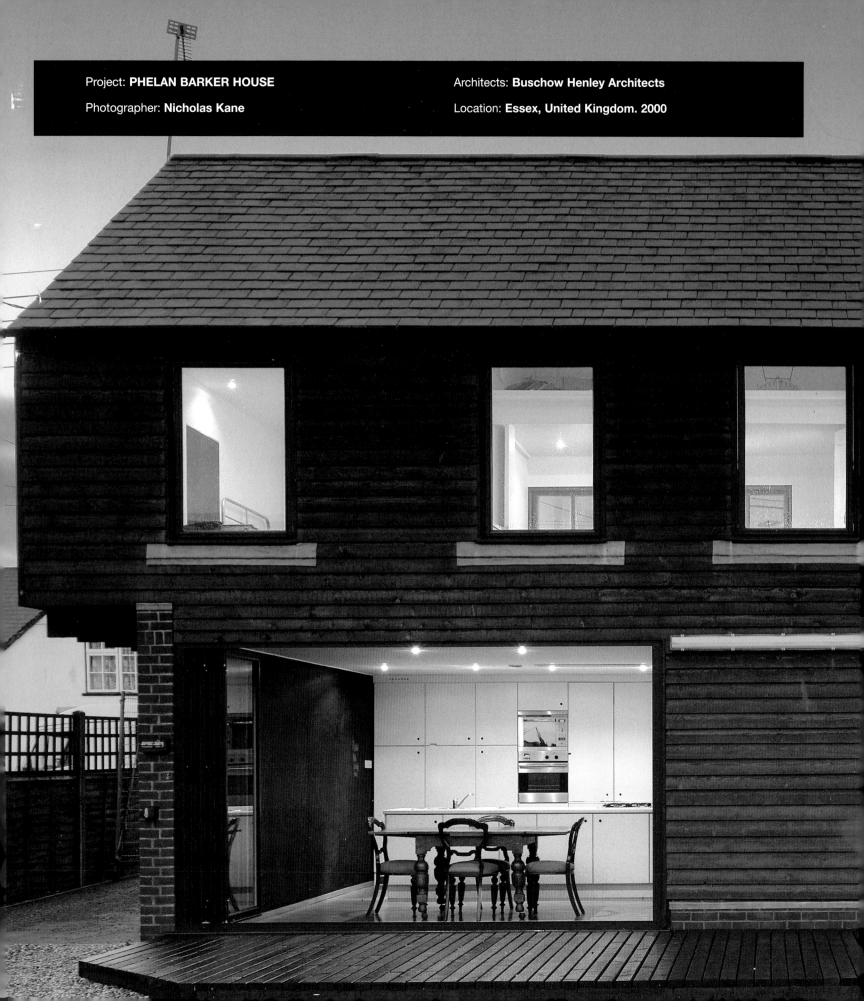

Project: **PHELAN BARKER HOUSE**

Photographer: **Nicholas Kane**

Architects: **Buschow Henley Architects**

Location: **Essex, United Kingdom. 2000**

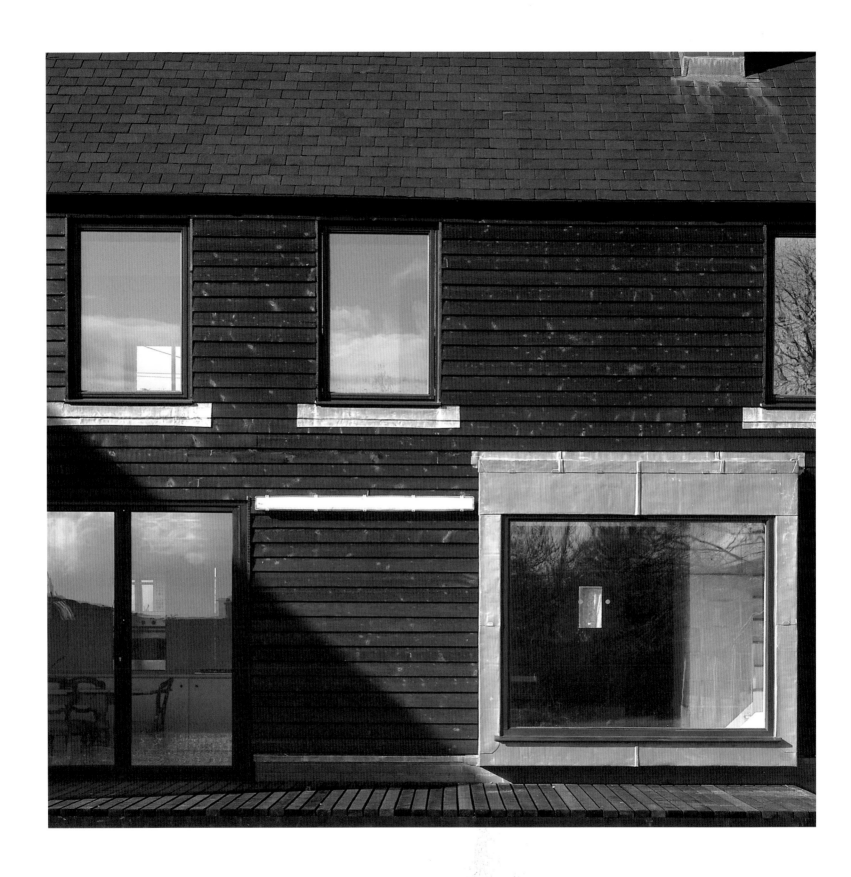

The formal proposal for this house expresses a square ground plan.
The materials used maintain and redefine the simple character.

Revealed brick, black-stained wood, and natural slate blend with the structural proposal of load-bearing walls in combination with metal beams in this highly cost-effective structure.

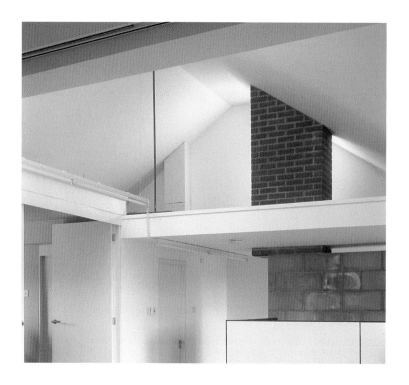

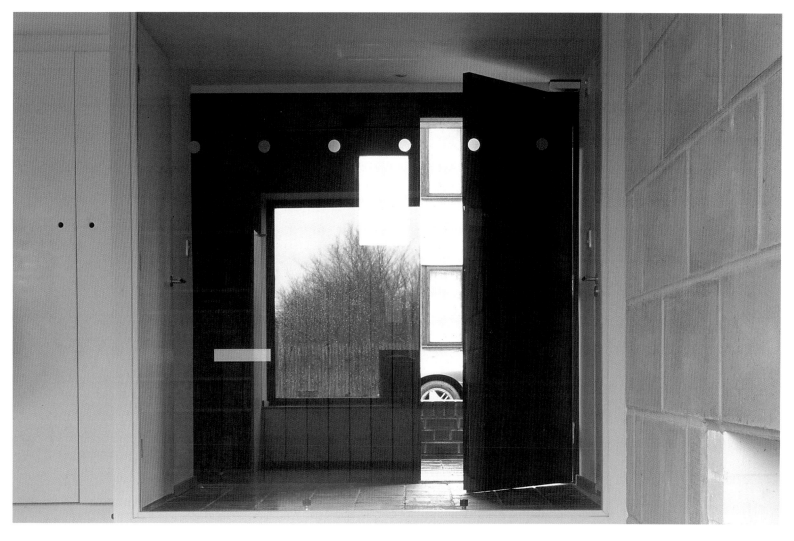

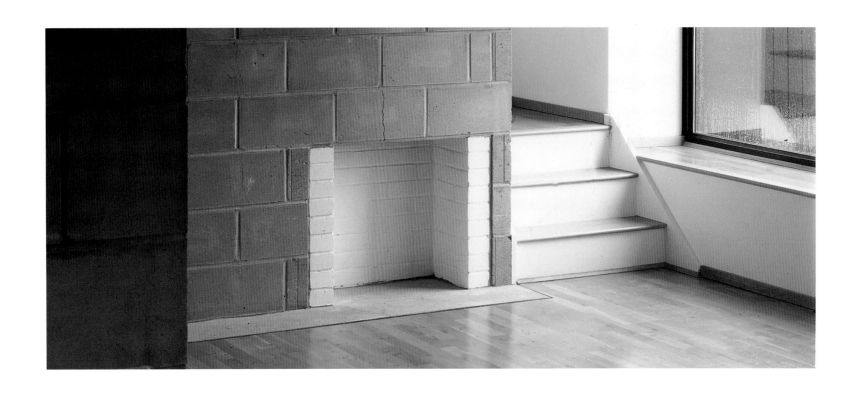

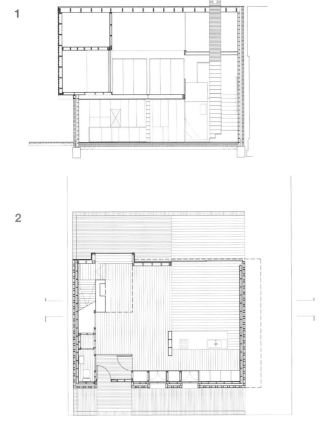

1. Section

2. Ground floor

A simple, geometrical ground plan was chosen as a solution to the financial requirements and the aesthetic and architectural conditions.

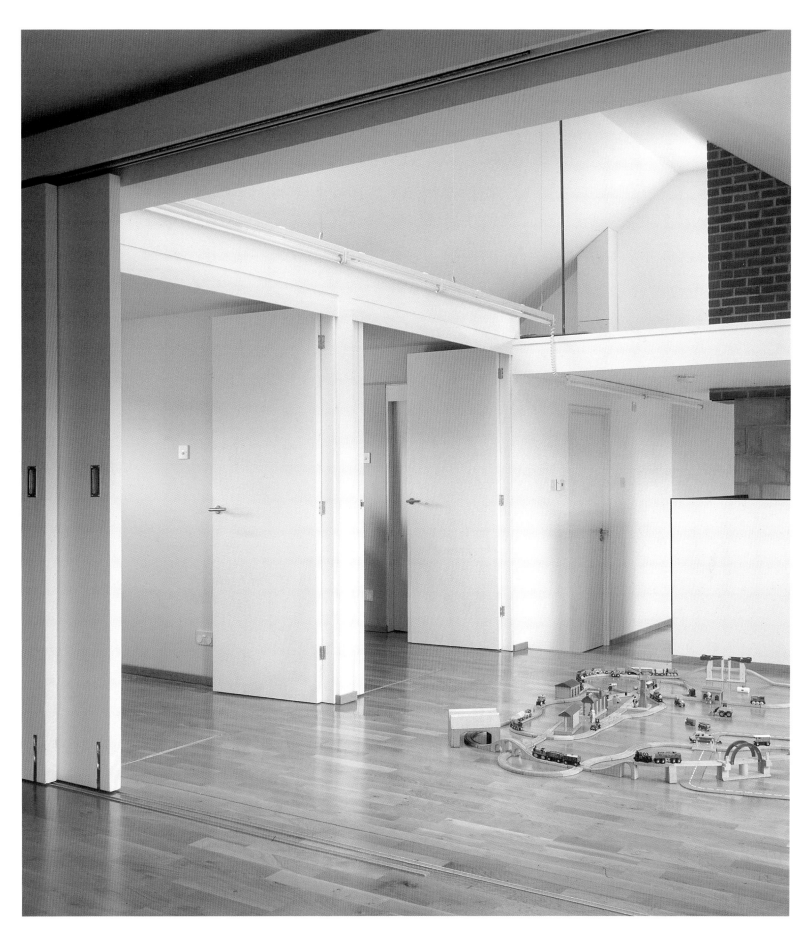

In reconversion or extension projects for buildings in need of refurbishing, the organizers must carefully consider the meaning of the concept "affordable" to make the new architecture feasible both architecturally and economically. Many proposals take maximum advantage of the special qualities of the preexisting architecture, as is the case here, where it was necessary to spatially arrange one area of the house. The structure is in a zone in Islington, and the intervention in this Victorian house meant reorganizing the living room area to increase illumination and provide a sense of spaciousness. The architects employed different strategies to fully realize the new idea while maintaining control of the investment. The architectural proposal focuses on demolishing walls and floors no longer needed and introduces overhead lighting via a translucent ceiling over a back patio. In addition to the living room, the kitchen underwent a complete renovation and extension. A group of aluminum elements for different functions went into the new spaces: a large box in the dining room, a storage wall, and a "floating" kitchen complete the transformation.

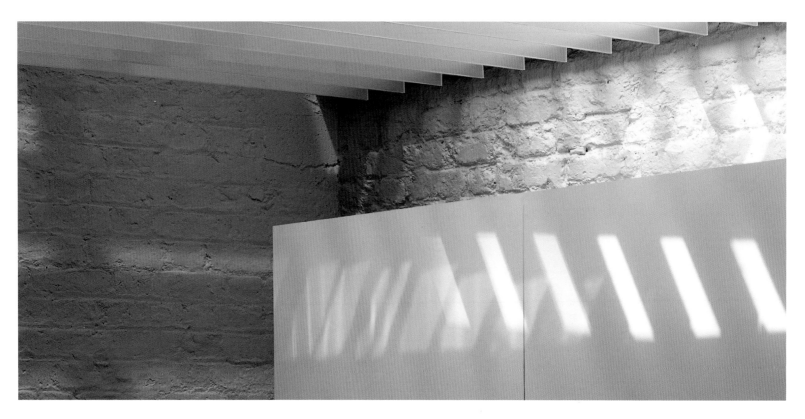

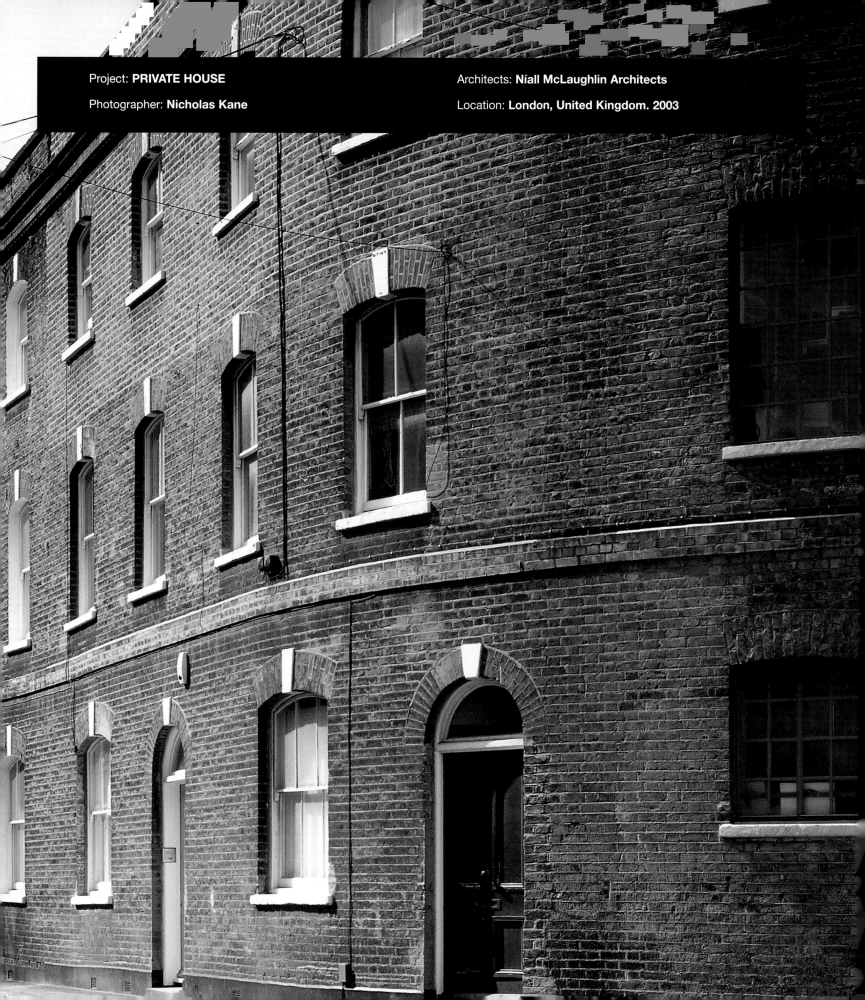

Project: **PRIVATE HOUSE**

Photographer: **Nicholas Kane**

Architects: **Níall McLaughlin Architects**

Location: **London, United Kingdom. 2003**

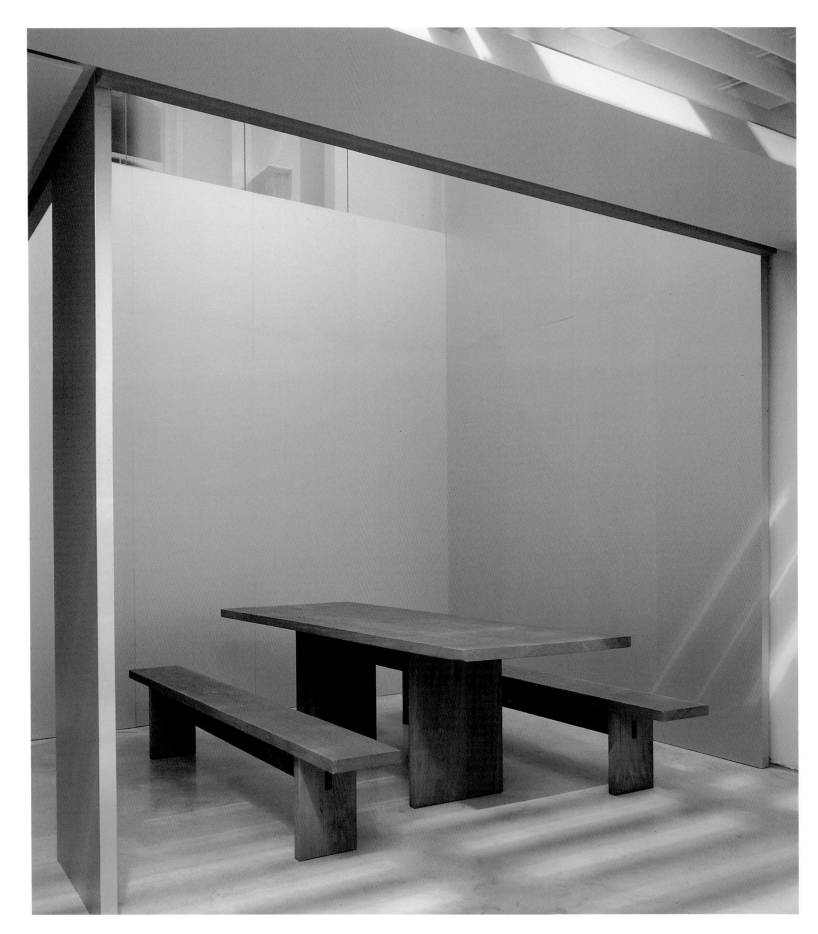

This intervention involved a complete restoration of the living room, in order to increase light and create a sense of spaciousness.

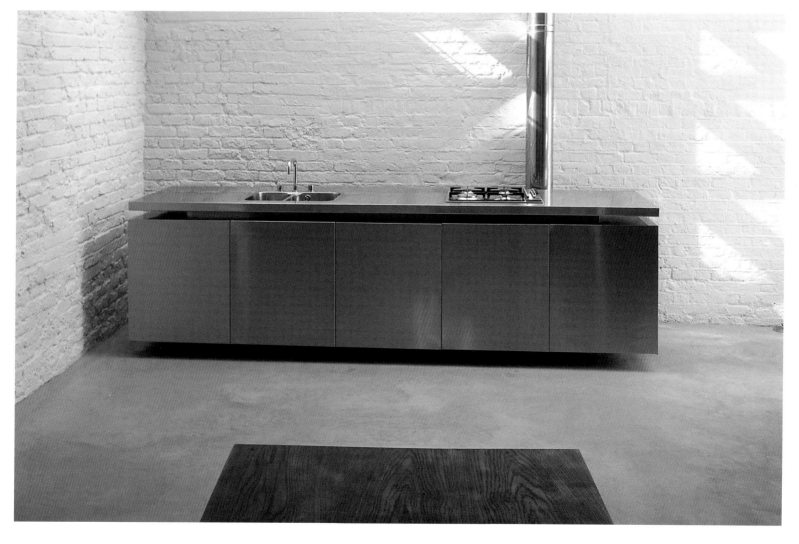

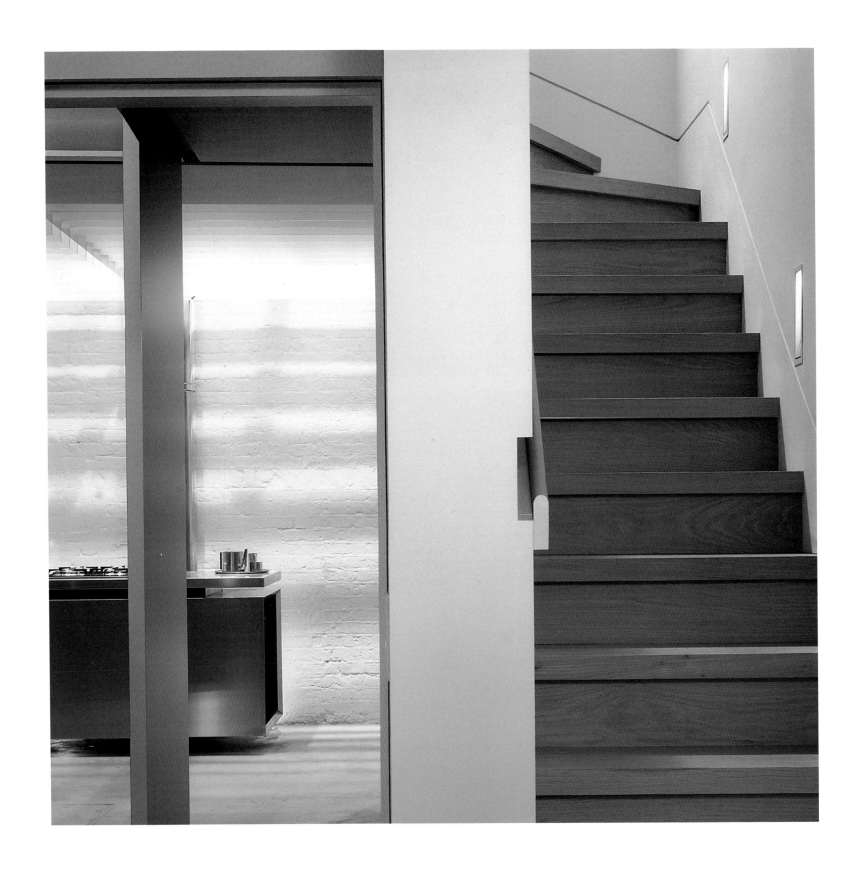

Various aluminum elements were chosen here, one of the most notable being the "floating" kitchen.

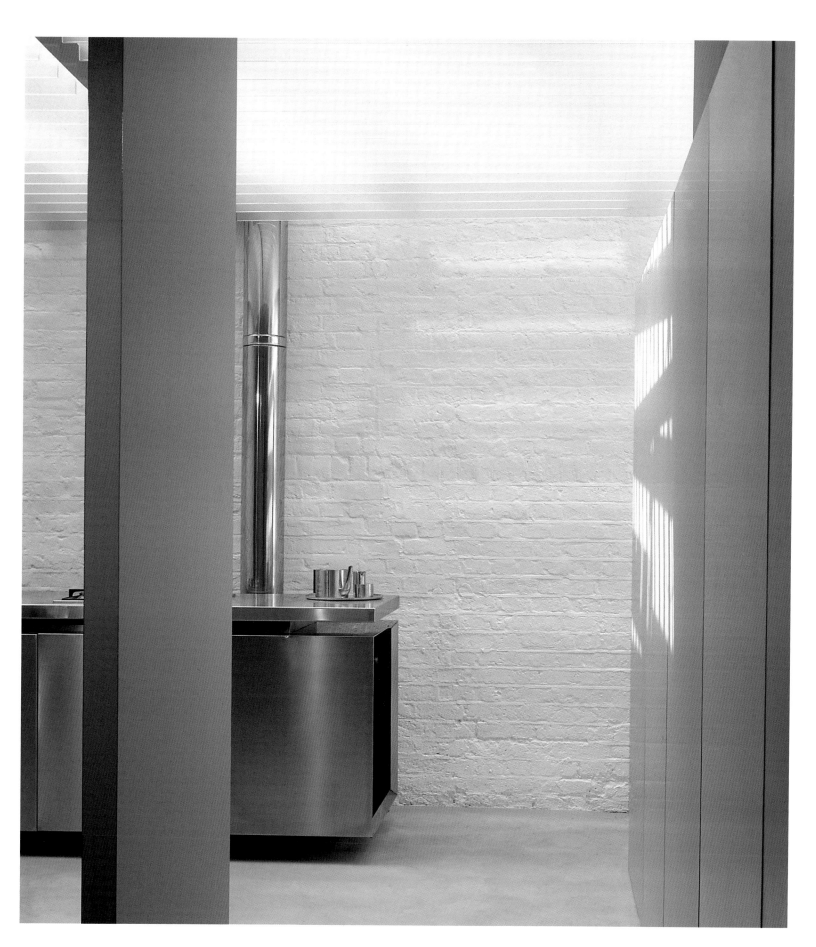

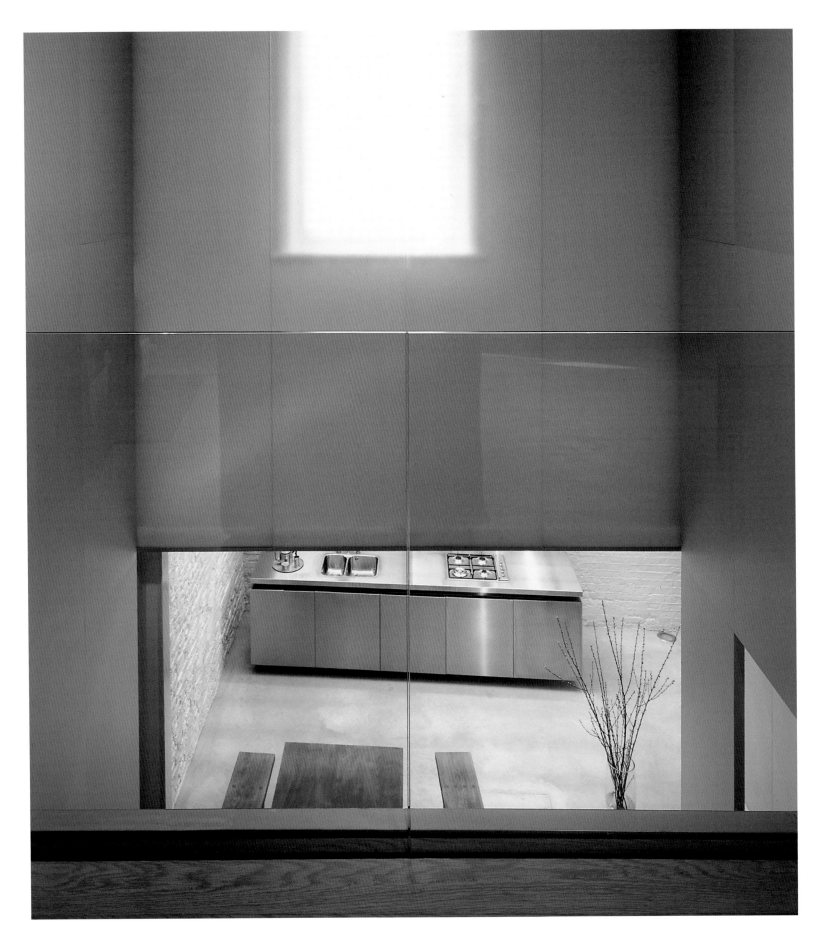

DIRECTORY

AJMK ARCHITECTS

36-37 Charterhouse Square

London, EC1M 6EA

United Kingdom

Phone + 44 0 20 7814 9125

Fax + 44 0 20 7814 9126

mail@ajmk.com

www.ajmk.com

ARCHITEKTEN LOOSEN, RÜSCHOFF + WINKLER

Klopstockplatz 9

22765 Hamburg

Germany

Phone + 49 0 408 57960

Fax + 49 0 408 56093

mail@lrw-architekten.de

ARCHITEKTEN ROLF DISCH

Wiesentalstrasse 19

79115 Freiburg

Germany

Phone + 49 761 459440

AUGUSTIN UND FRANK ARCHITEKTEN

Schlesische Strasse 29-30

10997 Berlin

Germany

Phone + 49 612 84357 / 58

Fax + 49 612 84359

augustin_und_frank@t-online.de

B & E BAUMSCHLAGER-EBERLE

Lindauerstrasse 31

6911 Lochau

Austria

Phone + 43 0 5574 430 79 22

Fax + 43 0 5574 430 79 30

office@be-g.com

BUSCHOW HENLEY ARCHITECTS

27 Wilkes Street

London, E1 6QF

United Kingdom

Phone + 44 0 20 7377 5858

Fax + 44 0 20 7377 1212

studio@buschowhenley.co.uk

www.buschowhenley.co.uk

D'INKA + SCHEIBLE, FREIE ARCHITEKTEN

Bahnhofstraße 52

70734 Fellbach

Germany

Phone + 49 711 575888

Fax + 49 711 580784

info@architekten-dinka-scheible.de

DAISUKE MIMURA / MALO PLANNING LTD.

150 – 0031,

306, 7-8, Sakuragaoka-cho, Shibuya, Tokyo

Japan

Phone + 81 3 5456 8333

Fax + 81 3 5456 8334

mimura@malo.co.jp

www.malo.co.jp

LEROY STREET STUDIO

113 Hester Street

New York, NY 10002

USA

Phone + 1 212 431 6780

Fax + 1 212 431 6781

info@leroystreetstudio.com

www.leroystreetstudio.com

LINDSAY JOHNSTON

Georges Road

Watagans National Park, Quorrobolong

PO Box 485, Cessnock, NSW 2325

Australia

Phone + 61 2 4998 6257

Fax + 61 2 4998 6237

M3 ARCHITECTS

49 Kingsway Place, Sans Walk

London, EC1R 0LU

United Kingdom

Phone + 44 0 20 7253 7255

Fax + 44 0 20 7253 7266

post@m3architects.com

www.m3architects.com

NÍALL MCLAUGHLIN ARCHITECTS

39 – 51 Highgate Road

London, NW5 1RS

United Kingdom

Phone + 44 0 20 7845 9170

Fax + 44 0 20 7845 9171

info@niallmclaughlin.com

www.niallmclaughlin.com

ÒSCAR LORENTE, ARCHITECTS

Magallanes 51

08004 Barcelona

Spain

Phone + 34 654 61 87 44

olm@arquired.es

RESOLUTION: 4 ARCHITECTURE

150 W 28th Street, Suite 1902

New York, NY 10001

USA

Phone + 1 212 675 9266

Fax + 1 212 206 0944

info@re4a.com

www.re4a.com

SETH STEIN ARCHITECTS

15 Grand Union Centre

West Row Ladbroke Grove

London, W10 5AS

United Kingdom

Phone + 44 0 20 8968 8581

Fax + 44 0 20 8968 8591

www.sethstein.com

THE NEXT ENTERPRISE ARCHITECTS

Ausstellungsstrasse 5 / 13

1020 Vienna

Austria

Phone + 43 1 729 6388

Fax + 43 1 729 6752

office@thenextenterprise.at

www.thenextenterprise.at